THE AMERICAN RENAISSANCE

THE
AMERICAN
RENAISSANCE

R. L. DUFFUS

AMS PRESS
NEW YORK

Reprinted from the edition of 1928, New York
First AMS EDITION published 1969
Manufactured in the United States of America

Library of Congress Catalog Card Number: 70-105679

AMS PRESS, INC.
New York, N.Y. 10003

THE inquiries reported in this volume were carried out as part of the fine arts program of the Carnegie Corporation of New York City. I wish to testify to the unfailing courtesy and patience of the artists and teachers to whom I went for information — a courtesy and patience so general that there is no room to mention names. I wish especially to acknowledge my indebtedness to Mr. Frederick P. Keppel, president of the Carnegie Corporation, and to my wife, Leah Louise Duffus, who made helpful criticisms and suggestions.

R. L. DUFFUS

FOREWORD · 1

✳

PART ONE

The undergraduate looks at art

✳

PART TWO

Art and the craftsman

I

THIS is the record of a more or less random pilgrimage undertaken in the hope of finding out if there are signs of an aesthetic revival in America, and if so what forms it is likely to take and what the typical American approach to the arts may be. One method of beginning this exploration seemed to be to inquire into the various ways in which the arts are being taught — a very broad classification in which it was thought logical to include not only art schools and collegiate art departments, but also art museums and non-commercial theatres.

The word random is used advisedly. I have tried to find instances of all types of instruction in the arts, but as the comparative slenderness of this volume testifies I have not assumed to describe all the important art schools, art departments, art colonies, art museums, and community theatres in the United States. If these institutions were to be arranged and considered in the strict order of their merit some I have omitted might have to be re-inserted and some I have mentioned might have to be left out. I have reserved the right to drop my line into any stream and to haul out whatever attached itself to the hook. I shall not apologize for the fish that got away.

It should likewise be understood that though this volume arises from a lively interest both in art and in education it is not the product of a professional experience. The author is guiltless, either of painting or of teaching others to paint. The chapters which follow represent a layman's point of view. But they would not have come into being at all had there not been a conviction in the mind of the author and in the minds of those who have encouraged and abetted this enterprise that the layman has rights, both in art and in education. He is, in fact, the most important as he sometimes seems to be the most neglected element in the situation. I hesitate to define art, partly because I know I shall invite criticism if I do so, and partly because I do not know how. But in at least one sense it is a medium of communication. It is not only a language through which the artist conveys a message to his fellow men, but also a device by the aid of which the latter reach an understanding among themselves. Those who love Botticelli or Degas are not strangers. But a medium of communication may be considered successful only to the extent that it communicates. If the layman cannot understand the artistic message of his generation something is wrong with his education or with the education of the artist. Something must be done to re-educate one or both before there can be an aesthetic revival — that is, before a given generation can utter forcibly and intelligibly its characteristic criticism of life. The layman's point of view is therefore important, whether

he is to be considered as a critic entitled to a hearing, or merely as a guinea pig whose symptoms in the presence of works of art or theories of art may have a certain scientific value.

There are other arguments to be advanced in favor of the lay attitude. The layman, like a good juror, comes to the case with no preconceived notions and prejudices. He is, indeed, in this democratic country, somewhat given to deferring to the authoritative and the customary. So far as a judgment of painting in galleries goes he has typically not advanced beyond impressionism. He is suspicious of the unusual in art as he is in government, biology and social life. It is only in the field of mechanics that he expects and welcomes an endless radicalism. But the truth is that the layman has had to become accustomed to the radical note in painting and drawing within the past few years, whether he would or not; for this note is not now heard solely in little upstairs galleries, but is sounded boldly in the advertising pages of the more sophisticated magazines, and makes itself audible in the newer architecture and interior decoration. Consequently the man in the street — at least in a metropolitan street — is no longer quite the aesthetic Tory that he was. We need not idealize him. He still has his horrid vulgarities. His tastes improve, it often seems, with glacial slowness. He will tolerate a Tribune tower but he will also bow down before the gold-encrusted banalities of a motion picture palace. None the less he has begun to have his doubts, and that is possibly the beginning of

wisdom. Let us, therefore, be gentle with him, not expecting too much nor yet thrusting him forth, as so many aesthetes are prone to do, into outer darkness. In making this plea an amateur in this field is really speaking in his own behalf. We shall all learn more, possibly, if we can be occasionally delivered from the thralldom of the Expert — that formidable figure who is perpetually freezing all the genial inaccuracy and speculativeness out of conversation — and indulge instead in what may be called travellers' tales.

A book of travellers' tales, at any rate, is all that the present volume affects to be. To be sure, it will be found to contain opinions. But these will be opinions which have arisen in the course of travel, and some of them will have been stolen bodily from artists and teachers who were good enough to discuss their problems. Others may turn out to be unsound, and they are in general designed to raise questions and start discussions rather than to settle questions and end discussions. It may be well to add, too, that there is a vast difference between a wish and an expectation — between the millenium, on the one hand and, let us say, Kansas or Chicago on the other. To predict is not to advocate. For instance, as I shall try to show, there is reason to believe that artistic expression in this as in every highly industrialized country will become less individualistic, more highly organized, more mechanized — in a sense more Egyptian and less Grecian. The dominant art of the future may be foreshadowed, not in easel

4

paintings, but in automobiles and set-back apartment houses. Personally one might be willing to sacrifice all that may thus be accomplished, sanely, responsibly and scientifically, for the year's work of one mad genius. Thoreau or Gaugin may have been right, or they may not. It does not matter. The point is that we are not given a choice. The windmills of our destiny whirl on. It is only an occasional Quixote who will set lance in rest and try to ride them down. And we cannot predict Quixotes, nor is it of much avail to advocate them.

2

MANY QUESTIONS might be raised as to the extent to which schools determine the kind of art and the kind of artist we have and are to have in America. Undoubtedly they reveal much, but are they a cause or an effect? Are they forming traditions, or are they merely the battlegrounds where traditions war with the newer forces for the mastery? One is tempted to come to one conclusion at one school and a different one at another school. There are types of art teaching which have not altered in any essential way for more than three hundred years. The whole form and color of man's life on earth has changed during those three centuries, but this teaching has gone complacently on. There are other types which frankly reflect the mechanized ideals of the present day. They would not be what they are if the steam engine, the electric dynamo, and the steel mill had not been invented.

There are still others — and here I am thinking of the efforts being made at several universities — where a recognizable creative influence is at work. Finally, outside the whole scheme, so far as he can get, stands an occasional independent artist, who swears up and down that all art schools are bad and that no painter ever learns anything about his trade that he does not find out for himself.

But nearly all artists do study at one time or another in one school or another, and except for the influence of innate tendencies on the one hand and the struggle for food and a roof on the other they do reflect the schools. The schools of today are eloquent of the general run of the art of tomorrow. As a very simple analysis indicates they represent three major approaches to the arts — the cultural, the practical and the adventurous. The cultural approach, as it was traversed by Professor Norton at Harvard and widely imitated, produces, not artists but appreciators. It is highly important, yet, creatively considered, it is literature rather than art. I shall discuss it because it is essential to an understanding of what follows, and also because it is a thoroughly charming phase of American cultural history. The scent of lavender is about it nowadays, but there are worse scents than lavender.

But because we are beyond all modern peoples, perhaps beyond any nation since the Romans, active and not contemplative, extrovert and not introvert, our artistic conflict will be between two opposing groups of creative workers —

those who follow art for art's sake and those who are for art for use's sake. At the present moment there can be no question that the latter are in the ascendancy. Just as the pioneer is passing forever from the world's stage so perhaps will pass, too, the great lonely forelopers of the arts — they and all their retinue, their followers, even their imitators. It may be lamentable, it may be true, nevertheless. The conception of the artist, the model upon which the apprentice to the trade of beauty forms himself, is changing before our eyes. And this is partly because the conception of art itself is changing. The sacerdotal attitude on the part of both artist and public is waning. Pictures, statues and ceremonial buildings were once closely linked with the act of worship. They were religious or they were nothing. Modern man more clearly sees that they are, like sex and food and struggle, of the essence of life; and he is, consequently, a little less reverential. One laughs with or at a modern painting, one loves it, one detests it, but one does not stand on tiptoe, converse in whispers, breathe prayers, burn incense, cross oneself, before it. I shall touch, a little later, on the evolution of the artist. It is enough at the moment to remind the reader that not so long ago tradition set the painter or sculptor apart from the rest of mortality. He was a priest, he understood mysteries, he communed with the stars, for he

" . . . on honey dew had fed
And drunk the milk of Paradise."

The common run, subsisting on bread and butter, tea and jam, were not supposed to have a stomach for this more etherial fare. But the artist of late, whether in lines or colors or in words, has begun to play a new rôle. He strives to be more human than humanity, more earthy than the earth. He bites nails in two. He paints pictures with his own blood and sweat. He has more than a touch of the Whitmanesque about him. Or he tries another tack. He drops handicraft, jumps into the current of the age, hails the machine as his brother.

3

THIS MEANS — we cannot in this generation escape it — an art that goes with the prevailing economic and technical drift. Just as the medieval artist served the church the modern artist must serve the machines, which are by way of being the modern church. But what does one mean by machines? Primarily an enormous power of reduplication and a corresponding loss of the individual touch. The machines are already duplicating endlessly for thousands and millions of persons the paraphernalia of daily life but they tend to do so in an imitative, insincere and stupid fashion. The artist's opportunity is to make of the machine a mightier etching tool, a vaster brush, to spread his idea across a countryside instead of confining it to a few square feet of wall or canvas.

Practically this demands a new development of the arts of design — or rather of the arts in which design is uppermost.

And what is called the modernist trend in art is not incompatible with this tendency; it is, as everyone knows, away from representation and in the direction of the abstract and the symbolical. But there is nothing new in the abstract and the symbolical. Pattern is older than human history. It is the essence of ancient buildings, carvings, utensils, textiles. The only new thing our generation has done is to surround it with a frame and strip it of utility. Take away the frame, put the pattern to work and we have, possibly, the industrialized art of the future. We see the beginning of such an art in the rise of what were originally trade or handicraft schools into schools of design. And we see the artists of the older dispensation resisting it by drawing what is to them a sharp line between the "fine" and the "applied" in art. But the very word, it is to be feared, gives the case away. Applied art is dynamic art. It enters into life. It cannot be overlooked. So the most pregnant phases of the teaching of the arts, for this moment and this spot, seem to be those which have at least one eye on the factory and the market place. For the artistic taste, or lack of taste, demonstrated at these strategic points will be that which stamps the nation, at least superficially. There is some hope, as I shall later try to show, of a development of regional and even local artistic dialects in the United States. But over this must always stand the language spoken by nationally advertised, nationally distributed goods — one is sadly tempted to add nationally advertised, nationally

distributed ideas. Here is equal chance for a great aesthetic expression, or for one that is cynical and debased. Here, finally, is opportunity to determine whether art is ever to be a great majority utterance, the accepted voice of a people, or whether it is to remain the delicate and poignant whim of a small minority.

What is involved here is not only the education of the artists but the education of the public. Often this is taken to mean the imposition upon the crowd of standards of taste which have previously been confined to limited coteries. But there is probably very little relationship, beyond the accidental one, between standards of taste and creative art. What most men seek in the arts is something that will give significance and coherence to what would otherwise seem an insignificant and incoherent existence. To do this art must not only have lustiness and gusto, but it must be the record of a recognizable experience. The demand for a record of this sort increases as leisure increases, for it is characteristic of human nature that it no sooner receives a reasonable guarantee of sufficient food and shelter to ensure continued living than it begins to ask, rather pessimistically, what life is for. Let that question be answered, in terms of science, of religion or of art, and there follows a Reformation, a Renaissance. The human spirit has for a time a sense of liberation. Creative talent, finding the prevailing mood congenial, springs up on all sides.

It would be as futile to advocate such a phenomenon as it would be to advocate an eclipse of the moon. We may, however, legitimately ask whether there are signs that America is about to undergo any such happy experience. That, indeed, as has been said, is an object of the present inquiry. The answer, one must frankly admit, cannot be more than tentative. Perhaps we are approaching a crisis which will decide whether we shall have our Renaissance or sink into a new Dark Age. Certain straws of evidence do point toward at least a quantitative gain for the arts. The registration in all art schools and all art classes of which I have any knowledge has increased greatly since the end of the World War. In most cases the ratio of growth has exceeded that in college and university registration as a whole. Furthermore, the applied if not the fine arts are manifestly offering careers which even the he-man and the go-getter do not altogether despise. Here again, of course, one must ask whether these newcomers are true converts or whether they will merely vulgarize the arts. A widening aesthetic interest among laymen is shown by the recent flowering of the museums of art, which, from being glorified attics, have become energetic and popular educational institutions. But the American layman is now not only willing to look at pictures; he is also, as the success of numerous lay art classes has shown, very often eager — even pathetically eager — to make pictures. This phenomenon is country-wide. It is found in the metropolis and in the rural districts,

among Americans of the older stock as well as among those who still speak English with an accent. In actual numbers, compared with the mass of our teeming population, these lay adventurers in the arts are few. They would be voted down a hundred times over by the devotees of the motion picture and the confession magazine. But there is no doubt that their numbers can be and will be multiplied whenever and wherever the facilities are available. Perhaps no creative ability that would not otherwise have come to light will be discovered in this way. None the less the area of appreciation will be widened. More persons will be able to tell the honest goods of art from the shoddy.

One hundred per cent Americanism in the arts might easily become as tiresome as one hundred per cent Americanism in politics and business. But whether we try or not we can hardly help a certain recognizability in all that we say and do. Let us suppose that an American goes abroad — a supposition requiring no great stretch of the imagination. He buys his clothes in London and cultivates an accent and a little pointed beard in Paris. He avoids the American bars and whenever a visitor from Indianapolis asks him the way to the Place de la Concorde he stares blankly, shrugs his shoulders and replies in what he fondly believes good Parisian. In short, he fools everyone except the Parisians, who instantly recognize, inside the clothes, the beard and the accent, something indestructibly Yankee. Not all tourists take similar pains to conceal

their nativity. In general the American abroad is as apparent as a camel in a herd of Holsteins — sometimes, to be sure, a very thirsty camel. There is unmistakably an American manner which identifies us, despite our wide assortment of divergent races and nationalities, our range of environments, and our varieties in culture and education. Some observers, thinking in terms of ready-made clothing, motion pictures, radio programs, and syndicated newspaper comics, may deny the variety. It is there none the less. But like the Chinese we all look alike to foreigners — we all, in a sense, have yellow skins and almond eyes, and our ways are peculiar.

There is an American manner, not only in ways of talking and acting, but in science and invention, in business and in journalism. An American newspaper, department store or factory may be set down in Lyons, Sheffield or Edinburgh, but it will not be mistaken for anything but American. Nor would any sensitive European miss the American flavor in the philosophy of William James, the humor of Ring Lardner, or the music of Paul Whiteman. But with the exception of a very little music, a very little painting, and a good deal of recent architecture, it is doubtful if anything notable has yet been produced in the arts which is so shot through with Americanism that it could not possibly have been produced on the other side of the Atlantic.

Our radical painters still get much of their inspiration from France, our conservatives from Italy. Yet here and there this

imported aesthetics is being translated into the American vernacular — it is beginning to acquire the Yankee twang. And why not? We have attained to economic maturity. We have made locomotives, automobiles, bridges and skyscrapers, and sometimes have stumbled upon beauty. Is there any reason why we should not now go deliberately forth to seek it? And need we be ashamed to seek it in our own way and our own places, not alone in quietness but amid sweat and dust, fire and molten metal? For the great ages do not repeat themselves. The American Renaissance, if it comes, will be a renaissance skeletoned in cement and steel.

The Undergraduate Looks at Art

I

NORTON & HARVARD

I

IN 1873 Charles Eliot Norton was forty-six years old
and newly returned from a stay of five years in Europe. He gazed at America with eyes which had been
glutted by the beauty of Italy and wearied by the study
of medieval manuscripts at Sienna and did not find the
prospect all that he could have wished. All his life, indeed, he had been and was to be a little homesick for England and the Mediterranean. Once he wrote to Ruskin,
" I am half starved here "; thought a moment and added,
" and in the old world I should be half-starved for this
strange new one "; thought a little longer and concluded, " A thousand years hence, perhaps, America
will be old enough for men to live in with comfort and
complete satisfaction." But unlike Henry James he did
not run away. Instead he dug in upon his paternal acres
at Shady Hill, not far from Harvard College, fortified
himself with old books and pictures, armed himself with
friendships, and for thirty-five years did valiant battle
with the Philistines. They were years not altogether
without their victories, as, to take two conspicuous
examples, a comparison of the architecture of the

Philadelphia Centennial with that of the World's Fair in Chicago, might show.

A reason for his persistence was that the love of beauty which had flowered in this son of an austere race had not driven out the love of duty. Norton had descended, on both sides of his house, from a race of incorrigibly upright men, many of them ministers of the gospel. His father, not himself a preacher, labored for many years at the Harvard Divinity School in the production of preachers. The family had established itself in the community not only by good works but by possessions. When Charles was a boy the Norton household was the only one in Cambridge, with the exception of that of President Quincy of Harvard, that kept its own carriage. His inherited income was enough to make it unnecessary for him to work for a living, and he lived and died in the house in which he was born. Once he said to a class at Harvard, " None of you, probably, has ever seen a gentleman." But in seeing Norton they had seen as perfect a specimen of that possibly imaginary tribe as America ever produced. We must think of him as a very great gentleman, indeed, trying to make generation after generation of Harvard students into gentlemen, trying, through them, to make all America more gentlemanly. That is what art and culture meant to him.

There is no more striking instance of the successful grafting of the ideal of fine art to the stem of Puritan morality. Norton never got over the habit of the ethical approach. " The last and best thing I can say to each one of you," he would conclude, in the final lecture of his

course in the history of art, " is to be a good man." This is the ultimate phase of a born moralist, who had edited hymns in his twenties, and at seventy-one dared threats and insults to denounce what his conscience told him was an unjust war. The sirens of sensuous loveliness would not lure such a Ulysses. It is significant that he chose the Parthenon as the supreme human achievement. When New England took up art it was natural for it to begin with something as perfect and cold as marble.

Norton is worth attention, not merely for his individual importance but because he was so excellent a type. He was born at Cambridge in 1827 and graduated from Harvard in 1846. What life would have made of him had he stuck to Cambridge as closely as Emerson, Thoreau and the Alcotts stuck to Concord might afford an interesting speculation. He might have been a reformer of the particularly insistent New England species. In fact he did watch politics attentively all his life, and only his acquired doubt that any good could come of them kept him from a more active participation — that and his poor health. He might have preached. He did, as a matter of fact, associate himself with an effort to improve the lodgings of the poor in Boston, and for years he went every Sunday afternoon to talk and read the Bible at a home for incurables conducted by a Catholic sisterhood. He started a night school for working men and boys. The instinct to be of service to his fellows would not let him rest.

But fate shook him genially out of his first small corner. Boston in those days still had romantically intimate

connections with the Far East. After working two years as a clerk for the exporting firm of Bullard and Lee, Norton found himself, at twenty-two, sailing out of Boston harbor as supercargo on a voyage to India. Life was opening before him like one of those Japanese paper flowers that bloom when thrown in water. One might say that he never returned to New England again — certainly not to the right little, tight little New England he had known before. He wandered over India, returned by way of Italy, France and England, met the Brownings and every one else worth knowing. Back in Boston again he set up a little office and applied himself for a time to exporting genteel cargoes of cotton and indigo to India. But business, even with India, bored him, and not needing an earned income he gradually withdrew.

The years passed, for the most part tranquilly. Norton went abroad from time to time. He knew Carlyle well, Ruskin was one of his intimate friends, everywhere doors opened before his introductions and his gentle, happy manner. The Civil War made him temporarily a propagandist, but he got over the experience and seemingly it left no scar. In the late 'sixties he is to be found drifting languorously, yet laboriously, too, through Italy. He visits and studies Florence, Venice, Sienna. He writes a history of the cathedral of Sienna and acquires a life-long passion for Dante. He decides that there are two ages of the world worth remembering — the golden age of Greece, and Italy between the fourteenth and sixteenth centuries. At forty-six he is

back in Cambridge, feeling worn and old — and his real career begins. President Eliot asks him to become a professor. Harvard might well stick a pin in its calendar at this point.

2

BEFORE SPEAKING of Norton's teaching it may be well to say a little more as to his attitude toward his native land and its inhabitants. As I have indicated this was not altogether uncritical. He never got over deploring the physical youth of the United States. " Nature, to be really beautiful to us," he pointed out, "must be associated with the thoughts and feelings of men. An Italian sunset is better than a Californian for this reason; a daisy is of more worth than a mayflower." He could not have endured any American environment outside of New England, unless possibly it was Virginia and the older South. He fairly shuddered at the prospect of passing three days in Lincoln, Nebraska. He admired the personal integrity he was sure he saw in a small Vermont village, but he thought the simple old standards were slipping in Vermont, slipping everywhere in America, and no good new ones taking their places. In short he was a classicist in life as in art.

He didn't sneer, however. " I agree with your view of the character of our people," he wrote to a friend in 1894, " but it makes me less despondent than it seems to make you. I do not wonder at their triviality, their shallowness, their materialism. I rather wonder that, considering their evolution and actual circumstances,

21

they are not worse. . . . They have no traditions of intellectual life, no power of sustained thought, no developed reasoning faculty. But they constitute on the whole as good a community on a large scale as the world has ever seen." No man with such finely, such exquisitely developed tastes could be a thorough-going democrat. But he would have had hopes of America if he could have passed it, individual by individual, through his classes in Harvard College. And with reason, too.

When we think of Norton going to Harvard to teach the history of art we must remember that this was a new and radical policy for an American college — a policy worthy of that young and reckless educator, Charles W. Eliot.

"Nowhere in English-speaking countries," wrote Norton himself, many years later, "had culture in the arts been admitted as an essential portion of education. They had been regarded as of trivial concern; the study of them had been relegated to professional artists or to mere dilettanti, and the idea that a complete and satisfactory education could not be obtained without some knowledge of their character and history, and without such culture of the aesthetic faculties as the study of them might afford, appeared strange and unacceptable to many even of the most enlightened thinkers on the subject of the education of youth."

Norton had fairly precise ideas as to what he wanted to do. He had fairly precise ideas about everything, even to the proper way of tying up parcels. And he put his ideas about his teaching into words. He wanted, as he

told Ruskin, to inspire the youth of Harvard " with love of things that make life beautiful and generous." " My plan," he added in another letter, " is to give my class at first a brief sketch of the place of the arts in the history of culture, of their early developments, and then to take them to the Acropolis at Athens and make them study it in detail, till they shall have some notion, however faint " — the two qualifying words are good Nortonese! — " of its unique glories. . . . I have it as much at heart to make them understand that the same principles underlie all forms of human expression, — and that there cannot be good poetry, or good painting or sculpture, or architecture, unless men have something to express which is the result of long training of soul and sense in the ways of high living and true thought." He explained to Carlyle that he desired " to quicken, so far as may be, in the youth of a land barren of visible memorials of former times, the sense of connection with the past and of gratitude for the efforts and labors of other races and former generations." He spoke with humorous deprecation of his " class of ingenuous youths," but he loved youth and loved teaching. He thought of himself, perhaps, as importing culture into America, as Bullard and Lee had imported silks and spices. In 1873, and for some years thereafter, this could really be done, for learning was not yet packed, like breakfast foods, into a thousand patent containers. One man could actually tell a class of college students all they needed to know — or, which is the same thing for practical purposes, all it was thought they needed to

23

know — about art. It hadn't been so very long since one man could tell them, under the title of Natural Philosophy, all they needed to know about science. Education was simple in 1874. One pried open the student's mouth and poured it in.

Norton grew and the times changed. He mellowed and he also became less systematic. In his later years he might come into class intending to lecture about the Parthenon, be drawn away from the subject by the sight of a horse-shoe stick-pin and never come within two thousand years of Greece. It used to be said that if a boy washed his face and tied his necktie straight and answered the roll call once a week he would get his credits. Culture at Harvard doesn't come so easily now, and the Norton method, in its original form, is being relegated to the smaller and poorer colleges and to a fast-disappearing type of instructor. It may not be a worse method for all of that — no one liked better than Norton to protest against the easy American optimism that assumes that all changes are for the better.

In any case he did succeed in making something very like gentlemen out of the most unpromising raw material. If the students did not remember much of what was told them (and what students ever did?) they at least learned that there was such a thing as good taste — and bad taste. All their lives thereafter they were likely to be uneasy about their pictures, their chairs and their houses, unless they had some assurance that these properties were aesthetically sound. No doubt this made the Victorian period in America in certain homes slightly

less painful than would otherwise have been the case. If we are to have our renaissance we must give Professor Norton some of the credit for it. He greatly reduced the amount of rubbish that has to be cleared away. He kept on putting the Parthenon and necktie pins into the same course long after it had become the scholarly whim to devote a life-time not merely to a single period but to a single painter. But it would be a sad injustice to think of him as superficial because he covered much ground. If he travelled fast he travelled hard. He despaired of each successive crop of new students. "This is a sad sight," he would say, with a lugubrious shake of the head, as he gazed at a packed class-room. But he made the gentleman scholar in the fine arts Harvard's finest product.

The apostle of art for art's sake, with whose point of view we shall come in contact later on, does not regard the Norton method, or the methods to which it has given birth, with wild enthusiasm. He wishes to commit art, not talk about it. He will tell you, with such truth as may be in him, that no one who has not painted can know much about painting. Norton, on the other hand, proceeded valiantly on the theory that "it is through the study and knowledge of the works of the fine arts, quite apart from the empirical practice of any of them, that the imagination, the supreme faculty of human nature, is mainly to be cultivated."

But it was possible to talk to America about the art of the Greeks and Florentines before it was possible to make the average American see anything but absurdity in a full-grown and healthy male puttering about with

paints and brushes on anything smaller than the side of a house. He helped produce a generation in America which would tolerate the production of fine art. A student made this note on one of his lectures: " The love of the beautiful is the best possession a man who wants to lead a moral life can have." At the moment no one wants to lead a moral life. Consequently art does not have to be justified, at least in sophisticated circles, on that ground. But Norton must be given credit for effecting a liaison between art and morality in a community and at a time when the two were not on speaking terms. But for him and his disciples the artist would be a far lonesomer creature in America than he actually is.

<div style="text-align:center">3</div>

OF COURSE it is not to be supposed that Charles Eliot Norton merely waved his hand and said, Let there be Art at Harvard, and there was Art. Such things do not happen, even in Boston. It would be more correct to say that for the first twenty years Harvard had not so much a course in art as a course in Norton. Or one might unite the two and say that it was a course in civilization — the particular civilization as Henry James said, " that a young, roaring and money-getting democracy, inevitably but almost exclusively occupied with ' business success,' most needed to have brought home to it." Norton held the fort alone for nearly two decades. Then Professor H. Langford Warren was appointed to give instruction in architecture. This was some thirty-two years after

Norton had observed, during a visit to New York City on the eve of the Civil War, " Architecture is not practiced here as a fine art, it is known here only as a name for the building trade." Warren's course grew by degrees into what is now a graduate school of architecture, ranking well up among such schools in America. But it all took time. President Eliot sympathized intellectually with the fine arts and gave them a place in his curriculum. But he did not collect pictures.

Art at Harvard received what should have been a push in the right direction in 1895, when the Fogg Museum was presented to the University. Unhappily this now familiar landmark of the Harvard campus would have made a far better tomb for an excessively secret undergraduate society. It was a Harvard man who called it, after some deliberation, " the world's worst museum." Architecturally it was unattractive, the lecture hall was notorious for its horrid acoustics, its galleries were badly lighted, and its collections consisted of little besides casts and photographs. But though the building remained bad its contents increased in worth until in 1924 it was possible to say that the Fogg Museum had " one of the best collections in the country of thirteenth, fourteenth and fifteenth century European paintings, principally Italian." Here was a development after Norton's own heart. In the old Fogg Museum, poor as its facilities were, was laid the foundation of Harvard's present reputation as America's principal training school for art museum curators. And this, considering what part art museums are coming to play in

the nation's cultural education, is no mean achievement. The methods are no longer Norton's, the ideals perhaps still are. There is a Yankee-like practicality as well as an Italo-Grecian charm about the new Fogg Museum, which in 1927 replaced the old as Harvard's laboratory of the arts. How different from the days when the university's artistic facilities were nearly all under cover whenever Professor Norton put on his hat.

The present-day Harvard student who wishes to learn something about aesthetics will find perhaps fifty courses to choose from, and of these perhaps thirty-five will be historical. To this extent, at least, the Norton tradition has been maintained. The Parthenon continues to receive its just due. The student finds art treated as a phase — and a very important phase — of the story of mankind. Why not? Paintings are more eloquent of human life than politics have ever been, statues tell more than statutes. What a people at any time thinks is beautiful tells more than wars, reforms and revolutions, simply because it is less accidental. On that point Norton's first enthusiasms are still reckoned sound.

But Harvard no longer stops with history, which can be almost too easily taught, to almost unanimously soporific students, by the aid of lantern slides, lectures, books, and visits to galleries. It has added practice, which Norton did not consider essential. It has brought in science. It is, indeed, the scientific approach that of late years puts the characteristic stamp on the Harvard-bred curator, and enables even a casual graduate to tell you why a certain picture in a certain collection is merely in

imitation of Rembrandt. What are the most important external facts about a painting? One wants to know who painted it, why he painted it, what sort of person he was, how he lived, what sort of life was going on around him. All that is history. It leaves out the little matter of inspiration — why, aside from any expected honors and emoluments, the picture was painted at all. It also leaves out what is for some temperaments an even more fascinating question — how it was painted. Harvard scholarship has gone into this last field in the same spirit in which the physiologists have studied the growth of the living cell. Pictures are not created instantaneously, any more than plants and animals are. They grow. They are built up, out of lines, out of brush strokes. There is skeleton, and there is flesh.

In the workshops of the Fogg Museum Mr. Alan Burroughs and others have used the X-ray machine to compel classic paintings to reveal their secrets. The process is too complicated to be described here, but it makes it possible to detect forgeries, to bring out an underlying picture when another has been wholly or partly painted over it, to restore injured or time-worn pictures, and to show how almost any work of art of by-gone centuries was put together. In time it may be possible to tell the forgotten secrets of medieval studios and workshops. There are tricks of mixing and applying paints concerning which we knew less than Tintoretto did. These were lost when painting ceased to be a craft and became a learned profession. When the painter no longer had to grind his own paints he forgot how. The modern studio

has few chores through which the eager apprentice can learn the elemental mysteries of his trade. Research may again open these mysteries to him. At any rate, no student who has studied even a single picture in an earnest attempt to reconstruct the workshop conditions under which that picture was made will ever again think of any painting as a merely static thing. All this may have nothing whatever to do with creative art. I suspect that Mr. Clive Bell and a few others would say it had not. It emphasizes technique, time and place, none of which, they might contend, is of the slightest importance to anyone but the pedant and the antiquarian. There is certainly something in these arguments. But even at Harvard it is no longer believed that one can learn everything about pictures either by listening to lectures about them or by analyzing them in a laboratory — or even by measuring their proportions to see if they conform to Mr. Jay Hambidge's conception of " dynamic symmetry." There is still another method — and here modern Harvard breaks away from Norton's Harvard. This is to learn about pictures by trying to produce them. Contrary to general opinion one need not be an artist in order to do this any more than he need be a novelist in order to write a letter. One may learn to appreciate the best pictures by drawing or painting the worst ones. Consequently the Harvard undergraduate who specializes in fine arts must do some drawing and painting, and the student who thirsts for general culture is urged to attempt the same thing.

Harvard, indeed, sticks to the principle that " the

purpose of a university Fine Arts department, as distinguished from an art school, is not, as is popularly supposed, the creation of artists." However, I saw in one class-room — and this incident is typical — an excellent student copy of a Flemish classic, ruff and all. The boy who had done it was planning to become a banker. He had no especial artistic ability — not even enough to make the copy a little different from the original. He had simply learned the grammar of painting, as almost any one can do if he takes the time. He was typical of more than half the Harvard undergraduates who specialize in the fine arts. They want them for their cultural value — for the enrichment of their lives — just as they may also want history, English literature or science. I do not wish to credit the undergraduate with more sense or farsightedness than he actually has. The impression among faculty members at Harvard and at most other colleges which have been able to select their entering classes is that he has more than his father did. The *Harvard Crimson's* " Confidential Guide to Courses " reveals a curriculum and a faculty under fire from keen young minds.

Art courses at Harvard, or anywhere else, would mean little if the students did not, on the whole, like them. It is as hard to force culture into an unwilling college boy in this generation as water into an unwilling horse. But at Harvard, as at almost every institution of any kind in which anything called art is taught, the number of students taking the art courses has not only increased since the end of the World War — though

the war may not have had anything to do with the increase — but has grown more rapidly than the general college registration. At Harvard only a hundred and twenty-five were taking fine arts courses in 1917. Ten years later there were more than four hundred. During the same period the number of "concentrators" who made a specialty of the arts went up from sixteen to a hundred and ten. This may not be many out of a student body of more than three thousand. It means something, however, when one considers that at the time the fathers of these boys went to college an artist was commonly regarded in America as a long-haired eccentric in a flowing tie and velvet coat, with an insuperable preference for loose women. More than a third of the students of Harvard College now-a-days are capable of a more accurate estimate, for at one time or another in their undergraduate days they will have taken at least one fine arts course. And they will have twenty or more instructors to pick from instead of the two who were thought adequate in 1894.

Fifteen years ago the "greasy grind" was an object of loathing on the Harvard campus, as on most other campuses, and there was no greasier grind than the boy who took the fine arts seriously. But with the passing of time even the red-blooded he-man finds it possible to study art without losing caste. Maybe this is because art no longer implies a wasteful or purely decorative life — the adjectives not so long ago meant about the same thing in our native tongue. But it now appears that culture does not only teach one how to spend or idle

gracefully. It also, as prospective bond salesmen are beginning to learn, helps one to acquire gracefully. The crudest materialist is impressed when he is told that in fifteen years America imported a quarter of a billion dollars' worth of objects of art. To measure art in this way probably proves that one hasn't the least notion what art is. Nevertheless the fact that some persons who would not otherwise be sympathetic do measure it in this way makes the work of the sincere artist and teacher that much easier. When did the French impressionists begin to be accepted by the public? Precisely at the moment when collectors began to be willing to pay high prices for their pictures. Meanwhile the post-impressionists were starving in garrets. But it is by such steps that the arts advance. The Philistines also do their part.

4

JUST AS Norton's one-man school of the fine arts was expanded in ways he never dreamed of, so the studio courses at Harvard mark the annexation of another large area of educational territory. Not, as I have said, that Harvard endeavors to turn out finished artists. The art faculty would be almost horrified at the thought of doing this in an undergraduate curriculum. The student performs his required exercises in drawing and painting just as he does his paragraphs and themes in English composition. He is not encouraged to think himself a genius. Nor are the standards by which his productions are judged the same which would be applied to them,

let us say, at an exhibition of the Society of Independent Artists. Dash and originality do not count for so much as does the correct use of the medium, the faithful performance of the set task. If the student does not like this system the fact merely goes to prove that he belongs, not at Harvard but possibly in a professional art school. If he has patience he may learn the rhetoric of drawing and painting at Harvard, and use them later in a professional course. He may not have the patience. The most highly gifted creative artists are not remarkable for their patience under instruction.

One finds in the art faculty men who dream of a graduate school of the fine arts on an equal footing with graduate schools of engineering, law, medicine and of course architecture. The would-be painter might come to college, acquire the essentials of a general education, together with an elementary knowledge of the arts, and after graduation plunge into advanced professional studies. This plan sounds reasonable to scholars. It is not approved of by those who believe that the artist must acquire the utmost of manual dexterity as early as he can, nor by those who are convinced that he is temperamentally so different from the rest of mankind that he cannot be squeezed into the ordinary educational framework. The question will come up again, in this book as well as elsewhere.

The nearest that Harvard — or any other American university — comes to attacking this problem is in its graduate schools of architecture and of landscape architecture. An architect, if he is worthy the name, is also

an artist. But because his buildings will fall down if he indulges to too great a degree in an artistic temperament he has been by common consent set aside from the other artists. A painter must not be disciplined — or so one is told. But an architect not only can be but is, in the most gruelling way. At Harvard he is required to take a particularly hard-boiled construction course, for it is suspected that his beautiful ideas will be of little use if he cannot direct their execution in steel, stone, wood and cement. From the time the freshman comes to Cambridge until he emerges, not as an architect but with as much architecture as can be taught him in a school, is usually a span of seven and a half or eight years. Four of these are undergraduate. The graduate course in architecture can be completed in as short a time as a year and a half, or it may take as long as five years, depending altogether upon the ability and industry of the student.

The contrast between the hard-worked architectural fledgling and the carefree student of the fine arts is amazing. It is not entirely the atmosphere of the graduate school that makes the difference, for the air of scholarly leisure — the flavor of the Norton period — still hovers about the graduate classes in the spick-and-span new Fogg Museum. Perhaps it is partly the feminine influence — as many as two-fifths of the graduate students in fine arts in a given year may be girls from Radcliffe. Perhaps it is the reflection of a less strenuous, a more purely decorative, perhaps a more gentlemanly tradition. Yet the Parthenon, whose gentility no one

doubts, seems to have been architecture as well as fine art.

The finest arts at Harvard, the visitor may be led to suspect, are the arts of hospitality and conversation. The very inadequacy of the old Fogg Museum led several of the professors to invite their smaller class groups to their own homes. And there are still informal evenings and afternoons, with fires blazing on the hearth to drive away the un-Grecian dampness of Cambridge, and the light tinkle of tea cups. Again there falls the Norton spell. One forgets the Boston subway, one forgets Times Square, one forgets the Pennsylvania steel mills, the West Virginia coal mines, the wheat fields of Dakota, the florid plains of Arizona — all the vast, rude, undisciplined parade of American life. Here is New England, paying little attention to New York and less to New York's mighty hinterland, facing, rather, toward old England, and Italy and Golden Greece.

Perhaps this is a dying phase, even at Harvard. Striding, clamorous America, in these quiet rooms, would muddy the rugs, rattle the windows, break the china. To educate oneself to grapple with America one must, perhaps, breathe a ruder atmosphere. Yet one cannot help hoping that the practicality, the science, the modernism of present-day Harvard will not be permitted to destroy this surviving charm. In far less than Norton's thousand years America may be old enough to cherish the delicate and exquisite tradition for which he so patiently contended.

II

THE NEW DAY AT YALE

I

IN a corner of the campus at Yale stands a modified
Gothic structure, neither very ancient nor very new,
nor very ugly nor very beautiful, which until recently
housed — though it was a tight fit — the School of Fine
Arts of Yale University. A new million-dollar art mu-
seum (how difficult it is to leave the millions out, even
in speaking of art museums!) now gives the school more
elbow-room. The old building stands as a link between
the decade of jazz, and the gray, mauve and pink
decades of a dead century. Look closely and you will see
where the cannon balls of the Philistines have scarred
its surfaces. But it was indifference rather than hostility
that cast a more than Gothic gloom over this building's
early history. Until very recent years few of the under-
graduates of Yale College ever attempted to pass its
doors, not to speak of its courses. Some of them seem not
even to have known it was there. This was quite pos-
sible under the peculiar scheme of organization which
left Yale College, like the pearl in an oyster, or the
oyster in a stew, an entirely independent unit in the
association of schools which make up Yale University.

And when he sang " Here's to good old Yale," he meant Yale College, not Sheffield, not the Divinity School and certainly not a school where young ladies prepared themselves for the responsibilities of matrimony by learning to paint china. For the School of Fine Arts lay under an additional blight — it was co-educational.

But now a different picture presents itself. The School of Fine Arts is alive. It reeks with energy, ambition and determination. It is geared to a speed at which the stereotyped college youth can but marvel. It is only by stretching a figure of speech that the usual undergraduate can be said to pursue his studies, but the boys and girls who weather probation in the Art School are like the hounds of spring upon winter's traces. The difficulty is not to make them work. It is to make them, from time to time, stop working. I am speaking now of the professional art students. Perhaps it is not fair to compare any professional student with any student of " general culture." But something of the same spirit, it appears, infects even the musing collegian, who comes to the Art School for the rudiments of polite conversation. A year or so ago some of the students, burning the midnight electricity, violated a rule which forbids smoking in the older building. As this imperiled a valuable collection of paintings the doors were ordered closed thereafter at nightfall. For a few days there was mutiny in the air. Must the art students fleet their time like mere college boys? Perish the thought. Then it was found that a rebellious minority had contrived to open a basement window and were breaking in after dark to model and draw — burglariz-

ing an education, like John Shands in *What Every Woman Knows*.

In Yale College the emotional climax of the year still occurs (though by no means so violently as in former years) during the football season. In the School of Fine Arts it occurs in the spring, during the contests conducted by the Beaux Arts Society of New York City. " For God, for country and for Yale " is not quite what is in the students' minds, but their sensations appear to be at least as intense as those which inspired that famous phrase. I visited the school just after a student had won the coveted Prix de Rome. No one I met failed to mention that incident, always with a triumphant gleam in the eye. It was as though the Harvard crew had lost by half a mile or Princeton had been trampled in the mire. In another sense it was not quite the same. The Prix de Rome had been won, not by beating somebody but by creating something. The old Gothic edifice, cramped and inconvenient, was alive with the creative thrill. It was vibrant with fierce young spirits. Perhaps one could not credit this to the educational system in use at Yale. Nevertheless the system had not stamped out the creative impulse, which is a good deal to say for any educational method whatever. How different, one thought, from sitting on a fence, drowsing through lectures, cheering the teams, making a society!

But to describe the situation in this way is to draw an unfair contrast between two very different objectives. The undergraduate in Yale College, or in any college, is, it is supposed, seeking a liberal education. The student

39

at the School of Fine Arts is, on the other hand, learning how to do something. One is cultural, in the classic meaning of the word, the other professional. But at Yale, as you must expect to be told if you go there, the art students have a capacity for enthusiasm that surpasses that of many professional schools. This opinion is that of professors who are obviously not unbiased. But the fact that the professors at the Yale School of Fine Arts will stoutly maintain that it is, without question, the best in the world is an indication of what Mr. Ralph Henry Barbour would call the spirit of the school. This is the more worth noticing, because though Yale has an intense local patriotism it is not in the slightest degree radical or easily excited. The Art School has a little of both these qualities. It is competitive and ardent. It applies the sporting idea to education. Though its theories rest upon a philosophy first evolved in Paris it remains charmingly American. Yale boasts that its graduates in the fine arts need no longer go to France, except to look at the palaces, churches and galleries. Its ambition is rather to make it necessary for France to come to America. It is a fact that architectural students from abroad are already coming here to complete their studies. Why not students of painting and sculpture?

It might be said that a school which dares ask this question has gone part way toward answering it. But it is not without surprise that one finds the issue a live one in New Haven, the ancient stronghold of a breed of men who had a holy distrust of almost everything that passes under the name of art.

2

ONE MAY IMAGINE the dismay with which the founders of Yale College would have witnessed the erection of a playhouse upon their campus, and the horror which would have curdled their blood in their veins had they stumbled in one of their stately tours of inspection upon a class of young men and women making pictures from the undraped human form. Fire and brimstone from heaven, wiping out all trace of the impious spectacle, would certainly have seemed to them a fitting sequel. This stiff-necked community, frigid, austere, more constrained in some ways than Boston itself, offered no encouragement to the aesthetic and positively frowned upon the sensuous. Only the chaste lines of its rooftrees, the golden proportions of its doorways, created by village carpenters out of dog-eared builders' guides imported from England, hinted at a shy sense of the beautiful. And yet this little New England academy, as a later generation was to boast, eventually had "the distinction of being the first university, either in this country or abroad, to include among its professional schools a School of the Fine Arts, with a faculty of its own, and technical courses in the arts of design."

The beginnings of the aesthetic attitude at Yale, everything considered, go surprisingly far back. Consider this, for example, from a commencement address of 1770: "I appeal to all persons of judgment whether they can rise from reading a fine poem, viewing any masterly work of Genius, or hearing an harmonious

composition of Music, without feeling an openness of heart and an elevation of mind, without being more sensible of the dignity of human nature and despising whatever tends to debase and degrade it. These are the delights which humanize the soul and polish away the rugged ferocity of manners which is natural to the uncultivated nations of the world." This was far enough from the doctrine of art for art's sake. Yet so skillful a casuist as Jonathan Edwards might have detected in it the first, the fatal step toward a full recognition of the fine arts.

It does not appear, indeed, that much was done immediately to polish away the rugged ferocity of the Yale students. Sixty-one years were to pass before an artistic landmark was discernible in the college's history. In 1831 Yale acquired John Trumbull's collection of Revolutionary paintings, in return for which it guaranteed the impoverished artist a life annuity of one thousand dollars. It is to be suspected that local pride, patriotism and historical interest had more to do with this purchase than did any love of abstract beauty — assuming, for the sake of the argument, that Trumbull possessed an abstract beauty. Twenty-seven more years passed by. In 1858 a new stir of curiosity about the arts, a belated reflection, perhaps, of the cultural revival of the 'forties, led to the holding of a loan exhibition at Yale, with explanatory and appreciative lectures by Andrew D. White, Donald Grant Mitchell, and others. Finally, in 1864, Mr. Augustus Russell Street, of the class of 1812, who had travelled in Europe and been appalled

by the artistic illiteracy of his countrymen, gave funds which made possible both the erection of the original art museum and the purchase of the James Jackson Jarves collection of Italian primitives. Perhaps Italian primitives are not the least painful introduction to the study of the art of painting. Perhaps, too, some of Mr. Jarves' pictures were, to put it bluntly, junk, and others had a bar sinister in their ancestry. Nevertheless there grew up under this odd partnership of Trumbull and the Florentines a university school of the fine arts. We commonly think of the first decade after the Civil War as one of wallowing materialism — which, on the whole, it was. But a few fastidious souls refused to wallow. There was a mild but unmistakable artistic resurgence.

A young artist named John Fergueson Weir, the son of a professor at West Point, became suddenly famous in 1866 when his " Gun Foundry " was shown at the National Academy Exhibition. Whether this result was due to the intrinsic merit of the picture or to the fact that R. P. Parrott, proprietor of the Parrott gun foundry, paid the astounding sum of five thousand dollars for it may be doubted. Weir achieved the limelight, at any rate, and in 1869 was called to teach art at Yale. He remained for forty-four years. The saga of his struggles both with academic conservatism and with the natural distrust of the aesthetic to be found in any Puritan community might be worth writing. There were dreary years when progress seemed slow — when, in fact, the principal value of the Yale School of the Fine Arts was that the salary it paid John Weir enabled him to go on

43

painting. After the first few seasons women were admitted to the classes, and thereafter, until about the turn of the century, outnumbered the men. It became quite the fad for young ladies in New Haven to study art for a year or two while waiting to be married. This was, possibly, an advance over tatting and embroidery, but very few of the sweet young students became artists. For a long time no degrees were granted. For a long time after that degrees were granted only on invitation, to students who had gone out into the world and distinguished themselves. Even now something more than four years in residence is obviously behind a Yale degree in the arts. Weir never caught the traditional academic point of view. He seemed to think that one could not pour art into a student in the same way that he could pour Latin or history. Art education seemed to him to require a giving out as well as a taking in. It was this way of looking at things that made the Yale school professional rather than cultural, though Weir's methods were undoubtedly out of date long before he died.

The School did not figure largely in the life of the College. A severe disciplinarian, Weir was none too indulgent toward the amiable but aimless undergraduate. He was willing enough, as he said, " to foster a general interest in art in the University and in the community at large " but he would not condescend from his more serious aims to that of " meeting simply the needs of general culture." He grew conservative. "We must not mistake novelty or eccentricity for originality," he warned his students. " The greatest masters, past and

present, venerate the types as fixed, as science reveals them fixed in man and in everything else in nature. . . . Originality in art consists of variations based on the type."

This was well enough as the expression of a generation which knew neither cubism nor futurism. But it was no bait for the student who sat musing on the Yale fence. " The Art School," said a writer in the *Yale Literary Magazine* in 1902, " is to the average undergraduate perhaps the least known of the college buildings, and the least taken advantage of. It is easy to believe that there are men in the College to whom it is a matter of pride, when the spirit of Philistinism is strong upon them, that they know no more about the Art School than they do about the meaning of the Greek over the entrance of Dwight Hall. They are totally unaware as to whether the Jarves collection consists of insects or meteoroids. And in this they rejoice." " Art at Yale! " echoed another writer in the same student magazine a few years later. " What does that mean to the undergraduate? It means perfectly useless candlesticks, a favorite picture or two, Morris chairs, de luxe editions of un-Christian authors, and what one of our contributors felicitiously calls ' the svelte sheathiness of poster girls.' There are courses in drawing and modelling, accidental glances into meaningless galleries, and a general assumption that it is odd to be interested in a subject which our own ignorance taboos." And the author of the article fell upon his knees and prayed for a man like Norton of Harvard. If what he said was true of Yale

what must not have been the plight of the more barbaric institutions farther to the West!

Weir retired in 1913, and was succeeded in turn by Sergeant Kendall, himself an artist of note, and Everett Victor Meeks, a teacher and practitioner of architecture. New blood brought in new methods. The School was no longer ashamed to devote a considerable amount of energy to " meeting simply the needs of general culture." It tried hard, and with growing success, to induce the Yale undergraduate to knock the ashes from his pipe and climb down from his fence. But the change in the Art School was not all. There was also a new trend in Yale traditions. Tradition at Yale, it should be understood, has awe-inspiring vigor. The laws of the Medes and Persians were rank anarchy beside it. It caused boys who had gone to Yale College to gaze with chill disdain on precisely similar boys who had merely studied at the Sheffield Scientific School, which is likewise a part of Yale University. It frigidly proclaimed that no one must be odd. It forbade the undue development of an intellectual or aesthetic interest. In all this it was not unique among American universities. But there grew up a new spirit of tolerance. The tyranny of the athlete became milder. The writing of poetry or an inclination toward first editions had no longer to be indulged as a secret sin. The high brow came out of retirement and even swaggered a little. Membership in the Elizabethan Club, with its safe full of fabulously rare books, became something to be sought after. Young men, in such clubs, began to drink tea and eat thin wafers at half-past four

in the afternoon, and yet the sky did not fall. They ventured to have opinions of their own, at variance with the grand old motto, " For God, for country and for Yale," and yet no bears came out of the woods and ate them. It got to be fashionable not to have illusions, not even illusions as to the supreme importance of winning football games. After the war blood and brawn were not quite the thing — they " dated." There also developed, as in other institutions of the higher learning, a certain respect for the purposes for which institutions of the higher learning are maintained. This has not gone to extremes, at Yale or elsewhere. None the less it exists.

This lifting of the heavy lid of tradition has made practicable a vigorous literary movement at Yale. It is making possible an artistic revival. Wealth, leisure, a diversion of virile masculine qualities — and ardent feminine ones as well: these are now reflected in the School of Fine Arts. And there is scarcely an undergraduate of Yale College who is now ignorant of the fact that the Jarves collection consists of pictures, not of beetles.

3

IF YOU LIKE you may say that the New England note in professional art teaching at Yale shows itself in a certain directness and practicality. Harvard, being situated in Cambridge and not far from Concord, might be expected to stir in a little other-worldliness with its art. But there has been precious little other-worldliness in Connecticut.

So art at Yale has not been and is not a vocation for dreamers. Fine art is pursued, but by craftsmanlike methods. Artists are made as shipwrights used to be. Weir's love of the traditional has been as nearly forgotten as it can be in a school whose business it is to explain traditions. If there is a shorter cut than the one customarily followed Yale is inclined to follow it. A layman hesitates to plunge into a discussion of detailed method in the teaching of art. He can easily understand what is meant, however, when he is told that at Yale there is early and unremitting emphasis upon composition. Composition is merely another name for self-expression. The art of composition is the art of putting ideas into color, mass and line. The older method in art education has been to provide the student with a technique and let him whistle for his ideas. He would begin by drawing from the antique — moldings, casts, block heads and statues. This might last a year — in some art schools it still does. Then he would be promoted to a class in drawing and painting from life, and do that for another year. A sculptor was a little luckier than a painter, for much of a sculptor's work is manual and he needs assistants. Promising apprentices to the art of sculpture have opportunities to help in the studio. They may do nothing at first but prepare the clay or even sweep out the litter, but they do see professional work actually in progress.

A student of painting, on the other hand, may graduate from any one of several reputable art schools with literally no notion of composition or any conception of

what to do with such skill as he has acquired. He has to learn that, often painfully, after he gets out. He may be able to draw better than some of the early Italian masters — several of these gifted creatures, it appears, never got to be draftsmen — but if he cannot compose his ability is of little use to him. Yale tries to teach its students to draw and paint, but it does not wait until the beginner can draw and paint before letting him compose. He devotes two hours a day to composition from the very first. Every Monday he is given a theme — a problem to be worked out in his own way. Three times a week the results are examined and criticized. If he has creative talent he can make use of it from the very start. Hence his enthusiasm. He can create — and who doesn't love to create? His progressive steps are worth looking at in detail. He begins with black and white in flat spaces. Then, little by little, as he acquires experience, he adds the clothing of light and shade and can work in three dimensions. Already, as one is told, he is facing the tasks he will have to perform when he goes out into the world. Sometimes he is doing journeyman work, and getting paid for it, before he leaves school. When he graduates it is expected that he will be ready to begin a career, and need not waste precious years in fumbling and experimenting.

The student does not find the course easy. By the fourth year he is giving half his time to advanced composition. He works eight hours a day and then has to work nights to keep up. If he stays in the school at all he does not mind that; if he does mind it he is likely to

turn to a less rigorous school or to another occupation. The high point of the year for the upper-class students is the month before the Beaux Arts competitions close. The last ten days some of the young artists work all night. The whole school becomes keenly interested in the competition. Even the beginners in the preparatory class — the kindergarten stage — take fire. In two or three years, perhaps, some of them will themselves be prize winners. Many, indeed, will drop out, for the school is rigidly selective. Perhaps one in five will go through the four years and take the degree. But the survivors are ready for professional work. It often happens, too, as in every art school, that students are offered jobs before they have completed their course, and drop out for that reason.

"We mean," the visitor is told, " to make the school above all things practical, so that our graduates can immediately begin earning a living. We don't approve of starving in garrets. We don't think it a disgrace for an artist to sell his work. We try to make our students see that anything that can be well done is worth doing. It doesn't matter whether it is a portrait, a factory, a statue to be set up on the village green, or an advertisement. We're not high-brow and we're not arty. There is a kind of art education which teaches young people to talk intelligently about what others have done. That's not our specialty. Our endeavor is to teach our students to do something that others will talk about."

Like every other privately-endowed institution of higher learning the School of Fine Arts has more appli-

cants than it can admit. Its limit of professional stu-
dents — not counting Professor George Pierce Baker's
Department of the Drama, transplanted several years
ago from Harvard — is about two hundred and fifty.
The architectural candidates can be sifted out easily
enough on a basis of previous training. With boys and
girls who wish to take up the plastic arts this is not so
simple.

" No one in God's world," I was assured, " can exam-
ine in drawing. At least no one has yet found a test that
is convincing. What we do is to accept applicants, up to
the limit of our capacity, in what we call our prepara-
tory course. If they make good they enter the regular
first-year class. If they don't they withdraw. In painting
and drawing we let them go ahead as fast as they can.
A boy came in here last fall with no preliminary train-
ing in art. In one year he shot from the preparatory
course into the third-year class. Of course even a bril-
liant student can't go through the courses in history
and criticism as rapidly as that. Since we have to choose
we go after the most promising. When we find them
we give them special privileges and personal attention.
They must discipline themselves, and they must learn
the grammar of their chosen art, but we don't desire
to put them in an educational strait-jacket. We try to
give them a chance to grow."

One finds the same principles applied in the Depart-
ment of Architecture. Weir of Yale, like Howard
Crosby Butler of Princeton, saw architecture as fine art
rather than engineering. He was as far as could be from

seeing it, as many practicing architects admit they are obliged to do, as a species of business enterprise. The course at Yale is rigorous enough, but not perhaps so grim as that at Harvard. The student works from thirty-eight to forty-four hours a week — good union hours! — and when his four-year ordeal is over he has had a good deal of architecture pounded and wedged into him. What he fails to receive is general training in science and the humanities. But that is a vice of professional courses everywhere, and cannot justly be laid at Yale's front door.

Quite as professional as the Department of Architecture is the department over which Professor Baker presides with such conspicuous success. Opinions may differ — and, in fact, do differ — as to whether the drama is literature or art or neither or both. At Yale the problem of classification was arbitrarily and generously solved by a million-dollar gift, under the terms of which the School of Fine Arts had to be expanded to take in the art histrionic. This gift has made it possible to build an experimental theatre which is as good as anything of the kind in the country. If one drops into the Department of the Drama one finds the back-stage atmosphere almost more intense than on Broadway. Young people of both sexes smoke and chat in a Green Room, air their personalities — they all have them! — discuss stage lighting, build costumes with the aid of co-educational sewing machines. The playwrights, mostly of an older vintage and possibly of a more heroic mould, struggle with their dialogue in secret, or tear each other's

efforts to tatters in remote class rooms, to which visitors are not allowed to penetrate. Several times a year they emerge with plays which members of the department stage and act. Selected audiences attend the best of these and are invited to write criticisms. Partly on the basis of these criticisms the plays are pulled apart and re-written. Sometimes Broadway takes them — in the case of *Chicago* one of Professor Baker's students scored the hit of a New York season. More often they are better adapted to the little theatres, of which there are plenty nowadays. Professor Baker picks his students partly from Yale College and partly from the high schools. It is, as a rule, far easier to get into his department than it is to stay in. An average entering class will shrink about two-thirds in numbers before it reaches the end of the second year. But as with the other Art School graduates those who survive can usually find jobs without much trouble.

A third professional school which cannot be overlooked, though it is not administratively a part of the division of fine arts, is the School of Music. Here, too, the practical spirit of Yale reveals itself, with perhaps a little less emphasis on the occasional genius and a little more on the competent hard worker. The fact is that musical geniuses do not often go to schools of music. There are perhaps not more than two such schools in America, both of which will be mentioned later, which deliberately bait their hooks for high creative ability. The graduate of the Yale School of Music will know the literature and intellectual principles of his art

thoroughly. He, or she, may become a composer or a performer. More often the student becomes a teacher. But sound musical instruction, of which there has been very little indeed in America, obviously raises the general level of appreciation, and offers the genius richer opportunities when he finally appears.

4

WHAT DOES all this mean to the boy in Yale College who is seeking, or thinks he is seeking, or has been told that he is seeking, a well-rounded cultural education? I have already said something about his pitiful plight in the past and about his increased interest in the fine arts. But the effort to lure him within range of the aesthetic has just begun. At Yale, as elsewhere, it is now recognized that the appreciation of art is itself an art. The historical and critical courses offered to the non-professional student are therefore being strengthened. Sometimes the results are surprising. A professor in charge of a class in Renaissance painting tests his students' information at the end of the term by showing them an unlabelled picture from the period covered, not necessarily one of the best-known, either. Eighty per cent. of them will not only be able to identify it, name its author and date it, but can also tell what its best features are, and whether or not it is typical of the man who painted it and of the school to which it belongs. It may be that this kind of training teaches the student to look for the accidentals rather than the

inner realities. But it is possibly better than complete ignorance.

As at Harvard the athletes and the professional he-men are beginning to take the elective courses in the arts. Not long ago the captains of both the football and the track teams came to classes in the Art School regularly and without shame. Within the last few years these lay volunteers from Yale College have multiplied three or four times. Many of them take not only the lecture and reading courses but also some practice work in drawing and painting. The Yale freshman comes to college with an increasingly appreciative attitude toward the arts. Often he has been abroad and dutifully tramped the galleries. At any rate he wants to be a gentleman, and it is impressed upon him that gentlemen no longer sneer at the fine arts. And even this, I think we must assume, is progress. The coming years at Yale will perhaps witness a reversal of the process taking place at Harvard. At Harvard, as we have seen, the cultural aspirations for which Charles Eliot Norton battled so courageously are being supplemented, though probably not supplanted, by others which are considered more modern and practical. Harvard begins to talk less about art and do more about it. At Yale, on the other hand, there may have been too little talking in proportion to the plenitude of doing. And this problem of the balance between talk and deeds appears to be a central one at the moment in American education in the arts.

III

SCHOLARLY PRINCETON AND MORAL OBERLIN

I

IN an official publication of the Department of Art and Archeology of Princeton University I find this statement: "A department of art is a very expensive plant to maintain in a university, so costly are its necessities of equipment, its books alone demanding from two to three times the outlay that is required in other fields of study, on account of their illustrations and size. So much is this the case that only two institutions in this country have fully developed their undergraduate and graduate curricula in art history to the point where they can train teachers and expert curators for museums." This is not a boast but a statement of fact, with which everyone acquainted with the situation readily agrees. If you wish to find a curator for your art museum you will do well to communicate with the art department at Harvard. If, on the other hand, you wish an instructor for your courses in the history and criticism of the fine arts you should consult Princeton. In either case you should act well in advance of your anticipated need, for so rapidly have the arts courses in American

colleges expanded, and so astonishing has been the development of art museums that qualified men are scarce.

At Harvard, as I tried to show, the typical product in fine arts has been obtained by a judicious marriage of the literary tradition of Charles Eliot Norton with the scientific method of his successors. The Fogg Museum is a laboratory which trains laboratory workers — that is to say, museum curators. Princeton has never had a museum equipment comparable with that of Harvard, nor has it had a Charles Eliot Norton, there being but one Norton. But it had in Allan Marquand, the founder of its art department, a man with as much missionary zeal as Norton and of a scholarship as sound as Norton's, though possibly of more limited a range.

The history of art at Princeton does, indeed, antedate Professor Marquand. It goes back to a cold January day in 1777 when Captain Alexander Hamilton, being then twenty years old and in revolt against the British crown, fired a cannon-shot through a life-sized portrait of King George the Second, then hanging in Nassau Hall. A life-sized portrait of Governor Belcher and a set of smaller portraits of British sovereigns were also lost or destroyed in the scuffle. This was a calamity for Princeton, but not necessarily one for American art. After the war General Washington bought and presented to the college his own portrait by Charles Willson Peale. But only in recent years has Princeton had many pictures worth getting off at Princeton Junction to see. The University Museum was not established until 1888.

A species of instruction in the fine arts seems to have begun at Princeton, on the other hand, earlier than at Harvard or Yale, and perhaps earlier than at any other American college. A course in Roman Antiquities was given in the early 'thirties, and during the same period Professor Joseph Henry lectured on architecture and civil engineering. But as Henry was primarily a physicist his course probably had more engineering than art. The same subject, taught by Albert Dod between 1837 and 1845, is said to have " made a deep impression on the undergraduates of his day." But Dod was a mathematician. Marquand, father and founder of the Princeton Department of·Art and Archeology, did not appear on the scene until 1882. For forty years he spent his time, his enthusiasm and much of his private income in building up the new department, and to this day the arts at Princeton are far more in Marquand's image than they are at Harvard in Norton's. He gave them their scholarly flavor, their humanitarian basis, and also, because he was an old-fashioned gentleman and a man of innate shyness, their air of reticence.

Marquand's father, Henry G. Marquand, was a collector of note and played a leading part in the establishment of the Metropolitan Museum of New York. His son shared his tastes, though not his liking for public affairs. Young Marquand's education and his natural bent drew him irresistibly toward art and archeology, and thus he found himself, in 1882, in charge of instruction in these subjects at Princeton. It is hard to decide how much of the growth that followed was due

solely to Marquand and how much came naturally out of the spirit of the times. Certainly Princeton, like most of the older colleges, was well satisfied — complacently so, in fact — with the species of cultural education it had worked out by the beginning of the 'eighties. Whether it was science or art a new subject had to fight for existence. When art and archeology began to detach themselves from the shadow of the classics the older type of academic mind naturally regarded the event with apprehension. But Marquand fostered the new development with a kind of calm persistence which was natively his. When the university budget did not provide for the purchase of the books, slides and photographs necessary in the historical courses he bought them out of his own pocket. He paid, too, for the publication of the results of research done by members of the department. He was himself a man of laborious, exhaustive, conscientious scholarship. His lifework, outside his teaching, was the study of the Della Robbia family. To this, with some interruptions, he gave forty years of research, and when he died he probably knew more about Della Robbias than any critic before or since.

Unlike Norton he was never what could be called a thrilling lecturer. His enthusiasms, though he testified to them by a life of devotion, were not on the surface. He had no spectacular ways of catching the undergraduates' attention. When he talked about Della Robbias he did not mention neckties or the codes of chivalry. It was the graduate students, already in the net of scholarship, that he most profoundly influenced. But as these

graduate students were to become missionaries to carry the Princeton idea through the colleges and universities of America this contact was of lasting importance. Marquand, like Norton, set an artistic ferment at work in American life. The difference was that it had to pass through more middlemen's hands before it reached the wider public, and it was less flavored with one man's personality. That, however, may not lessen its value.

Marquand died in 1924, full of years and honors. Next to his name, in any outline of Princeton aesthetic history, must be put that of Howard Crosby Butler, an archeologist who shaped Princeton's first courses in architecture. In some schools the study of the fine arts has budded from the professional work in architecture. At Princeton the development was the other way round. Like Weir at Yale Butler conceived of architecture as art rather than engineering. It was, indeed, as he saw it, the queen among the arts, the summing-up of the high moments of human history. He made the class feel, one of his students said, "as though architecture were the most fundamental thing in life." He was one of Marquand's disciples and lived in the older man's home during his first year of graduate study. As tangible records of his career are the findings of several archeological expeditions to Syria, and the Princeton Graduate School — the traveller sees its Gothic towers from the main line of the Pennsylvania railway — which he first suggested and over which he long presided. Without him there would probably have been no School of Architecture at Princeton. And in his teaching he tied archeology

and architecture together, as ancient and modern dialects of a common human language. He died in 1922.

Other distinguished names have been, and are, linked with art at Princeton. But Marquand and Butler suggest well enough the Princeton method. The fine arts, under their influence, are taught as parts of the humanities, not as technical performances. Just as Harvard's typical artistic hobby is, perhaps, the use of the X-ray in analyzing paintings, Princeton's is the great Index of Christian Art, which is an attempt to catalogue every Christian painting and statue from the earliest times to the year 1400. It contains, as this is written, about 20,000 cards, and is perhaps less than half done. This is scholarship of a sort that fairly makes the layman's head ache. But it represents the Princeton ideal of exact and thorough knowledge. More than that it typifies Princeton's historical attitude. Its use is to enable the scholar to tell when a given picture was painted, to fit it into its proper place in the story of man's artistic evolution. No user of the Christian Index will ever regard a picture as a mere combination of forms and colors. It is, also, for him, a date, like 1492 and 1776. It is a human being, at such and such a date, giving permanence in such and such a way to a human predicament. Harvard centers its study upon the object itself in art — the painting, the statue, the building. But for Princeton, even in its ecstatic moments, the proper study of mankind is man.

2

THE PRINCETON STUDENT does not learn to draw or paint unless he teaches himself to do so, or unless he takes some of the professional courses in architecture. What he learns is the drawing, painting, carving and building that has been done by others — the cultural hand-me-downs of the past. He does not learn " appreciation," for that, as Princeton looks at it, cannot be taught. "Appreciation " is an expression of something inside the appreciator, the result of such thought and experience as he may have undergone, the reflection of the kind of person he is. It can be imitated, like table manners. But it is not art. What can be taught is facts. Pictures, statues and cathedrals are facts — the most important facts about the human race during long periods when ninety-nine out of every hundred men were illiterate. Here, as the Princeton student will be told, is a Giotto. It is far more than pigment on a wall — it is also a piece of first-hand evidence regarding the civilization of the thirteenth and fourteenth centuries in Italy. " The Big Parade " or the New York Telephone building might tell as much about America at the beginning of the second quarter of the twentieth century. To look at pictures in this way is one method of making dead lines come alive. Such is the Princeton idea.

When a Princeton undergraduate has gone part way through a course in the history of the fine arts he is subjected to what is called a " spotting test." I have mentioned a somewhat similar test used in the classes at

Yale. He is shown photographic reproductions of objects of art, of which a third will be new to him if he is in an elementary class, or all if he is in an advanced class. He will be asked such questions as: " What national art is illustrated? What is the subject? What is the approximate date? " If it is his first ordeal of this kind his sensation is one of acute dismay. Then he begins to see some sense in the questions. He discovers that art is a language that can be read, if one knows how, almost as easily as print. Each age has its character — its handwriting. One cannot mistake the twelfth century for the fifteenth, the eighteenth for the nineteenth. Columbus sights the West Indies. Somebody stumbles upon the principle of perspective. Men do not paint the same thereafter. The French revolution takes Europe by the throat. The fact is recorded on every post-revolutionary canvas. Again, the artists of Sienna have ideas differing from those of the Florentines. The Flemings bloom into an art that has precious little in common with the contemporary art of France. These facts dawn upon the student and the spotting test becomes a game. It is a good game for anyone who has access to a gallery, or even to a collection of good reproductions. The University Museum gives the Princeton undergraduate some of these facilities. If its art treasures are not numerous an attempt has been made to make them representative. Here you will find professors or preceptors, with small groups of students, discussing a French stained-glass window of the thirteenth century, or it may be Jerome Bosch's grotesque " Christ before Pilate," or a sweet sixteenth

century Virgin from Champagne. No university with limited funds can collect supreme masterpieces. Princeton is trying to have an authentic representation of every major school and period. Here, again, the drift of the Princeton training in the arts is evident. The student learns his schools and periods thoroughly. He might find it more difficult to tell why a given painting, irrespective of its school and period, is — or isn't — great art.

The growth of the Princeton art department was slow, but since the World War it has shared in the revived popularity of all the college and university art departments. From two-thirds to three-fourths of all undergraduates now take at least one course in fine arts, and many take more. Fine arts, in short, have become quite the vogue, which means something in a university where good form is confessedly almost the most important factor in the student's life. As at Harvard and elsewhere even the athlete has ceased to look upon the aesthetic as beneath his notice. Nor are those students who specialize in the arts a group of super-refined aesthetes. They are healthy young animals who are planning to find a career in teaching a probably useful subject in other colleges and universities. They almost seem to assume a kind of roughness and practicality, as though to disarm the suspicion of other-worldliness.

They are sure of finding a field for their training and abilities, for, as I have pointed out, there is a growing hunger in American institutions of the higher learning for the kind of missionary work these Princeton men are trained to do. A year or so ago eleven colleges and uni-

versities east of the Mississippi river were employing
Princeton graduates to teach the history of art. At the
same time Princeton was represented on the staffs of six
of the country's leading museums. In the course of a
life time these men will influence a great many thousands
of their countrymen. At their best they will not only
" brand the ugly and the vulgar and the inferior
wherever they find them," as was said of Norton at Har-
vard, but will perhaps teach at least a portion of the
public to do its own branding.

3

As THIS is written it is a Princeton man, Professor
Clarence Ward, who presides over the department of
fine arts at Oberlin College. I had intended to bring in
Oberlin as an example of the influence of Princeton
on the smaller colleges. Yet even here it is difficult to
say which is Princeton, that is to say, Marquand, and
which is Harvard, that is to say, Norton. The scholarli-
ness of Princeton is evident, but so too is the high moral
purpose of Norton's Harvard. In fact there could hardly
be a better illustration of what might be called
the moral approach to the arts than may be found
at Oberlin. With Oberlin's history the case could
hardly be otherwise; and we have to add to the
Harvard and Princeton element a strong native Oberlin
element.

Oberlin, about thirty-five miles west of Cleveland,
was founded in 1833 as a Congregational college, with

a pronounced New England flavor. Its "educational facilities have always been open, without regard to sex or color, to all worthy applicants qualified to enter the classes." Thus it was radical on two counts at a time when it was difficult for women and practically impossible for Negroes to obtain a college education. Before the Civil War it was an important station on the underground railroad, and many a fugitive slave was passed safely through Oberlin on his way to Canada. Until recent years it was one of the leading schools in America for the training of Protestant missionaries for the foreign field. A monument on the campus commemorates several of its graduates who lost their lives in the Boxer rebellion in 1900. With this heroic background the Oberlin conception of beauty was bound to have a large element of duty stirred in. In that respect, at least, it harmonized with the doctrines emanating from Shady Hill.

The arts in Oberlin began with music, which is naturally acceptable even in a conservative, religiously-inclined community. The Oberlin Conservatory, on the same grounds as Oberlin College, grew out of an interest in sacred song and became one of the best institutions of its kind in the country. A passage in one of its published bulletins reflects the whole Oberlin spirit:

"We are coming to recognize more and more fully the fact that real democracy is impossible without equality of educational opportunity; that all men have a right to share the beautiful things of the world as well as the

useful ones; and that a man's ability and ideals rather than his wealth or his social position should determine his station in life."

Certainly there is an unmistakable Concord echo about these sentiments — perhaps more of Concord than of Cambridge. And Oberlin lives up to its ideals as far as is humanly possible. It is basically and unfeignedly democratic. Living is relatively inexpensive, the nearest large city is more than an hour's ride away, and the simple life is the rule. The work in fine arts, in such an environment, was developed slowly and cautiously. There was even more reason at Oberlin than at Harvard and Princeton for not attempting to train artists, and also even more reason for training cultural missionaries. The scholarly rather than the creative aspects of the subject have been emphasized, and the history of the arts is carefully and thoroughly taught with the aid of lantern slides, lectures and readings. When a student has completed the historical survey offered at Oberlin he may not know what art is, but he will certainly know a little of what it looks like and what has been said about it. Perhaps the atmosphere is not quite so rarified as that of the older Eastern universities. Co-education and a Middle Western neighborhood make for informality.

Some practice in drawing and painting there actually is — enough to qualify a student for teaching these subjects in elementary schools. But he, or she, does not have the opportunity of working from the nude figure

in " life classes," as would be the case in all professional art schools and some college and university courses. That would be a little too much to expect of a community in which even the appearance of a slackening of moral standards has to be avoided. In the near future, to say the least, Oberlin cannot be expected to produce creative artists. It has neither the educational plant nor the atmosphere of joyous irresponsibility which seem — one doesn't quite know why — to be required. But its function, like that of Harvard and Princeton, is not an unimportant one in America's present stage of artistic evolution. It helps to educate an art-loving, that is to say an art-understanding public. Its students come mainly from relatively small Middle Western communities and return there, after graduation, in greater numbers than would be the case if they had gone to a larger and more sophisticated institution. Oberlin tries to teach them to carry good citizenship into the aesthetic field.

And much can be done on Main street under just such patient and sympathetic leadership. The day of contentment with small-town barrenness and ugliness will pass as travel, good magazines, good books, good music and the aesthetic rudiments become accessible to nearly every one. If these latter can be taught they will be. The average American shows occasional signs of groping for something better than his average community has yet afforded him. If fine arts classes in colleges like Oberlin produce men and women — and the women are often

68

more important in this job than the men — who can assist judiciously in the search, have they not justified themselves? And would not the enfranchised wraith of Charles Eliot Norton break into genteel applause if it could know what was going on?

IV

CANVAS, PAINT AND CULTURE

I

THOSE who have read thus far may begin to suspect that American colleges and universities have not yet worked out an ideally satisfactory combination of canvas, paint and culture for the general student. But earnest and increasingly satisfactory attempts are being made to stir these ingredients together. In this chapter I propose to discuss four instances which I hope are typical and to indicate as far as I can in a brief space the educational philosophy which seems to be behind them.

To those who are interested in American pottery the mention of Newcomb may bring up the picture of a delicately blue vase, carrying, perhaps, a design in which effective use is made of the drooping lines of Spanish moss. Fewer will know of the excellent work which Newcomb students have done in jewelry and in hammered metal. These products, carried to a salable stage by graduates working in the Newcomb studios and laboratories, are the outcome not of a school of the crafts but of courses whose aims are cultural. Newcomb, established in 1886 as a college for women, is affiliated with its well-known neighbor, Tulane University. It lies

in the lovely outskirts of New Orleans, near Audubon Park and not far from the great river. Its founder, Mrs. Josephine Newcomb, the widow of a New Orleans sugar merchant, expressed the hope that " the education given should look to the practical side of life as well as to literary excellence." This desire has been strikingly fulfilled in the courses built up under the direction of Professor Ellsworth Woodward, a New Englander who became probably the South's most distinguished educator in the arts.

Throughout every course in the arts at Newcomb runs the idea of a practical, though not necessarily a money-making application. One does not ask here whether the fine and the applied arts are the same thing. The degree given to students who complete their studies is Bachelor of Design, on the theory that sound design is behind all sound art — behind the Parthenon, and also behind a well-made poster or a pleasingly-arranged living-room. An increasing number of Newcomb students earn their own livings for at least a few years after graduation, though most of them are still old-fashioned enough, sooner or later, to marry and become mothers. But it is part of the Newcomb plan to prepare for this contingency. Newcomb College, and especially the Newcomb School of Art, was founded to retain and revive the cultural heritage of the South. It has been the life-long ideal of such teachers as Ellsworth Woodward to give to such Southern homes as they could influence a new conception of the art of living. They have worked for a culture as gracious as the old, yet with its roots

71

deeper in the earth. It may be significant that they have been successful, not principally by talking about Art — not by the Norton method — but by teaching the actual practice of the arts and handicrafts. And they have done this, under the roof of a school for women, in a community which has clung longer than most American communities to the tradition that women should not be educated to earn their own livings.

Newcomb has had to meet the needs of the general student who wishes to know a little about the arts as well as of the special student who plans to give most of her time to them. The intermixture has been so successfully accomplished that the casual visitor does not find it easy to tell the two groups apart. For the girl who has no technical aptitude there are courses in the general aspects of history and criticism. The value of such courses depends largely on who gives them. They can easily become a very thin species of literary gruel. A gifted and enthusiastic teacher may compress a whole college education into them. This was Professor Woodward's great achievement at Newcomb.

But the typical Newcomb atmosphere is to be found in the studios rather than in the lecture room. It was in a class in water-color painting that I found an instructor bending over a board on which was represented a bedraggled poinsettia. When he straightened up I waited to hear some more or less technical comment. What he actually said was, " Have more fun with it." The Newcomb School of Art has other objects than to amuse. Still, it has achieved, as few collegiate art schools have

done, the joy of creative effort. Naturally this becomes most noticeable in the advanced courses in which the student can acquire a degree of proficiency and produce something of which she may be proud. One finds it in the rooms where pottery, jewelry, or work in precious metals is being carried on. But it exists even when the student does not expect to make a practical use of what she learns. Professor Woodward brought to Newcomb a typical union of New England shrewdness and idealism. But in sub-tropical New Orleans the New England influence expands, mellows, lends itself to brighter colors. When the economic revival that is already under way brings wealth and prosperity again to the old Confederacy Newcomb may be counted upon to play its part in ironing out the inevitable crudities of the new epoch.

2

IN LOUISIANA a school of the fine arts discovers traces of an old and delicate craftsmanship which it may do something to restore. Within the limitations imposed by the materials and purposes of the builders the houses and iron-work of the Vieux Carré came near perfection. They could not have existed without an enlightened taste and a passion for excellence. By way of contrast let us glance at the art problems of a pioneer community. The state of Washington has so recently emerged from the raw that it can be said to have no artistic traditions at all, except those which may have existed among the Indians. The first settlers, as they crossed the plains,

shook off their New England culture far more thoroughly than the first New Englanders had shaken off their English culture. The state of Washington had no *Mayflower*. It produced no distinguished or lovely architecture, and the furniture with which the parents of the community made shift will never grace an antique shop. While Charles Eliot Norton was teaching his uncouth Harvard sophomores the art of looking at pictures the pioneers where rolled the Oregon were finding their art, such as it was, in straight furrows and clean-cut chips. Much could be said and much has been said about the pioneer's indifference to aesthetics. The simple fact seems to be that art comes from a questioning of the value of life; in its gorgeous moments it is a triumphant defence of life. But communities in which the pursuit of the raw materials of existence is still an engrossing game have neither the energy nor the incentive to raise the question. One lives — if possible. What need of an excuse?

Washington has passed beyond the raw-material stage, but she has no ancient colleges, no tradition of leisurely living, and no widespread acquaintance with the arts. The burden of lifting up the state by its cultural bootstraps has, therefore, fallen largely upon the State University at Seattle. It has been met with a thoroughness, an enthusiasm and a degree of success that surprises the condescending visitor from the East, especially if that visitor has first heard certain startling tales about Washington politics. A competent school of music was perhaps to be expected, for music must be taught in the

public schools, and the public schools look to the State University to provide them with teachers. A school of architecture was logical, too, for the State is entering upon a long period of physical expansion, and expansion means building. But an art school capable of producing professional artists was not inevitable, nor would it necessarily have been expected that a few courses in elocution should develop into a professional school of the drama. This evolution came about because those in charge of the university's academic policies, notably Dr. Henry Suzzallo, who was president until late in 1926, thought the community ripe for them. They seem to have been accepted by the public rather than demanded. Yet the response to them, as reflected in student registrations, was immediate. A narrow-minded and pinch-penny state administration caused Dr. Suzzallo's resignation, but its attack was not directed against the courses in fine arts. These seem to have impressed themselves, even upon very reluctant tax-payers, as worthy what they cost. The case might have been different a few years ago.

The growth of student interest in the fine arts has been steady. The number who took their major work in this field increased more than one hundred per cent between 1920 and 1927. About one student in every ten specialized in the fine arts in the latter year — a showing which promises well for Washington's cultural sophistication in years to come. As usual the courses in architecture are almost wholly made up of men, those in music largely of women. In painting, sculpture and design

there were last year about nine women to one man. Obviously the arts are not yet as generally tolerated by the undergraduate male in Washington as they have been in Eastern communities. One reason is that a large proportion of the graduates in fine arts intend to teach rather than practice them. And the male high-school teacher of music or drawing still labors under the suspicion of effeminacy; chemistry is a far more manly subject. Moreover, Washington does not offer a lucrative field nor a stimulating environment for the independent artist. If he is to make a living he must ordinarily seek a wealthier and more populous community, which can afford the luxury of beauty.

Conceivably this might deprive the teaching at Washington of its creative note. Actually this doesn't happen. Washington has gone in heavily for practical courses in an eminently practical way. The purpose is avowedly to teach the student to " work as the artist works," regardless of whether or not he will be an artist after he graduates. Besides the usual courses in painting, drawing, and sculpture there are classes in pottery, metal work, jewelry, costume design, and interior decoration. Graduate students may continue with portrait painting, or develop their technique by painting from the model, as they would do in a professional art school.

First-year students begin their studies, in a business-like fashion, with drawing from casts, water-color painting from still life, and the study of perspective and composition. Composition — the conception and expression of ideas — is emphasized as we found it to be at

Yale. In his second year the student enters a life class and draws from the nude model. When this was first proposed there were objections; there are none now. Boys and girls work together in these classes, just as in the professional art schools, and if it does them any harm the effects are not visible. As the visitor wanders through the studios he will perhaps forget — if he has been supercilious enough to have had it in mind at all — that he is two thousand miles west of Chicago and three thousand miles west of New York. He finds the modern atmosphere and the modern method. The absence of tradition makes it easy for an instructor to be as modernistic as he likes, just as it makes it easy for all of Seattle to have electric lights when certain venerable portions of New York City get along with gas. For instance, a class in design is taught by the use of abstract forms — cubes, cones, cylinders, prisms, planes. It produces, with immense enthusiasm, drawings which would have been quite at home in almost any modernistic gallery during the cubistic furor of some years ago. Incidentally the student learns that he is not to rival the photographer. In architecture there is the same elasticity of method. Washington, like Princeton, has endeavored to create artists rather than engineers — the West has engineers enough. The first-year student is thrown immediately into practical problems, and, as an instructor said, " learns his calculus without knowing it." With the technical courses goes as much general culture as can be crowded in. At the end of his four years the student is not a perfected architect, but it is pretty certain that

77

when he later becomes one he will have at least a suspicion of the broader cultural implications of his trade.

The department of the drama, as has been said, began with courses in elocution, designed principally for high-school teachers. Then the high schools suddenly became inoculated with the dramatic virus, and teachers able to coach plays in professional style were demanded. The community theatre movement caught hold here and there. The department adjusted itself to this demand and grew alarmingly. Now its students do everything connected with the theatre — they write one-act plays, design settings and costumes, shift scenery and act. A small workshop theatre affords opportunity for practice and several public performances a year are given in the large university hall. The department has been slow to rival Professor Baker of Harvard and Yale by producing student plays for a general audience. It does not assume to prepare students for the professional stage. Yet its graduates sometimes do go direct from school into professional companies. One girl graduated several years ago, spent twelve months in vaudeville, then, by a combination of luck and talent, found herself in a leading part in a Broadway success. The constant hope that the lightning will strike again keeps the undergraduate in the school of drama constantly on his toes — or rather her toes, since the girls are in the majority.

Though Washington has avoided the literary and archeological approach to this field it has one course in which may be seen the lengthened shadow of Professor Norton. This is the " Introduction to the Fine Arts," to

which hundreds of students listen five mornings a week in the great hall of the music building. These lectures were inaugurated by Professor Herbert Cory, a philosopher as well as a critic. But instead of depending solely upon his own erudition Professor Cory called in specialists in the several arts to explain in a lecture or two what they were doing — and why. The morning I was there a sculptor took his clay to the platform and told how he set to work to model a figure for a fountain.

The leaven works. The spirit of Athens and of Florence becomes a living thing, now and then, to a child of the pioneers.

3

WITH JOHN DEWEY's example before it the University of Chicago could hardly help approaching any educational problem in a scientifically analytical spirit. This is certainly true of its instruction in the arts, which has been carried on by a separate Art Department only since 1924. The case was, and is, complicated by the existence of the Chicago Art Institute, the largest professional art school in the world. Obviously the University could serve no useful purpose by duplicating the work of the Institute. It must stick to the proper aims of a university. But what were those aims? They were well outlined by Professor Walter Sargent, chairman of the department, whose lamented death in 1927 removed one of the most forceful and winning personalities in American education in the arts. First, he proposed to " offer to all students the kind of acquaintance with the arts which

every one should possess, and to develop an intelligent enjoyment of the world's artistic inheritance, as part of general culture." Second, he desired " to help students who show special abilities in art to develop those abilities." He pointed out that " those who plan to take up art professionally have seldom been able in the past to carry on any laboratory work in the art in connection with a college course," and that " they have been compelled either to postpone systematic studio work until after graduation, or go earlier than is wise to a professional school with its special interests." Finally Professor Sargent recognized the need of training "teachers and leaders in the field of art."

Here, as will be seen, we come upon a crucial issue affecting the relations between the colleges and universities on the one hand and the professional art schools on the other. Yale has met the situation by building a professional art school under its own roof, but this is not an example that every university can follow. The typical art school teacher likes to take his students direct from the high schools, before they have learned too much, as he looks at it, that they will subsequently have to unlearn. The college teacher, on the other hand, cannot help thinking that the profession of art, like other professions, should rest on a foundation of liberal culture. And in education, he thinks, as in architecture, it is advisable to put in the foundations before adding the superstructure.

The University of Chicago has approached a solution by planning a college course which will lead into the

professional course. It does not emphasize art as a species of history, but " as a thing of the present as well as of the past — an expression of the life and thought of to-day." That is, it does not choose to adopt the Harvard method of the scientific study of the classics, or the Princeton method of using the art of the past as a chapter in the story of mankind. Finally, the Art Department " feels that in studying art, as in studying any other language, a certain intimate insight and interpretation is gained if the student has some practice in the actual use of the language." Professor Sargent gave much earnest thought to the problem of " developing types of laboratory courses in art suitable for college students," and no one familiar with his work could doubt that he was making progress. It is from experimentation of this sort, one suspects, that a new and perhaps typically American variety of education in the fine arts will come. The policy at Chicago, as laid out by Professor Sargent, has had at least the merit of being fluid. It is not yet possible to recognize a Chicago graduate in fine arts by his opinions, his way of walking, or his accent. Alluring though the rôle might have been Professor Sargent never tried to be a Charles Eliot Norton. Even his courses in history and appreciation were founded upon the theory that art does not need history, science or a moral purpose to justify it — it justifies itself.

The history of painting, as Sargent saw it, is an absorbing illustration of the way in which the human mind works. It has, besides its emotional background, the same kind of interest one finds in the story of

an intricate invention — for instance, the motor car. So the student at the University of Chicago was taught the history of art as a history of certain ideas — the idea of perspective, the idea of light and shade, ideas of color. He learned to look at pictures, in a truly modern way, not as illustrations or portraits but as pleasing arrangements of lines, shadows, lights, colors, tones and textures. Of course he had already been accustomed to consider a silver vase, a fine chair or a building somewhat after this fashion — they actually are what they are and have no anecdote to relate. And women doubtless look at dress in the same way; it is only rarely that a fabric in feminine attire carries the history of an Egyptian king or any other pattern of literary significance. Professor Sargent's method therefore seemed to be only quite Chicagoan and American but even human.

Registration in the Art Department at Chicago has been increasing rapidly. It rose from about two hundred students in 1924 to about nine hundred in 1926, the last full year of Professor Sargent's life. The practical courses, as Sargent worked them out, include the usual drill in drawing, painting, composition, color and modeling. There are also courses in pottery and a beginning has been made in an " Introduction to the Minor Arts." The weight of the teaching is still thrown upon the lecture and reading courses, and even the practice courses differ from those in the professional schools in the amount of time given to lectures and personal conferences. The student is guided, not left to sink or swim.

Or, if you like, he is subjected to a system instead of being allowed to work out his own salvation.

The future of the art courses at the University of Chicago will doubtless depend to a large extent upon the development of the Chicago Art Institute; that, in turn, is a subject to which I shall recur in speaking more particularly of the professional art schools. We can probably count on something fairly original and unconventional in the working-out of art education and art expression in Chicago. The city is now large enough and self-conscious enough not to take its pattern from the East. It should become a center for upper Mississippi valley art. For, despite the pessimists and the scoffers, can we be sure that the Mississippi valley will never become artistically vocal?

4

THE UNIVERSITY OF PENNSYLVANIA, like the University of Chicago, has had to wrestle with the question of the proper relation between the professional art school and the institution of higher learning. The problem of the art department at Pennsylvania was a little different from that at Chicago, for the reason that it was built up around the solid nucleus of a first-class school of architecture. But because Philadelphia has excellent art schools — notably the Philadelphia Academy and the Industrial School of the Pennsylvania Museum — there was, as in Chicago, the danger of an unnecessary duplication of courses. There was also the possibility of working

out a new kind of art course — a possibility which appealed to Dr. Warren P. Laird, dean of the school of fine arts. The University has already announced its willingness to give undergraduate credit toward a degree for work done in the recognized art schools of Philadelphia. But such plans take a long time to realize. The universities and the art schools stand at two opposite educational poles and do not speak each other's language.

Dr. Laird's policies have rested on definite ideas regarding graduate work in the theory and practice of art. He pointed out some years ago that one by one law, medicine, business administration, and other professional courses have been taken under the wing of the university, with ultimate satisfaction to all concerned. Why not the fine arts? The undergraduate, as he believed, was already being fairly well provided for. On graduation, however, he had to choose, if he wished to pursue an aesthetic vocation, between the traditional art schools and such methods as he might work out for himself. Many of the men who had shown most promise as college undergraduates found the methods and atmosphere of the art schools unsatisfactory; the schools were too narrow, too poorly organized, and there was no opportunity to meet men doing advanced work in other fields. Laird saw no reason why a university graduate department of painting and design in connection with a department of the history of art should not be developed as other graduate departments have been. The methods might differ from those employed in the sciences, but

intelligent experimentation would show what needed to be done. As time passed the nucleus of students would increase and there would be a body of alumni whose experience and prestige would be of value.

" Such a body originating among University men," said Professor Laird, " would be unique in the field of art. It might conceivably bring to pass in the advancement of art what medical, scientific and other associations are accomplishing in their respective fields. It would exert a strong influence upon professional art schools, because it would force into the light some vital questions which are now treated with indifference. Few present-day art schools could longer attract the strongest students without revising their methods and organization of classes. Indeed, it is possible that it might effect a new and beneficial kind of relationship between art schools and universities."

It must be clear that when such a suggestion as this is responsibly put forward we have come a long way from Norton's " study and knowledge of the works of the fine arts, quite apart from the empirical practice of any of them." The university camel is crowding into the artistic tent with a vengeance — to the horror and dismay of many veteran teachers and practitioners of the arts. Perhaps they are right in dreading the application of the higher pedantry to the most delicate of human activities.

The proposal could not have come, however, from a less pedantic source. Dean Laird's opinions as to education in the fine arts carried authority not only because

of his position and personal prestige but because he had successfully applied them in teaching the fine art of architecture. Since 1874 architecture has been taught at Pennsylvania, since 1890 it has been a separate department, and since 1920 it has been the balance wheel of the School of Fine Arts established in that year. Among American schools of architecture — and since the World War this has very nearly come to mean among the world's schools of architecture — it stands near the top. But it has never been narrowly technical. It has maintained at all times courses in history and appreciation, given a fairly broad cultural background, and in Dean Laird's words " turned out men for the architectural profession who are at the same time possessors of the essentials of a liberal education." Its success in producing well-rounded men who were also architects could not help strengthening Dean Laird's opinion that a similar school might turn out well-rounded men who were also artists in other fields — men who would know that the world is spherical, that Columbus discovered America, and that France has reason to be proud of Pasteur as well as of Cézanne.

Beginning with the fall of 1926 the Department of Architecture divided its five-year course into two parts. The lower two years were considered as a probationary period, during which the student would pursue studies of a cultural nature, together with enough architecture to determine whether or not he had the gifts and temperament for the profession. Those who passed this test were then to go on to the final three

years of professional study. The others might become business men, politicians, farmers or what else they could contrive, but not, so far as the University of Pennsylvania was concerned, architects. The system has hardly had time to prove itself, but it will certainly send the stock of the Pennsylvania architect even higher than it has been hitherto. Here, again, the professional art schools might profitably take a leaf from Professor Laird's book. There are probably more misfits in the art schools than in any other department of education.

The architect must be able to draw and to design. During the entire five years at Pennsylvania the student is increasingly drilled in free-hand drawing. Here the aesthete, the temperamental lover of the beautiful, might be expected to shine. Yet, one is told, he does not; rarely, even, does he complete the five-year course. Genius is useful, as it is anywhere, and makes its own rules, but in architecture it seems to need will power and a willingness to sweat. The basis of fine art, as Pennsylvania sees it, is at least half science; science is another name for clear thinking; and clear thinking and determination together will work wonders. One boy came to Philadelphia bent upon becoming an architect. He could not draw, though he worked early and late. It was a year before he even began to suspect what drawing was. But he graduated brilliantly. That species of temperament Pennsylvania can understand, but it has no patience with the kind that cuts classes on fine days, or is unable to work unless the stars are propitious.

Whatever the rights and wrongs of the matter,

science and sound technique do not dim the enthusiasm of the Pennsylvania students of architecture. The spirit of the vast drafting-room, in which two hundred and sixty students — more than two-thirds the total enrollment in the department of architecture as this is written — may work at one time, is one of splendid eagerness. But it is eagerness intent and self-disciplined.

Registration in the fine arts courses more than doubled between 1920 and 1927, though out of a total enrollment of about four hundred and fifty students in the later year less than ten per cent. were taking the general courses in fine arts. However, as the maximum number to be enrolled in the department of architecture hereafter has been set at three hundred and fifty, whatever future growth there is will take place in the other departments. The significant feature of the teaching of fine arts at Pennsylvania will be not numbers but methods. We may look to see the long-established traditions of art education, and of the nature and function of the artist himself, subjected here to a cool, practical and perhaps revolutionary scrutiny. The artist as he now flourishes in America is a European product. What one becomes aware of at Pennsylvania, at the University of Chicago, and at several other cultural institutions is an effort to Americanize him.

There is much to be said about the work being done in departments of fine art in colleges and universities other than those I have been able to mention. Columbia, the University of California and a dozen others would have to be included in anything like a complete survey

of the field. Nor should such of the women's colleges as Bryn Mawr, with its scholarly note, or Smith, with its fine teaching collection, be left out. But as there is not time to fill in every corner of the picture it may be sufficient to suggest that the institutions described are typical of a much larger group. Courses in the actual practice of the arts as well as in their appreciation are being introduced and expanded in American colleges as rapidly as qualified teachers can be found to direct them.

The discussion of art as taught in the colleges naturally brings up the question of art as taught outside the colleges. Now art outside the colleges is taught in two distinctly different ways. It is taught as a craft or profession, and it is taught as an adventure in self-expression. These varying objectives, in turn, involve two different theories of the place and function of the artist. The history of art education has yet to be written, but it is perhaps possible as well as worth while to indicate how and why each species of art school came into being. This will be the subject of the next two sections of this book. And first I wish to say something of the craftsman's approach to the arts.

Art and the Craftsman

I

THE SERVICE OF ADMETUS

LOVERS of Grecian mythology will remember the fable of the god Apollo, who for a time kept the flocks of Admetus, king of Thessaly. This is one of the first-recorded apprenticeships and it seems appropriate that it should be associated with the patron of music and the arts. We may suppose that the fine and applied arts were one and the same thing very early in human history, and that both were learned by young men submitting themselves for a time to the tyranny of their elders. There may have been rebellions against the natural conservatism of age, and venerable academicians may have been found with spears between their ribs. But the tendency to regard the traditional body of knowledge as of far more importance than any individual's possible contribution to it must have been established very early and very strongly. Indeed, it is this that gives continuity to the history of the arts, whether we are dealing with Greek vases, with Chinese paintings, or with the aesthetic adventures of the Florentines. Budding genius has ever been cramped in the ancestral flower pots.

The earliest schools of the arts and crafts, so far as we

can be certain, were the workshops. The apprentice learned how to do by watching the work done. From performing menial labor at first he progressed toward the simpler processes of the craft and so by degrees, after his seven years or something more were up, became himself a master — and a tyrant. Cellini was put to work under a goldsmith. Michelangelo was apprenticed to Ghirlandaio, and under his direction sweated unthanked at the frescoes of Santa Maria Novella. Most lads who had a flair for the aesthetic began as Cellini did, for the goldsmiths had managed to draw almost all the artistic trades under their control. The apprentice did everything as fast as he became competent — he ground paints, he drew and painted the coarser kind of work, he made models, he tried his hand at jewelry and metal-work, he carved and gilded wood, he learned the elements of architecture. Sometimes he learned them most inadequately, as some of the surviving buildings of the Renaissance period prove. The training of the artist and craftsman was probably not different in general principles, though naturally different in kind, from that of the carpenter, the mason and the baker.

"In the Middle Ages," says Elie Faure, "the artist was a workman, lost in the crowd of workmen, living the same life as theirs. Later on, under the Renaissance, he was an aristocrat of the mind, moving almost on a par with the aristocrat of birth; later on, again, a skilled laborer seized upon by the victorious aristocracy; and still later, when the autocracy finally crushes the aristocracy under its own ruins, when workman is separated

from workman by the death of the guilds, the artist is lost in the crowd, which is ignorant of his presence, or which misunderstands him."

The end of this series of retrogressions has taken place in our own time, though the beginning was some centuries ago. A chasm parts the artist and the craftsman, with unfortunate consequences for both. The one is too far removed from common life, the other too frequently its docile slave. This process took place, perhaps, as part of the modern revolt against authority — a revolt which began with the Renaissance, and continued, in a darker mood and nastier temper, with the Reformation. Frank Jewett Mather speaks of Botticelli, who was born in 1444, as the first of the modern type of temperamental artist — " the first individualist who strained sorely at the bounds imposed by the collective taste, required a select public, and painted to please himself." Carry this attitude to its logical conclusion and we have the modernistic attitude of Julius Meier-Graefe: " Artists have a right to be idiots; they owe it to themselves." But an architect, a furniture-maker, a silversmith, cannot be quite an idiot, for his houses must stand up, his chairs carry weight, his vases hold water. So the maker of beautiful things and the maker of things that are fundamentally useful have gone along different and not parallel roads.

The early art schools emphasized this divergence, for they seem to have taught mostly what could not be conveniently taught in the workshops. " The first systematic art school," if we are to believe Professor Mather, was

that of Francesco Squarcione in Padua, about the middle of the fifteenth century. Denis Calvert of Flanders founded a school in Bologna toward the end of the sixteenth century. Lodovico and Annibale Carraci had an academy in Bologna, in 1585, in which, to quote again from Professor Mather, " the antique, the nude and competitive composition were the staple of instruction, quite as in French and British state art schools to-day." The French School of Fine Arts in Rome was founded in 1671, and the Academy of Architecture the same year — the beginning, according to Magonigle, " not merely of governmental education in the arts but in large measure of the official control of national taste through educational agencies." A sinister anniversary, viewed from certain points of vantage!

Under such auspices the artist and the artistic tradition became, to say the least, artificial. Spontaneity was discouraged. " A self-made artist," said the English painter Constable, lecturing in 1836, " is one taught by a very ignorant person. I hope to show that ours is a regularly-taught profession; that it is scientific as well as poetic; that imagination alone never did and never can produce works that are to stand by a comparison with realities; and to show, by tracing the connecting links in the history of landscape painting, that no great painter was ever self-taught." There is a superficial similarity between this doctrine and that I have described as prevailing at the University of Pennsylvania. It is not at all at variance with the good old theory of apprenticeship. But it is an apprenticeship to a creed

rather than to a flesh-and-blood journeyman master. And Constable's " comparison with realities " gives him completely away in the eyes of a generation which does not care a tinker's damn for realities. Inevitably there was a revolt. Out of the revolt came a conception of the artist which had many romantic aspects, but which was still further removed from the old ideal of the craftsman. This I shall touch upon a little later.

The nineteenth century saw the fine arts growing more and more experimental, making a technical progress comparable in some respects with that of science itself, but becoming all the while more and more the vernacular of the few. But the same period also saw attempts. Dear old William Morris, with his pre-Raphaelite beard, tried to make even wall paper beautiful. But, which was far more significant, the machine system, the industrial regime, revealed here and there some symptoms of being about to give birth to an aesthetics of its own. Trade Schools became craft schools, craft schools showed signs of becoming art schools. More recently, industry itself has felt the need, in very self-defence, of cultivating the arts of design. This is a phase not only modern but peculiarly American. Because it goes with the currents of the time, not against them, it has vitality. It may be capable of rescuing art from eccentricity and the crafts from vulgarity.

To illustrate this thesis I have grouped under this section a number of schools of diverse origin and purpose. But differ though they may they are tied together by what may be called the thread of workmanship.

II

MR. PRATT WHITTLES OUT
A CURRICULUM

I

THE one art in which the Puritan excelled, it has been remarked, was housebuilding. No one can explore certain New England villages without becoming aware of a deep instinct for loveliness that once flourished there. The Alcotts and Emersons of Concord were perhaps no more philosophers than the carpenters who built their houses. Make all possible allowances for the fact that these carpenters were humble journeymen who took their very simple plans largely from books, and the fact still remains that they had sufficient artistry to copy the very best designs. They were kin, though remotely, of the craftsmen who hewed out Notre Dame and conceived the palaces of the Medici. Their houses possessed a quality of folk lore. They had not the cheap and shoddy acquaintance with the world which would have enabled them to produce the gimcrackery of a later period.

The Puritan had another art, if it may be called that, more modest, yet allied — the art of whittling. On the sunny sides of Maine wharves and around the winter

stoves in Vermont general stores the whittler may still be found. His father and his grandfather whittled before him — whittled paper-knives, with round balls mysteriously inside the handle, or to beguile the leisure of the dog watch on long whaling voyages, carved spoons and pie markers out of the leviathan's bones. So there may be something pertinent in the fact that Pratt Institute was established by a man who loved to whittle. Without a whittling streak in its founder Pratt might have remained what it seemed in its beginnings forty years ago — a good trade school that one wouldn't go far into the brick and plaster wilderness of Brooklyn to see. From such an institution might have come, and did come, the existing School of Science and Technology, but hardly the admirable School of Fine and Applied Arts which is also an integral part of the Pratt Institute of to-day.

In order to understand the Institute it is necessary to know a little about its founder, for this is almost uniquely the expression of a dominant personality. Superficially the story of Charles S. Pratt is the familiar one of the self-made man of a generation or two ago. He was born in 1830, one of a family of ten children on a farm in Massachusetts. As was not to be wondered at the family was hard up. At ten the boy left home to do chores for a neighbor and give his parents one less mouth to feed. At thirteen he was a clerk in a Boston grocery store, at fourteen a machinist's apprentice. Then he went to school for a year, and because he was hungrier for knowledge than for food he lived the whole

time on a dollar a week. Later he was a clerk in a paint store in Boston, and at twenty-five a partner in a modest paint and oil business in New York City. A year or two more and he was making Pratt's Astral Oil a household necessity. Then came a favorable alliance with Standard Oil and the poor farmer boy found himself one of America's wealthiest men. But his early deprivations had left him with an ache of regret. He had longed for education and skill and his opportunities to acquire them had been pathetically slight. When he turned toward philanthropy, after business had ceased to absorb his energies, it was to help young people situated as he once had been. He went in this direction as far as his imagination would take him and learned as he went along. He traveled and probably knew of the industrial art schools abroad, in England, in Belgium and elsewhere. He was familiar, too, with Cooper Union, founded a generation earlier. He took the best educational advice he could get.

He also had educational ideas of his own, many of them far in advance of the American practice of his day. He was one of the first to recognize the need of manual training high schools, of free public libraries, of business colleges, of kindergarten training schools. He had confidence enough in himself and his purposes to endure the ridicule he invited. " Some one else has been laughing at me to-day," he would remark with a philosophical smile. He endured the sad fate of the man who is so successful in making money that people are slow to credit him with ability in any other direction. One of

the first men he went to when he decided to start his school was Mr. Walter Scott Perry, who was dean of the art courses from the beginning and largely responsible for the shape they took. " He developed a very simple pedagogic creed," Mr. Perry afterwards said, " which, briefly stated, is this: Show men how to do something and insist that they do it as well, as honestly, as economically and as beautifully as it can be done." The last adverb permitted the introduction of an aesthetic element into the training of boys (and, very soon after the opening of the school, of girls as well) to earn their livings.

" One thing is clear to me," he told Mr. Perry, " and that is that drawing must be a foundation study, and must enter into almost every course of study that may be pursued in Pratt Institute. Therefore I think I shall be entirely safe and make a right beginning if we start with drawing classes. Then I will feel my way to the next subject." This was in the fall of 1887. " Hence," wrote Mr. Perry, " the ' Drawing Department,' as it was first called, eventually included all kinds of free-hand drawing — design, architectural and mechanical drawing. . . . From the small beginning of twelve students in drawing there has developed the present School of Fine and Applied Arts." Outside observers did not see so clearly what was going on. They saw a school in which there were, indeed, drawing classes, but in which there were also courses in foundry work, plumbing, cooking and dressmaking. " Such institutions," was the complacent conclusion of a magazine writer who visited

Pratt in 1888, "elevate the dignity of labor, raise the tone of society, improve the quality of work, and contribute to the happiness and comfort of wage earners."

But it was no purpose of Mr. Pratt's nor of his sons', who most intelligently and devotedly carried out and expanded his policies after his death, to duplicate other agencies. As soon as trades could be learned in public high schools the Institute substituted engineering courses. The "Drawing Department" survived and flourished because its work was not being done elsewhere. But something of the directness and practicality of the trade school survived, too. Art, at Pratt, was never allowed to become an escape or a means of solace. There was nothing expressionistic, nothing temperamental about it. It was something to be fitted into the existing scheme, which happened to be a mechanized, commercialized civilization.

Mr. Pratt gave the school almost as much attention as he did his personal affairs — indeed, the school was one of his most cherished personal affairs. Since his death, in May, 1891, six of his sons and four of his grandsons, with rare enthusiasm and self-sacrifice, have served on the directorate and on the active executive staff. Several of the teachers, at the time I visited it, had been at the school from the beginning. In this way it has had a most unusual continuity of policy. There has been no modification of the original intention that " its courses should be so conducted as to give every student definite practical skill along some one line of work."

It is taken for granted that the way to learn is to do, just as it used to be in the old *bottegas*. If this is cultural so much the better. Culture, as Matthew Arnold, John Ruskin and Charles Eliot Norton, might severally have defined it, is not the primary motive. If achieved it is a by-product.

Because training for a specific job comes first, and because tuition fees and other expenses have been kept low, Pratt has always drawn a majority of its students from among those who have little time or money to expend. About half of them earn all or part of their expenses, and standards of living on Ryerson street are simple. Membership, the student is warned in advance, " is conditioned upon regular attendance, faithfulness, earnest work, proper conduct in and out of the Institute, and willingness to co-operate at all times with the instructors and officers." Hazing, secret societies, fraternities and " unauthorized social affairs and organizations " are strictly forbidden. Plainly it is not quite *la vie de Bohême* that is lived at Pratt.

Yet the usual student is too glad of the opportunity to rebel against the conditions that accompany it. So carefully are the candidates sorted over before admission that relatively few have to be dropped afterwards. In a typical recent year only thirty of the five hundred and fifty-four who registered in the day courses were off the rolls at the end of the second term. Of these one or two had died, others had been ill, and the remainder had shown " lack of natural ability," or had been advised by the faculty to leave. Once admitted the student

is rarely allowed to fail. He is supervised and regulated to forestall failure. When he has chosen his course his studies are laid out for him with military precision, and he must be on hand five days a week, from nine to four. He cannot room or board in houses which have not been inspected and approved by the Institute. He must take a thorough physical examination, and he must, whether he likes it or not, undergo a course in physical education. Even sociability is compulsory — the tuition fee covers membership dues in the Men's or Women's Club. The school has a community life of its own. The individual cannot trail by himself. This may prepare him, as training in a more individualistic school would not, for the regimentation to which he will be subjected when he goes forth to earn a living. As to whether an artist ought ever to submit to regimentation, that is another question.

There is a feeling that every student is on probation from the first day to the last. Art is long and time is fleeting: the problem is to get as much art as possible into the least amount of time. Teachers and students alike are aware, the visitor suspects, of strain, of the constant need of effort. The atmosphere is charged with anxiety. A course at Pratt, for most of those who take it, is a race against necessity. And, as in other races, the contestants carry no more weight than they need. The Pratt curriculum does not provide for genial by-play. It marches straight to a destination. It flouts the superstition that the artist is a happy-go-lucky fellow, who cannot be held to schedule, but must occasionally loaf

and invite his soul. He may try this experiment, but not at Pratt. One recognizes the quality to which industry and commerce, bowing modestly as before a high god, have given the trade name of efficiency. Artists are produced at Pratt with as little waste motion as automobiles at the Highland Park factory in Detroit. But to say this and no more would be rankly unjust. What Pratt seeks to conserve is precious time, which is another name for human life. Were its methods more leisurely many of its students would be automatically excluded. The danger is that in learning to earn their livings they may never learn to become creative. Pratt accepts that danger because it must.

The need for haste makes frequent compromises necessary. A course must either be narrowed or treated more superficially. Pratt, in this dilemma, always chooses the first alternative. It does nothing that it cannot do thoroughly. An architect, for instance, may profitably spend six or seven years learning the mere elements of his profession against a background of general culture. Pratt produces a good draftsman or superintendent of building construction in two years, an architect, duly registered as such by the New York State Examining Board, in three years. An additional year, everyone admits, would be desirable. But to add a year would be to diminish by one-fourth the number of architectural students who could be admitted each fall, and to increase by one-third the time and money each student must spend. So the step is not taken.

I asked an architect who knew the school well what

the careers of these youngsters would be. Could they hold their own with those who had taken from four to six years to prepare themselves?

" They are already a selected group," he explained. " Out of forty who enter the first year in architecture only fourteen, on the average, will take the third or professional year. They will be turned out as good draftsmen as can be found. For a time they will go ahead more rapidly than graduates of other schools who have studied longer and learned more theory. But at the end of perhaps five years, unless in the meantime they have managed to broaden their training, they are likely to be outdistanced. The danger is that they will not develop the imaginative grasp that would enable them to plan and carry out large enterprises. But they do get more at Pratt in three years than they would get in the same length of time in almost any other school. And the choice is, usually, not between spending three years at Pratt and five or six elsewhere, but between getting a training in three years or not at all."

If we are concerned chiefly with raising the general level of architectural work we must steel ourselves against any educational methods which tend to flood the field with half-trained men. But it is well to remember that the architectural profession has many levels and many phases. An architect is an artist, an engineer and a business man. Rarely does he excel in all three capacities. Even if he does his career is not thereby assured. Social connections, the opportunity and ability to mingle pleasantly with well-to-do clients, have some-

thing to do with ultimate success. And no school can control these factors.

2

DEAN PERRY long ago made a study of short-cuts. He decided that the practice of starting the student with cast and block head, then promoting him to a life class, was anything but economical. A student working day after day at the same thing, he concluded, soon reached the point of diminishing returns. So at Pratt the student is not kept working on any subject longer than half a day at a time. When his interest would naturally begin to flag he turns to another subject. He may be in a life class in the morning and in a class in design in the afternoon. He may do still life in the morning and anatomical drawing in the afternoon. The teachers at Pratt will tell you that their students often get through as much in a day as those at the average art school do in two days.

No one can doubt that they work hard. The visitor who makes a tour of the class-rooms will be aware of an atmosphere of tight-lipped effort. One wonders if some of these young people won't be under a less severe strain after they are fairly out in the world and earning a living. The arts are no lackadaisical affair at Pratt. They are athletic and virile. No engineer student from across the street ventures to hint, as some were in the habit of doing a few years ago, that the male " Arties " had better put on skirts and be done with it. As seems to be the case nearly everywhere paints and crayons have grown

rapidly in the respect of the student public. The he-man at Pratt, like his brethren at Yale and Harvard, now thinks rather well of them. The percentage of men in the arts classes is rising steadily; a few years ago the males were a small minority, now they are nearly or quite half. The number of women who are preparing for work rather than for matrimony, and who will prove anything but effeminate when they begin to compete with their brothers for jobs, is also increasing. That tendency, however, is difficult to measure statistically. It is complicated by the fact that more women than men become teachers.

Why have the art classes grown in size and importance? The question comes up again and again as one visits schools having a general curriculum from which to choose. Is it because of a growing interest in aesthetics? That is one explanation, and a very pleasant one. Another is that the pursuit of beauty has risen in favor because it has become economically worth while. If a young man says he has gone in for art because he loves abstract beauty he cannot always be sure that his friends and relatives will understand. If, on the other hand, he says that he has chosen his career because it offers well-paid employment, he will be understood, even by engineers and Philistines.

The evidence of public approval of the Pratt method is that its graduates are always in demand. From eighty to eighty-five per cent are assured of positions before they leave school, at an average wage of about $40 a week. The teachers, of whom the school has now grad-

uated very nearly two thousand, are never numerous enough to satisfy the demand. Incidentally, the teachers are largely responsible for the fact that Pratt is not a neighborhood school, but draws at least half its students from outside New York City, including a few foreign countries. Students in the practical courses may become textile designers, interior decorators, costume designers, illustrators, silversmiths or goldsmiths, or they may find use for their training in the field of salesmanship. Perhaps one-third will be creatively engaged in the arts ten years after leaving school. Art, like Jordan, is a hard road to travel. There are many temptations to step aside.

" Do you make a distinction between the fine and the applied arts? " I inquired. This was a question I asked many times in many schools.

" In theory," said one instructor, " there is a distinction. In practice I don't see why there need be. What is called commercial art is simply art patronized by those who have goods to sell — or, to look at it in another way, who are in the market to buy. Art has always needed patrons. Benevenuto Cellini had to deal with the Medici, the Popes and the Kings of France. Was he really a free man? Was he untainted by commercialism? Is the artist worse off in our day, when he must make a living by catering to the tastes of advertisers and magazine editors? What we urge is that the student should learn to accept the conditions of his own time and express himself in terms of the present. If an advertising agency will let him do his best work he need

not be ashamed of being on its payroll. Many of our graduates do, in fact, become directors and assistant directors in advertising agencies and advertising departments. Of course there are sometimes drawbacks to such a career. In some agencies the work is so subdivided that one man draws nothing but hands, another nothing but heads, a third makes figures, and no one of the three has a chance to execute a complete picture. Or a man may slip into some specialty of commercial still life — he may spend his days drawing pickles! But at the worst he earns a living in a workmanlike manner, and if he has ability and creative fire he will manage to escape into a broader field."

Like all schools Pratt likes to have its successful graduates drop around occasionally. Some of them come to give lectures. But it is not in Pratt's origin and nature to look for a ragged success, with masterpieces in the attic. No fanatical empty-pocketed pursuer of hidden beauties will return to expound his theories here. Students and teachers look to this day's and world's rewards, being willing to pay for them in honest craftsmanship, if not in perilous flights of the imagination. And in a day when ink and paper are so plentiful, and there is so much stone, steel and cement to play with, and all are bound to be used by some hands, competent or incompetent, craftsmanship is not to be despised. Pratt's pickles, if pickles they must be, are good pickles, and its whittlers are worthy of their long and heroic lineage.

III

THREE SCHOOLS OF DESIGN

I

THE 'seventies and 'eighties of the nineteenth century in America are usually spoken of with a kind of horror by refined people, as though they were an extension of the Dark Ages. Indeed, there are some critics of human affairs who are quite fond of the thirteenth century but would, if they could, omit the nineteenth altogether. These particular decades, all things considered, were deplorable. On the other hand they did see the beginnings of movements toward civilization to which our own contemptuous generation has fallen heir. Norton of Harvard and Marquand of Princeton had their dreams, as we have seen, of an America which would know how to shudder at the cheap and the banal. Probably of nearly equal importance in the long run were such shrewdly practical projects as that of Charles Pratt. His Institute, though typical of the period of its founding, was neither the only one of its general species, nor the first. As far back as 1870 the Massachusetts Legislature passed an act requiring that " in future every child in schools supported by public taxes shall be taught to draw." The children could not

be taught drawing unless some one first taught the teachers. So this, the first and only state art school in this country, was started forthwith to light the torch which was to be handed on to the children of Massachusetts. The first director, an Englishman named Walter Smith, believed that it was as easy and certainly as desirable to teach a public school pupil how to draw a cow or a house correctly as it was to teach him how to write an accurate description of it. This idea was too radical for the time and place. It is a little radical even to-day. However, an excellent teacher-training school and eventually an excellent art school as well grew out of Walter Smith's originality. After a while it became evident that the school could turn out more teachers each year than could find places in the state's educational system. So the institution began to give more and more of its time to fitting young people for practical work in commercial and industrial design. This was its evolution over a period of years.

After the World War it became apparent — so many things became apparent at that time! — that this was not enough. It was seen that the school's task was only half done when it had trained its designers, illustrators, and so forth. It was necessary to educate merchants and manufacturers to see the advantage and the profit of making their goods artistically more attractive. It was necessary to educate the public until it would prefer beauty to tawdriness. This was a large order, but Royal Bailey Farnum, who came to the school as director in 1921, made almost as spirited a crusade as did Norton

of his struggle to turn raw Harvard cubs into accomplished men of the world.

But Farnum, unlike Norton and Marquand, paddled consciously with the main currents of his day instead of against them. He frankly conceded that America would have for some time to be interested in moneymaking. So, for that matter, was Greece during the age of Pericles and Venice in her glory. One might argue this point not unprofitably. Great periods in the arts seem to be the result of a heightened sense of life — an aliveness keener than the ordinary. Individuals, nations, whole races suddenly jump out of the ruts in which they have been travelling and start off with a whoop in new directions. There are controversies, wars, discoveries, inventions, new philosophies, new trade routes, a vast amount of noise, an intolerable degree of vulgarity, but also, because the world is suddenly so new and interesting, an artistic effervescence. The same elemental energy which will send one man on a frantic quest for dollars will spur another to build a Nebraska State Capitol. The forces which produce motor cars by the million may also produce significant form in spoons, office buildings, warehouses and canvases.

Mr. Farnum may not have been guilty of any such line of reasoning. But he did not, at any rate, try to find an antidote for the commercial motive. On the contrary he set to work to make business more artistic without making it a whit less businesslike. He proposed to introduce better ideas of design into machine-made goods, into advertising lay-outs, into window dressing.

By way of illustration: a certain Boston department store established what it called a clothing information bureau, through which it conveyed to its women customers some elementary notions of costume design. Presently it was found that many of the customers knew more about styles and fabrics than the clerks themselves. In self-defence the clerks asked for instruction which would at least enable them to look intelligent when customers talked of linear rhythms and color harmonies. Farnum, quick to seize such an opportunity, offered a series of lectures, for which eighty-four saleswomen, buyers, advertising men and department executives promptly signed up. The experiment was so successful that it has now grown into a year's course of intensive study, open to senior women in the art school. Part of the course is given in the stores which coöperate in the plan, part in the school itself. Candidates must have " initiative, tact, patience, and a practical point of view toward the machine, mass production and merchandising." In other words they must take the world as they find it, and not, like modern Luddites, try to smash or outwit the cogs and wheels by which we all live. Is this Art? I do not attempt an answer. But perhaps as much art gets into the world through this course as would do so if the same young women spent the same amount of time in learning to make oil paintings. Few of them could sell a painting, but nearly all of them can exercise a healthy influence over the kind of taste to be displayed in retail merchandising in Boston.

The plan is like others of Mr. Farnum's devices for

linking his school with the commercial and industrial life of the state. For the art of the Massachusetts Art School, like that of Pratt Institute, must be one that men can earn their living by. It must have businesslike value, a sales appeal. This is one more difference between the Farnum or Perry product and the Norton or Marquand product. Art was almost never a means of livelihood in Norton's heyday. Perhaps he would have been slow to admit that an occupation which enabled one to earn a good living in the business world ever could be an art. The business men of his day might have agreed with him in that if in little else. But there has, strange to say, been a change in business men. Ten or fifteen years ago, as Mr. Farnum will testify, it was of little use to talk to commercial organizations about art. They would not listen. Now they are eager to learn something about the subject. This may be partly because the increased amount of foreign travel has made European galleries more familiar and art in general more respectable. But one need not suppose a change of temperament or an increase in careless geniality in commercial circles. Of more importance is the fact that American business is finding it necessary to depend more and more upon home-grown talent for its designs. A good design has value, as business men understand value. It can be bought, sold, exchanged for the goods of the realm. Financially it is as tangible as a bank note. This is applied art. Again, it may be asked, can it also be fine art? I mentioned this difficulty to one of the instructors in Mr. Farnum's school, as I had previously done at Mr. Perry's

school. " Fine art," he instantly replied, " is useless art. On the other hand a man might design a garbage can which would be just as fine as anything in the Boston Museum." This comment is offered for what it may be worth. To a degree it typifies the spirit of the convinced industrial artists. Of course not all industrial artists are convinced. Some of them are embittered exiles from what they look upon as the paradise of the fine arts.

Tradition does not play a large part where the object is to obtain practical results with as little waste motion as possible. Farnum is more interested in developing the abilities of the individual student than he is in imparting a given quantity of cut-and-dried subject matter. A good deal of conventional still-life material has been packed away in the attic, and its place taken by the motion picture. An episode is run through rapidly on the screen. Then it is run slowly. The student draws what he remembers, then compares it with what was actually shown on the screen. After a while he learns to see more accurately, which is a step toward drawing and painting more accurately. Some artists will quarrel with this method, on the ground that accuracy may safely be left to the photographer, and is the last quality a painter should seek. But even though the painter departs from the norm he is perhaps the better for knowing precisely what a norm is. This is certainly true if he has to earn his living in commercial art.

Mr. Farnum puts his stress, from the day the beginner enters school, on ideas rather than technique. " In some art schools," he points out, " the student is so handi-

capped by the constant drill in technique that he isn't able to express his own thoughts. Or perhaps he reaches a point where he hasn't any thoughts to express. We go at it the other way round. If a freshman has anything to say we let him say it — we've got four years to teach him technique. The idea — having something to say as well as knowing how to say it — is the important thing here." I have quoted something in a similar vein as being characteristic of the method used at Yale.

The Massachusetts School of Art differs from some institutions of its type in requiring a four-year high-school course as a prerequisite for admission. It is unique in that it charges no tuition in its day classes to legal residents of Massachusetts. One consequence is that it is under no temptation to admit or retain students who are not up to its standards. Its course of study is no four-year joy ride. Some can't stand it. Out of possibly one hundred and fifteen boys and girls who enter within a given year more than a fourth will have dropped out inside of twelve months. Some will have found that they are not called to the arts. Some are looking for an easier approach. During the first two years the courses are practically identical for all students. They involve a general survey of the field of the arts — color, design, drawing, painting, modeling, water color, composition, an outline of architecture, and history as revealed in the arts. Enough English is taught to make the student at least literate — and literate is an adjective that cannot be applied to all young people who go to art schools. In his junior year the beginning artist

must select a specialty — teacher training, design, drawing and painting, modeling and sculpture. To this list the retail trade course already mentioned should be added. Practically all these courses lead as directly as possible toward jobs, though possibly not so directly as is the case at Pratt. The head of the school, in his capacity of liaison officer between art and industry, is constantly working to make business men aware of their needs and to provide the trained men and women to fill them. He believes that " a state school of art must be to the people, to their commercial and their industrial interests, what a school of agriculture is to the people's agricultural interests."

There is still another function of a state school of art, as Mr. Farnum conceives it. " It must," he believes, " be the research laboratory for art information for all problems involving the use of color and design, as expressed in human existence." This is a magnificent enterprise! But it has the merit of captivating the imagination. And it is peculiarly appropriate in New England, which can no longer hope to hold her own economically by the mere bulk of her manufacturers. The region turns to more delicate products out of sheer necessity. The Greek head on Yankee shoulders may have a market value as well as a philosophical significance.

2

THE PENNSYLVANIA MUSEUM'S SCHOOL of Industrial Art came into being in 1876 as a direct result of the aes-

thetic interest aroused by the Centennial Exhibition at Philadelphia. One must be a little cautious here, for in some ways the Centennial was aesthetically pretty terrible. But as was to happen on a grander scale at Chicago in 1893 the buildings and displays did give people a new though vague idea of the rôle the arts might play in their lives. They started a revolt against criminal ugliness. This revolt hasn't yet been completely successful, yet those who complain of filling stations might do well to ask if they are not an advance on most old-fashioned livery stables; even a stucco bungalow is progress when compared with the typical wooden band-box of the 'nineties or one of those jig-saw puzzles in domestic architecture which were popular in the 'eighties; and what woman is there who would tolerate the sartorial abominations of the *fin de siècle?* The schools may have had something to do with this amelioration.

The Pennsylvania Museum school is very much in the modern mood. Its announced aim is " to give workers a thorough training in the fundamental principles of design and the practical application of these to every branch of artistic production." Design is what Lewis Carroll would have called a portmanteau word — it holds a lot of baggage. One can design a bath-tub or a salon painting, using the same fundamental principles. But as for a century or more the best artistic minds did not stoop to design bath-tubs, or any common things, there was, in the 'eighties and 'nineties, and is to this day, a crying need for good industrial pattern-making. Huger Elliott, at this writing of the Metropolitan

Museum of New York City, and formerly a principal of the Museum School, has expressed the idea admirably.

"The term 'Industrial Art,'" he says, "is used to designate the multitudinous objects which serve our daily needs, but which have been raised into the realm of the arts by the creative power of the designer. It is of the utmost importance that these objects be of the highest artistic value, for they play so large a part in our daily lives that to have them commonplace or ugly means a general lowering of our standards of taste. Their influence makes itself felt hour by hour; in our clothing, our furniture, our china and glass and silverware, in our books and magazines. It might be fairly claimed that upon a widespread distribution of beautiful objects of daily use depends the future artistic standing of the nation."

Industrial art, viewed in this way, needs no apology. We may hold with Thoreau that the mere multiplication of objects by the use of machinery is not civilization but barbarism. We may deplore the continual intensification of our wants by means of the gigantic mechanism of advertising. But though any individual who desires to do so may go and live in a cabin by some Walden Pond or other, the age is, and promises long to remain, industrial. In such an age the industrial designer stands upon the firing line, whether we regard him as making the best of a bad job or rising superbly to the opportunities for a good job. Every school of applied art that is worth its salt has to proceed upon this latter assumption.

The school of the Pennsylvania Museum takes its material in the raw state — that is, it does not require a high-school education as a prerequisite for admission. The student is judged by what he or she accomplishes after being admitted. Those who have no calling to the arts are likely to find themselves weeded out during the first year; or, if they survive the first, during the second. This leaves a selected and fairly serious group to fill the classes during the third and fourth years. The students may become teachers, or they may specialize in design, in advertising, in illustration, in interior decoration, in costuming, in pottery, or in woodworking, metalworking or the making of jewelry. If the school differs markedly from the last two described it is in its even greater emphasis upon practical contacts with business and industry. Pratt and the Massachusetts Art School still make these contacts, as a rule, after the student has graduated, despite such exceptions as I have noted. The Museum School, on the other hand, is trying to give the technical student something akin to the practice teaching commonly done by the apprentice teacher. The prospective pedagogues in the School now do one and a half days of practical teaching in their third year, and two and a half in their fourth. A similar schedule is planned for the designers and other prospective commercial artists. Thus they will become acquainted with the problems of their craft in a way that would be impossible in the school itself. They will also be putting themselves in the line of future employment.

Critics of this system maintain that it trains the student, not in the principles of art, but in the notions and prejudices which employers entertain about art. In fact, this is one of the battle lines of education in the artistic crafts. Shall the schools wag the industries or shall the industries wag the schools? The stage, the motion picture industry and the publishing business know the same dire problem. But it is certain that industry is less arrogant than it used to be — in this field, at least. It manifestly feels the need of the schools, that is, so to speak, of the aesthetic " expert." In consequence we are getting more competently designed chairs, lampstands and pickle forks than we used to. But the problems involved are not simple. A good industrial designer ought not to be a lesser artist, but a super-artist. He needs, as Mr. Huger Elliott has said, " technique, theory and taste — and of these three taste is the greatest." The difficulty about taste, as Mr. Elliott has pointed out, is to define the meaning and to decide whose taste shall prevail. The student must be exposed to very careful training, yet not much is gained if he is merely required to master other people's ideas of what is true, good and fitting. Technique and theory — what has been done, how it was done, and why it was done in that particular fashion — are comparatively simple matters. They are, as Mr. Elliott notes, almost too simple.

" The student enjoys," as he says, " the acquiring of technical skill; the public bestows upon it its warmest appreciation. The duty of the school is to see that, while the training in technique is thorough in every way, the

more important training in understanding and appreciation is made the predominant interest."

To what extent any industrial art school has escaped the dangers Mr. Elliott describes it is difficult to determine. The desire to escape them is undoubtedly there in nearly every instance. At Pratt, at the Massachusetts Art School, at the Museum School, and at the Cleveland School of Art, which we shall presently touch upon, the inspirational note is sounded in general assemblies, which the student is required to attend. The degree to which it penetrates the teaching depends upon the individual teacher. Too much "inspiration" — or "culture" — and too little technique obviously hurts the student's chances of getting a job after graduation. All of this is but another way of saying that in the schools of industrial art, as in the art courses in colleges and universities, the ideal formula has not yet been found. The practical and the ideal are forever battling for the championship. Nor can either command one's entire sympathy, for the one is always in danger of becoming purely commercial and the other of becoming merely sentimental.

The Museum School does make at least a brave attempt to stimulate something more than the finger tips. In the required courses for the first year the beginner " is trained to be as exact in dealing with color relations and color harmonies as is the performer on a violin in dealing with sound intervals "; but he is also exposed to " a course of lectures on ' Artistic Expression,' " which, it is hoped, will provide a background " for his

general cultural development." A required course for the second, third and fourth years consists of a weekly lecture, to which each student brings an original composition for criticism. The aim here is " to awaken, stimulate, and develop the student's mental ability, his pictorial talent; above all his imaginative powers." The compositions are criticized for " their sincerity, their truth and their practical use " — a set of qualities of which genius itself could give no more than an adequate demonstration. But the intangible values are always in mind, even though the job and the salary are not likely to be forgotten. And unless every boy or girl who can draw a straight line is immediately endowed by the government or by private philanthropy the job and the salary can scarcely be ruled out of court. Costume designing, for instance, is taught as an art, yet the student must also learn to figure costs and adapt herself to prevailing business methods. The same practicality appears in the courses in interior decoration, pottery, woodworking, jewelry, and metal-working. The successful graduate should be proficient enough to be worth a living wage as soon as he leaves school. He is taught not to be high-hatted or up-stage. His first thought is to fit into the scheme of things as they are. The school would believe that it had failed him if he did not. It does not set out to produce what former Mayor Hylan of New York City is reputed to have described as " art artists."

Yet I found in a cluttered basement a young enthusiast from New Jersey, who had come to Philadelphia to become a teacher, had stumbled, almost by accident,

into the sculpture room, and had known, from that moment, as certainly as though he had had direct inspiration from the god Apollo, that here was his life work, here his reason for being on earth. There was not an instant's hesitation. He would live on bread and butter, he would work eighteen hours a day, but come what might a sculptor he would be. Such youngsters, very often with no artistic background to explain them, do crop up, even in the most practical of industrial art schools. Does the drill of such schools hurt them? Perhaps no more than the discipline of the *bottegas* hurt the Florentines.

3

IT IS DIFFICULT to say anything about the Cleveland School of Art without speaking first of Mr. Henry Turner Bailey, a true evangelist of the industrial arts. The school does indeed antedate Mr. Bailey's directorship. It was incorporated in 1882 — some years later than the Massachusetts Art School and the Philadelphia Museum School, and some years earlier than Pratt. This was under the most uninspiring consulate of Chester A. Arthur. Nevertheless some of the citizens of Cleveland craved art even then, though the days of their city's civic grandeur were far ahead. The school took root and survived — survived while Mark Hanna and Tom Johnson, each in his separate way, conferred personality upon the city. Mr. Bailey and the modern note arrived simultaneously at about the end of the World War. Mr. Bailey, like Mr. Farnum in Boston, conceived his task

as a three-fold one, of which the most important phase, as he has confessed, was to " sell the school to Cleveland." It was his theory that no school of the arts can be highly useful unless the community in which it is placed knows it is there. He therefore made a practice from the first of speaking before women's clubs and business men's organizations at every possible opportunity, and of carrying on popular lecture courses. His talks were effective, and it was not long before he became a kind of walking advertisement not only of his institution but of the aesthetic attitude toward life. And as he preached that artistic salvation can be had at not too high a cost he made numerous converts.

But he also accepted the creed of the up-to-date publicity expert that it is of no use to advertise anything not worth advertising. He has made a school in which the fine arts are respected but in which there is also the discipline and practicality of the industrial or commercial art school. Distinguished visiting artists do much to keep up the enthusiasm for the more creative types of work and the more remote rewards. Just as Mr. Bailey has endeavored to sell his school to Cleveland so he has sought to sell his ideals of art to his pupils. It is an honest product, which has its uses and also its beauties. Like the Pennsylvania Museum School the Cleveland School of Art admits students without a high-school certificate, except in the case of the teacher training courses. Intending teachers need this certificate in order to comply with a state law. The school therefore receives at least a minority of girls and boys who have, or think they

have, some artistic talent, but who are short on general education. Except for what they get from their course in the history of the arts they will not emerge much better trained in this respect than they were when they entered. Cleveland may be a little further from solving this problem than are some of the kindred schools in other cities. That is, at Cleveland the student acquires more " art " and less " culture." But are not some technical courses also cultural? And just how cultural is culture " ? These queries are brought forth for what they are worth, and with no idea of fetching a pat answer for them.

The would-be artist at the Cleveland school must work as hard and submit to as severe a discipline as he would at the Massachusetts Art School, at Pratt, or at the Philadelphia Museum School. He pays a fairly large tuition fee — it is $200 a year in the day classes at this writing, and may soon be more — and the management tries to see that he gets his money's worth. He must not be absent from class without good reason. He cannot, without special permission, even leave the room in which he is working. During the first two years he must follow a prescribed curriculum, which is expected to give him a general background in the arts and develop special tastes and capabilities. " The aim," it is specified, " is to train each student intensively for some particular field of work." This does not exclude those branches of the arts which are not primarily commercial. The student may specialize in sculpture, graduate brilliantly, and starve. He may specialize in landscape painting, with

a slightly greater chance of dining upon the proceeds of his vocation. He may specialize in portraiture, in which the art of salesmanship is as important as that of painting. The more practical courses, if one may call them that without making illogical distinctions, are those in illustration, commercial art and decorative design. As yet there has been no systematic attempt to bring the student and the prospective employer together prior to graduation. Nevertheless business men constantly turn to the school when they have odd jobs of an aesthetic nature on hand. Mr. Bailey's students have designed coats of arms; decorated stores and club rooms; made maps, posters and designs for medals and book plates; painted china, and done almost every other kind of artistic chores that can be imagined. Thus they gain experience before they are actually cast adrift in the chilly world of competition.

Cleveland is a coöperative city and the School of Art is no exception to the rule. An arrangement has been made by which a student who wishes to combine a regular college course with a course in the arts may obtain the degree of either Adelbert College or of the College for Women, of Western Reserve University, together with the diploma of the School of Art, by putting in three years at each institution. Not many students have the patience or foresight to do this, but the opportunity remains. The School also has a close connection with the Cleveland Museum, of which more will be said in a later chapter. Mr. Bailey is an educational adviser of the Museum and its children's classes are a recruiting

ground for prospective students of unusual ability. The tendency, probably, will be toward a more careful selection of students, which in turn will be made practicable by the discovery and development of talent whenever it shows itself in public school children. The school system, the Museum, the Art School and even the public library have worked together at this common undertaking. Doubtless there will be more coöperation rather than less as the years go by; and juvenile talent will find its path made straight from the kindergarten to the studio or the designing room. Every school child will carry the Prix de Rome in its lunch box.

I should add that though I have used the masculine gender in speaking of the students in the Cleveland School seventy-five per cent of the attendance is in fact feminine. The men are gaining in numbers, but the superstition that art and masculinity do not go well together still holds sway in Cleveland rather more powerfully than it does farther east. The age of chivalry has not passed upon the banks of the Cuyahoga — nor, as Cleveland's smoking furnaces testify, the age of iron.

This chapter and the preceding ones will have failed in their intention if they have not kept in the reader's mind the central question of what sort of person the American artist ought to be, and what sort of success the schools are having in making him that sort of person. The colleges, as we have seen, have one method, the industrial and commercial art schools another. But there are points at which the two tend to converge. These tendencies are illustrated, to take two convenient

instances already mentioned, in the policies of the University of Pennsylvania and the University of Chicago. From another approach they may profitably be examined in the work being done at the College of Fine Arts of the Carnegie Institute of Technology at Pittsburgh, and of the Chicago Art Institute. These will require a chapter to themselves.

IV

PITTSBURGH AND CHICAGO

I

IF for no more than the fine dramatic contrasts in its history and surroundings one would not want to pass by the College of Fine Arts at the Carnegie Institute of Pittsburgh. Pittsburgh is as vibrant and picturesque as any city in America. But these qualities are incidental to the making and marketing of steel. And steel, though it may furnish subjects or even material for artists, has yet to be aesthetically digested. That will come but in the meantime artists do not, as a rule, work in steel mills, nor go into the steel business. Pittsburgh has been heroic but hard, magnificent but materialistic. In short, it has been a great deal like the rest of industrial America. Could art come out of such an environment? With the encouragement furnished by an endowed school it could and did. And it is at least a plausible theory that in any case the distinctive American art of the future will emerge from unexpected places — out of mills, factories, filling stations, garages, and other milieus that are vulgar, shirt-sleeved and lusto. Art requires gusto; there it may find it.

Originally Mr. Carnegie seems no more to have

contemplated a College of Fine Arts at the Carnegie Institute than Mr. Pratt did at the Pratt Institute. In its early years, as President Baker has said, the Carnegie school " was intended to train workers " — and nothing else. It was " to do a practical work for the young men of Pittsburgh." Mr. Carnegie, like Mr. Pratt, had felt the bitterness of hungering for books and teaching and not being able to get them. He wanted to make the struggle a little easier, or a little more fruitful, for other ambitious young men. This meant, as he saw it, technical training for an industrial job, to which an introduction to the world of ideas should be added when and where possible. The College of Industries, completed in 1906, was first in time and first in Mr. Carnegie's thoughts. The College of Fine Arts did not open its doors until ten years later.

How did the Fine Arts make their way into a school which was meant to be severely practical? The answer is that no one was able to mark out a sharp line between the applied art which is essential to industry and the other kind which at first didn't seem essential. Mechanical drawing had to be taught at Carnegie as it did at Pratt, for there can be no accurate engineering without. Then architecture came in. In one sense architecture, it is hardly necessary to repeat, is engineering. In another it is a fine art — as some suppose, the finest of the arts. The training of architects demands not only mechanical drawing but also most of the rudimentary courses in drawing and painting taught in the usual art school. Sculpture, too, is a logical study for apprentice

architects. But when such courses are offered there will invariably be students who don't care to become architects but who do care to draw and paint. These are received, since the facilities for teaching them exist. But if students of painting and sculpture why not students of music and even of the drama? By being relentlessly logical the Carnegie Institute soon found itself with five arts — painting, drawing, music, and the drama — under the same rooftree.

But this fruit of practical logic was none the less revolutionary. It led, as President Baker said, to " a project which has never been attempted by an American college." The Carnegie school is attempting to do in the arts what the traditional college does in literature, history, mathematics and science. But it turns things around. It tacks the traditional subjects on to the arts instead of the reverse. The students are not allowed to graduate in complete ignorance of the nature and history of the civilization of which the fine and applied arts are but a subdivision. But so far as possible they find their literature and history in the galleries, their science in color and anatomy, and their mathematics in perspective and design. To be able to give the date of Napoleon's birth is not half so important to them as an ability to put life into a painting, or to walk upon the stage in such a manner that the audience instantly knows that they have sunk their own personalities in those of the characters they are portraying.

Whatever the merits of this system in the light of pure educational theory it has the merit of working

admirably. One finds at Carnegie not only that quality of enthusiasm which visits to art schools lead one to expect. One finds not only the usual community of eager youngsters, painting and drawing, working out designs, modeling (though sculptors are few), practicing on musical instruments, rehearsing plays, laying out architectural projects for the Beaux Arts contests. One is aware not only of picturesque groups in lovely corridors between classes, of boys and girls skylarking together like colts in a pasture. There is this and more; there is a quality of balance and sanity, of organized and oriental effort, that is rare in any college or any art school. The architects are the most dignified and aloof, as befits members of a grave and responsible profession, the actors and dramatists most bohemian in manners, as is suitable for those who not many generations ago were legally classed with rogues and vagabonds. But there are common qualities arising from the very nature of the school. And these are not qualities stamped on the student, willy-nilly, as at some West Point of the arts. There is discipline enough, to be sure, but it is self-imposed, not clamped on from above. It is a discipline coming from the student's recognition of the rationality and economy of the educational process.

Carnegie's peculiar stamp is a quality of resourcefulness and adaptability. The Carnegie graduate expects to earn his living by his art, just as does the graduate of Pratt or the Massachusetts Art School. This means that he must begin by convincing some employer that he will be worth, in dollars and cents, more than the

total he receives in wages and wastes in material. He might do this more readily at first if he were carved to fit into an existing job, as he would be at Pratt or at the Museum School in Philadelphia. But the Carnegie Institute believes that in the long run the graduate in arts will be better off if his technique is elementary than if his imagination has atrophied. Its students are supposed to carry ideas and ideals into practical life, not merely to accept those already existing. This may slow them down at the commencement of their careers. It is likely to speed them up after they have attained a proper mixture of experience and enthusiasm.

The enthusiasm is as valuable as the experience, and much rarer. It is perhaps Carnegie's greatest achievement to send its graduates into the world with their ardor undiminished by too stringent a technical education. Not that technique isn't insisted upon. One has only to watch a faculty jury inspecting the six weeks' work of a class in painting, or a dramatic coach putting a cast through its paces, to see that hard and exact work is demanded. Yet this does not frighten students away. During one recent period of five years applications for registration in the College of Fine Arts increased almost exactly twice as fast as those for the Institute as a whole. They might have increased even more rapidly had it not been necessary to increase tuition rates. In this growth the male sex seems to be holding its own. Three times as many girls as boys take music — largely in preparation for teaching — but in painting, drawing and the drama the girls have only a slight lead. Architecture, which is

practically a masculine monopoly, in school and out, evens up the scale. There is nothing effeminate about Carnegie. One hears of tough lads from smoky steel towns up and down the valley who bloom into competent artists. Smoke glows with color, if you look closely enough. A veteran of the A. E. F., chiefly noted for his proficiency as a pugilist (his name wasn't Tunney, however), came to school because he had a government scholarship and had to go somewhere in order to draw the income. He blundered into architecture, milled around uncertainly for a while, then suddenly developed talents which won him the Prix de Rome. His favorite reading, it was said, had been the Police Gazette, but at last reports he was deep in Remy de Gourmont and Walter Pater. It seems natural for these things to happen in Pittsburgh. They lead one to believe that Mr. Carnegie was right in allowing himself to be persuaded, in the course of human events, to try to make it an art center.

Mr. E. Raymond Bossange, a former director, has stated the objectives of the school in terms which apply to its past and present equally well. "Our policy," he pointed out, "differs from that of the usual art school or conservatory of drama or music, for we require a high-school certificate for admission; and our students must devote a considerable part of their time to general studies. In this policy we have been pioneers. We assume that to become a useful artist a man must know history, must be in direct sympathy with at least one other na-

tion through its language, must know something of science and literature, and possess enough general education to have a sympathetic understanding of the meaning of life about him, its problems, ambitions and traditions, and the longing of the people for happiness. Our history courses emphasize the spirit of the different periods, the ambitions and emotions which have influenced art, rather than dates, names and cold records of events. In short we require the general education of a bachelor of arts, as well as the fundamental technical training of the professional artist, before we award our degree. We try to fit our students for the career of an artist by broadening their sympathies and developing their social instincts."

President Baker has been equally explicit in discussing the question of general education. " It is difficult," he declares, " to secure an unbiased opinion as to the amount of such studies as English, history and foreign languages that should be included in the instruction of the artist. Some successful painters maintain that everything should give way to technical drill — that the young painter should devote himself unreservedly during the plastic years to acquiring technique. Others maintain with equal sincerity that the artist should be well educated and well read, and should be able to assume a philosophical point of view with respect to his art. We shall never secure unanimity on this subject. There are successful painters in both camps, but as we call our school of fine arts a college, and as we confer

degrees, we are forced to maintain the collegiate point of view, and insist upon our students having the elements of a liberal education."

The outward effects of this policy, as the visitor sees them, are such that the College of Fine Arts is rather like a College in the morning, when the lecture courses are under way, and rather like an art school in the afternoon. There are classes in the general history of the arts, in the history of the different branches, in the history of literature. The student is subjected to English composition and to at least one modern language. Anatomy and the theory of color give a taste of science, if not a taste for science; and for the architects there are options of chemistry and physics. Disciples of all the arts meet regularly in some of these general courses, and it is hoped that they will receive a perception of the unity of art underneath its protean forms. But the dramatists, the painters, the teachers, the architects and the musicians seem each to flock with their own kind. Each acquires as soon as possible the professional stigmata.

The best teachers in art schools are those who are themselves producers. But they are likely to put the emphasis upon good work in their own fields, irrespective of the nice balance of a general curriculum. No school, therefore, is in more need of an intelligent centralized direction, a continuing policy of what the whole institution should mean and stand for. And this, above almost any other school, is actually the case at Carnegie. Directors have come and gone but the school itself has progressed toward a sane ideal. The union of the colle-

giate and the artistic has not injured its usefulness in either field. Severe " technical tests " exclude students who are palpably not fitted for an artistic career; equally severe achievement and progress tests eliminate those who cannot keep up to the productive mark. There is no such thing as " getting by " — a student must show marked ability or be dropped. " An art school," President Baker has said, " cannot justify itself unless it has as its main purpose the training of creative artists." Carnegie, for all its collegiate atmosphere, lives largely by that motto.

<div align="center">2</div>

IN THINKING of the Chicago Art Institute one is reminded again of the importance of the division of the arts into the fine and the applied. It should be evident that the kind of art to be expected in America will depend upon how these two ingredients are mixed. A former dean of the Institute, Mr. Raymond Ensign, expressed the opinion that the mission of that school was " to pull the conception of the fine arts and the commercial arts together " — to make the commercial arts finer and the fine arts, if not more commercial more practical. In this direction, if anywhere, must lie our approach toward an American Renaissance — the birth of a new national art. For it means that the artist will come out of the most powerful forces of his own time. Such, one feels, is the vision taking form at Chicago.

The Art Institute is, at all events, in a good position to train just such artists. Established almost half a century

ago it set up housekeeping in its present buildings soon after the World's Fair of 1893 and profited by the aesthetic enthusiasms which that great carnival had stirred up. It has ever since been an important institution, both as a school and as an art museum, in one of the most dynamic cities the world has ever seen. It has nursed that aspiring quality which may be as easily developed in commercial Chicago as it was once in commercial Athens and commercial Venice. It has tried to make corn, wheat, hogs, beef, railroads, prairies, skyscrapers and art not absolutely contradictory terms. A thousand miles from the Atlantic seaboard it has grown into one of the largest and certainly the most thoroughly American of the world's art schools. In Chicago one is aware of the pulse of the great plains, and the slow rhythms of the great rivers as well as of the rumble of machinery. The man in the street cannot be said to think much or talk much about these influences. He may feel them just the same. They are the kind of thing that makes the art of one country, or even of one city, different from that of another.

The student in the Art Institute is drawn toward the applied arts by the fact that he lives in a practical community and usually needs a job. But he cannot avoid the influence of the fine arts, for the reason that his workshop is under the same roof with a great museum of fine art. So it happens that in its attitude toward the practical the Institute has taken a place somewhere between Pratt Institute and the College of Fine Arts of Pittsburgh. It does not whittle the student to fit the job as

precisely as Pratt does, but it goes a little further in that direction than Carnegie does. Its courses, excepting those for teachers, cover three years (at this writing) as compared with Carnegie's four, and it is the studies in general " culture," not those in the arts, that are lost in the shuffle. This is not the result of a theory but of a demand. The student does not care for " culture " — or thinks he does not. He has come to the Institute because he wants to be an artist, and he is fiercely impatient of anything that stands in the way of a swift realization of that ambition. This may be a mistake, but it is one he will not discover for himself until long after he leaves the art school. He begrudges the time given to books, or to anything but actual practice with the tools of his chosen profession. There was almost a revolt when a required course in the history and appreciation of art was announced, a year or two ago — though a gifted teacher soon made the subject popular.

Here, too, order and discipline, self-imposed or otherwise, are the rules of the school. They have to be when much must be done in too short a time. They go with the realization of the stern struggle for existence that will follow graduation. In schools where art exists for art's sake — and we shall come to them presently — one may pause to pick daisies; but when art is to be also bread and butter there can be no such digressions. The Institute operates with a minimum of waste motions. All students must attend punctually and regularly or not at all. They must take the same prescribed courses during the first year. The first-year pupil is plumped immediately

into a life class, and there learns a swift method of drawing the nude human form in sweeping curves. Head, torso, thighs, legs, arms — all are resolved into more or less elongated ovals. To his surprise the beginner finds he has drawn a human form. A year of this is said to accomplish as much as two years of the older, rule-of-thumb method. One hears it said that it makes whole classes draw alike, and kills originality. But it may be that it merely teaches a greater number of unoriginal people how to draw.

An art course which seems to have been originated, or at least most highly developed, at the Institute, is called " Research in Nature." The first-year student is taken to the near-by Field Museum, or occasionally to the Zoo, and there allowed to get at the fundamentals of design by studying fishes, insects, birds, animals, ancient pottery, textiles, and so on.

" The principles of structure as discovered in the spiral construction of a shell," as former Dean Ensign said, " the typical growth of a plant, the patterning of a bird's feathers, all prove of inspiration to the student who is seriously building a groundwork for the development of his creative ability. This work is carried on entirely in the spirit of research rather than of sketch problems. In other words, it is not a surface observation of the natural form that is desired, but an intensive study of its structure, leading to a realization of the beauty and orderly scheme of its organization."

In such work the scientific and the aesthetic go hand in hand. Mr. John Wilkins has made a notebook of draw-

ings by his first-year students which impress the layman as nothing short of marvellous. Here were boys and girls of eighteen, or a little more, by no means a rigidly selected group. Yet they had been trained to see accurately and to record beautifully. The first-year student also draws from the cast, but not with the slavish regularity prescribed in the older type of art school. He studies design and composition, colors and still life, lettering and "creative perspective." "Directness of technique is sought," so runs one of the announcements. What this suggests is Pratt Institute or the Pennsylvania Museum School, with a dash of imaginativeness added. The Art Institute seems less handicapped by precedent, readier to throw its teaching into new forms if these can prove their efficacy, than almost any other art school in America. It is not freakish, nor does it attempt experiments for experiment's sake, but, speaking in industrial terms, as one is likely to do in Chicago, it continually adapts its processes to the raw material, and its product to the market. But it does not defer to its market as much as do one or two, at least, of the other practical-minded art schools. It stands in a position of no little authority, in Chicago and in the Middle West generally. It is able to set standards, to determine aesthetic drifts. For this reason it is the more important to note that it has grown toward the practical rather than away from it. Since 1920 it has added departments of printing arts, of costume design and illustration, of advertising design and of drama. But whether it is a woman's frock that is to be planned, a book that is to be bound, or a play that is

to be staged, the student follows the process through from beginning to end. He plans like an artist, but he must also, as his instructors tell him, " get the feel of the tool," like a craftsman. The intention constantly is to show how art runs into craftsmanship and craftsmanship rises into art. The lesson is perhaps not lost, even though more than a third of those who enter drop out before the beginning of the third year, and the majority of the survivors, one may be sure, will never do anything creative in the arts. Creative ability is rare in any vocation. But no one who has ever planned and made with his own hands an honest and craftsmanlike object of any sort will ever be artistically a barbarian. So runs the Institute's creed. It looks upon art as standing on as firm a basis, educationally considered, as any other subject.

Let us take the case of a student who goes to the art school because a friend advises him to, because he thinks the life of an artist a romantic one, or for some other more or less trivial reason. He has sufficient ability and perseverance to survive the three years. Possibly he goes into the department of drawing, painting and illustration. His only literary course is the survey of art, which runs through his first two years. He spends three years in the life class, three years in composition, two years in still life. When he graduates he is offered an opportunity to enter his father's wholesale grocery business, and as he is eager to marry he accepts it. Has his education been wasted? Would he have done better if he had spent three years in the customary college? Of much that

makes up the baggage of a conventionally educated man he is not only ignorant but even unsuspecting. On the other hand he looks upon his environment, very likely, with a more intelligent eye than a full load of Latin, modern languages, literature, mathematics and political economy could have given him. He has been rendered sensitive to the niceties — or lack of niceties — of color, light, shade, form and texture. He has been made literate in the arts. This is not a complete education. But it is an education.

A second case may be that of the youngster who learns the principles of a craft which he may use either as a worker in the shop, as an employer or as a salesman. Thus he may learn the art of printing and book making. He may study interior decoration, either to set up as a decorator or to make himself useful in a furniture store. He — or more likely she in this connection — may take up costume design and costume construction, and this may lead to any one of a dozen different employments. The connection of the courses with the " outlets " in commercial and industrial life is graphically shown in a chart which the Institute hands out to every entering student. The study of painting and illustration may lead to book and magazine illustration, advertising illustration, mural decoration, or lithography. The sculptor has no easy task in making a living, but there is still a place for him, not only as a free lance but in the architect's organization. The students of advertising design may take up not only the usual newspaper and magazine work but also store window display, and what is

euphemistically described as " outdoor publicity." But if there are to be painted billboards they are perhaps the better for having three years of Art Institute training behind them. The emphasis upon " outlets " is unavoidable in a school where most of the students are hard put to it to pay their expenses, where many carry on outside work in order to remain in school at all, and where more than a few save money by going without lunches. And the commercial " outlet " is at least a thing of life. It is a part of the working machinery of the community, endowed not by patrons but by consumers. It is the point at which any improvement in the national taste in things aesthetic must begin to show itself. The necessity for being " practical " may be as much opportunity as handicap.

The importance of whatever the Chicago Art Institute does may be realized from the fact that about one-fifth of all living American artists have studied in its classes. In the past few years the number of its students has nearly doubled, and the number of students in the graduating class has doubled or more than doubled. So, too, has the number of instructors. If the evening and Saturday classes are counted in — and I have omitted them from the present discussion because they are not professional in their purposes — the total enrollment by the time this is printed can hardly be much under three thousand. The proportion of men to women in the day classes is in the neighborhood of three to five. Advertising design is the only subject in which there are consistently more men than women. Yet the latest fig-

ures which I have handy show seventy women and sixty-four men in the third year in drawing, painting and illustration — a more evenly balanced ratio than in any other school I know of. The women, as is usual, nearly monopolize the teacher training courses. These take four years, as against the three necessary for the " practical " courses.

But three years, or four years, is a brief time, with " the life so short, the craft so long to learn." A high-school boy or girl, after putting in the usual length of time in this or any other art school, is not a journeyman in the stern old medieval sense. It is not easy to make even a good carpenter, bricklayer, or garage mechanic in three years. The high-school graduate has only begun to learn, has only commenced to be aware of the difficulties and possibilities of the trade. Years of hard experience are usually necessary before the creative talent is sharpened to a fine point and focused upon a clearly-realized task. The Art Institute now plans to shorten this period by selecting from among its students the few who are greatly gifted and making them into " super-designers." Perhaps there will not be more than half a dozen new students a year in the graduate school of the Industrial Arts. Yet if there had to be twenty directors for each student, thinks Director Robert B. Harshe, it would be worth while to employ them. One need not suppose that there will be literally one hundred and twenty teachers ready to receive an entering class of six. But the animus of the new graduate school is in the phrase. No amount of pains will be too much.

The handful of graduates each year will go into key positions in industrial design. They will be able to affect American taste, through the common objects of everyday life, as only the greatest painters and architects have done in times past. They will be able to create an American type of design, suited to machine production, and reflecting also the American mood and temperament. Behind them will come the lesser designers, as the lesser artists followed Giotto, da Vinci, Rembrandt and Cézanne. Possibly a great movement in the arts cannot be started in this deliberate fashion. But perhaps a movement already started can be directed and kept from frittering itself away. If I were listening for a new note in American art I should not fail to keep an ear cocked in the direction of Chicago.

V

THE ART AND CRAFT OF MUSIC

I

MUSIC is the most abstract, the least representational, and possibly the oldest of the arts. Our ancestors must have made sounds before they made pictures, even before they made weapons or tools, and these sounds were a form of music. The rhythm of the heart beat, of the wind among the trees, of surf on a shore, of the footfall as one walked or ran, must early have entered into consciousness; the songs of birds, cries of animals, rasping and buzzing of insects, rustling leaves, falling water, thunder, and above all the different noises peculiar to humanity made up the first symphonies. Nor is it likely that any modern composer has yet outdone them in cacophany. But because of this antiquity and intimacy music has seemed to be more overladen and shot through with conservatism than any other form of human expression, unless it be religion. In its most important phases, indeed, it early came under the domination of religious influences, and has only recently begun to emerge. Even now, as the pious decorum of a well-trained audience at a symphony audience shows, the supernatural taboo is still felt to be present.

As religion changes more slowly than any other human institution, so music has been restrained by its association with the church. Medieval innovators who introduced such barbarous dissonances as the third and fifth were lucky not to be excommunicated. Originality in music has always been a species of sacrilege. The art attracted the passionate geniuses, but it also attracted, and continues to attract, the plodding and mediocre type of person with a neat, orderly, methodical, mathematical, law-abiding mind. Of such have been multitudes of teachers of music, and such, accordingly, has been much of the practice of music. Even technically a great deal of American music teaching has been bad. In the smaller communities it has often fallen into the hands of amiable widows or maiden ladies whose chief qualification was that they needed the money. There have been conservatories which conserved nothing, except, perhaps, the students' fees. But even in schools which were eminently sound and conducted by teachers of distinction there has been too often a kind of dryness, an atmosphere of the drill-ground, an emphasis upon technique at the expense of the imagination. The worst faults of the academic art schools have been reproduced and even intensified in some of the music schools. The burden of tradition has been made too heavy — much too heavy, certainly, for an age and a country which has every incentive and excuse for breaking out new paths and creating new musical traditions of its own.

I would like to make the point clearer, not by describ-

ing what appears to many people to be an obsolescent variety of musical education, but by touching upon two American music schools which are attempting to teach the art and craft of music with some regard for the future — that is, not statically but dynamically. These are the Eastman School of Music, which is a part of the University of Rochester, at Rochester, New York, and the Curtis School of Music in Philadelphia. They are by no means the only forward-looking music schools in the country, but they do stand out, almost arrogantly, in the forefront of the movement. It is, certainly, their deliberate purpose to flavor the teaching and making of music in America with the salt of originality. They are striving to give us a voice of our own, which shall not be merely an overtone of Europe.

No music school can turn out a great composer or a great performer every week-day morning. But one may hope that these two schools will spread abroad some notion of what it is that makes a musician wish to compose, or, for that matter, an artist wish to paint. For this is a fair summing-up of what the American public most needs to know in the field of the arts. This can be done, I begin to believe, in a businesslike, straightforward, un-temperamental fashion that can be understood by any man or woman who can understand an automobile. Huxley called science organized common sense. There is, it may be suggested, a large element of organized common sense in the arts. It may not be the largest element or the most important element, but it is perhaps the one that can be taught. And there are signs that

the Eastman and Curtis schools are getting rid of much of the traditional mystery and hocus-pocus and attempting to teach this other element. Nor is it strange that the result is inspiring.

2

THE EASTMAN SCHOOL grew out of a conservatory which had been conducted in Rochester for some years on reasonably sound pedagogical grounds but with poor financial success. The artistic budget may or may not have balanced but the money budget assuredly did not. Mr. George Eastman, who had already indulged his love of music by endowing an orchestra, came to the rescue with a gift for a new music school far more ambitious than the old. In fact, so far as physical equipment is concerned — and that is the least of the story — the Eastman school is not excelled. Mr. Eastman's donations, at this writing, including the Eastman theatre, have reached the interesting total of twelve million dollars — surely a fairly broad financial foundation upon which to erect a school of music. The theatre seats thirty-three hundred persons, a smaller auditorium five hundred. There are class-room and studio accommodations for a student body of about two thousand. Through the theatre the school links itself with the community. Motion pictures were inevitable, reasoned Mr. Eastman; accordingly he admitted them to his theatre, taking pains to secure the best. Here may be heard the Rochester Philharmonic Orchestra, which includes

a number of student players; here may be heard, also, one of the largest and best pipe organs in the country; and here the students from the school of the opera have an opportunity to begin their professional training.

But these facilities merely symbolize the school's educational ambitions. America has heretofore imported her leading musicians, and sent abroad most of her native talent to receive the foreign stamp. The Eastman School hopes to put an American stamp upon the best American musicians, an aspiration it shares, as will be seen, with the Curtis School. It accepts both those who expect to become teachers of music and those who will be primarily composers and performers. For its school of the opera it offers scholarships to a number of students whose voices are promising, and who are prepared to do graduate work in music. Such students have an opportunity to sing in operas and operatic sketches in the Eastman theatre. The danger is that musical comedy will pluck them before they are ripe. The opera school is far more important than the actual number of its students — and they are necessarily few — would indicate. They go through a two-year course, which includes not only vocal training and musicianship, but also instruction in the theory and practice of acting, even to the art of making up. If their voices are superb some defects in stagecraft may be tolerated, but on the whole they will be better actors than most opera singers of the not remote past. As soon as they can qualify they are given minor parts in performances of the Rochester

Opera Company, an organization which wins the respect of critics when it invades Broadway.

As a number of recent examples have shown, an exceptional native voice can sometimes win early and generous recognition in present-day America. The lightning of success may strike almost any one of these young singers. One never knows when he is passing a future prima donna. In a bleak little room a girl is rehearsing, with an instructor at the piano. Barring accidents it is certain that her voice will be heard some day in grand opera, in metropolitan concerts, on phonograph records, over the radio. Even those who dare not set their mark so high are influenced by such an atmosphere. A creative and hopeful spirit runs through not only the operatic department but the whole school. The students are expectant as well as gay — they are so exuberant that a notice has to be kept posted to warn them not to slide down the banisters. It is obvious that there is something more here than the dry-as-dust regimentation of the older types of music school. There could not fail to be an inspiring quality in a school directed by Dr. Howard Hanson, who is not only an educator, but also one of the most distinguished of the younger American composers.

Mediocrity must have its chance, if only because there is not enough genius to go round. But to keep out those who can never attain the key and tempo of the school a set of " musical intelligence tests " is now being applied to all candidates for admission. These are the well-known standards worked out by Dr. Carl E. Seashore

of the State University of Iowa, and first employed at Rochester by Dr. Hazel M. Stanton. It is fair to say that many musical educators do not believe these tests reliable; it is also fair to say that the records at Rochester show a close correlation between the student's musical intelligence, as revealed in the entrance examination, and his subsequent standing in the school. There are standard charts which check the sense of pitch, the sense of intensity, the sense of time, the sense of consonance, tonal memory, " auditory imagery," and mental alertness. Unless all of these are above a certain minimum the student is not encouraged to become a professional musician. Musical ability is inherited; some interesting studies are being made, with the aid of the Seashore tests, to determine how. The tests are still in an experimental stage, and are likely to remain there for a long time. But it already seems sure that they will cut down the turnover among the students, reduce the economic waste resulting from attempts to give a musical education to persons who cannot profit by it, and perhaps decrease the number of bad musicians with conservatory certificates at large in the country. At Rochester the tests will probably be applied more severely as time passes, and the students will be more and more a selected group. During the first year or two about one in ten of those who took the examinations were rejected. These were all students who had met the ordinary college entrance requirements, and who had also completed, to the satisfaction of their teachers, a certain amount of elementary work in music. They had come to Rochester

ready to make music their life work, whereas nature clearly intended them to be carpenters, salesmen, milliners, or, at all events, not professional musicians.

Besides a preparatory department the school has two main lines of study — one leading to a degree or certificate and the other limited to a particular branch or instrument. The student may, if he or she wishes, take the degree of the University of Rochester, of which the School of Music is a part. The difference is that the bachelor of arts or bachelor of music degree represents at least the minimum of a cultural education in subjects other than music, whereas the certificate is a record of professional study, and no more. It is interesting to note that within the past few years there has been a striking increase in the number of students who chose to take the cultural subjects, and in the number who registered for the University degree. Even the technical student, however, takes a course in the history and appreciation of music, and another in the history of fine arts as related to music. This is frankly an attempt to give the youthful musician as easily as possible as much culture as he can stand. But the school of music, like the schools of the graphic arts, is still far from success in compelling the technical student to become a broadly educated person — or, as one may put it, in giving him a clear idea of the kind of world in which he lives and in which he must find a market for his music or his skill. It is the prospective teachers of music who are most inclined to take the degree courses, but this, one guesses, is partly for the very practical reason that a degree is now essential

to securing a desirable teaching position. But the train-
ing of teachers is not unimportant, even in a school
which watches the horizon for geniuses. It is the teach-
ers, largely, who will sort out the next generations of
musicians.

The teaching at Rochester has a dynamic and mascu-
line quality not always found in schools of music. The
tendency is toward getting away from written notes
and printed words and teaching the subject orally. The
elementary classes are perhaps drilled more carefully in
what may be called sound-reading than in sight-reading.
Men are, as might be expected in the minority — not
much more than one-fourth of the total registration is
male. Nevertheless the thoroughly masculine man seems
to be coming into the music school as he long ago came
into the art schools. He cannot play baseball or go in for
boxing, for his hands are usually a good share of his
stock in trade, and he cannot risk spoiling them. But he
often excels in jumping and running. If he wishes a
university degree he must take regular courses in physi-
cal education. He does not wear his hair uncommonly
long, nor does he, as a rule, sport a flowing black tie.

The typical girl graduate will teach. The boy graduate
will play in an orchestra, play the organ in a motion pic-
ture theatre or a church, or both, take private pupils,
sing, compose. His opportunities are a little broader
than his sister's, though they may not remain so. But
each will start out with a conception of music that is
unsentimental, virile and scientific. That is Rochester's
trade mark.

3

THE CURTIS SCHOOL, like that at Rochester, owes its existence to an individual's love for the art it teaches. It was established in 1924 under an endowment given by Mary Louise Curtis Bok — an endowment enriched by the giver's own labors and enthusiasm. By its friends it is spoken of as the Johns Hopkins of musical education. It may be too young to have yet earned the name, but its aims, at least, are comparable with those of the great scientific university which did so much to put education in its field on a sound footing in America. In methods it would not be wise to seek so exact a parallel. It is frankly for the gifted pupil, not for the vast army — in whose ranks most of us, alas! are forever included — who give the word mediocrity its meaning. It has chosen the policy, unfashionable in a democracy, of putting quality before quantity.

" The purpose of the Curtis Institute of Music," says its announcement, " is the training and development of students of talent. To this end it offers a faculty of surpassing distinction, comprising artists who are the great masters in the world of music to-day. The sole qualification for entrance is the possession of a native musical gift, of a quality worthy to be taught by such masters. . . . It tries equally to serve students who wish to be concert artists and those who intend to become teachers." The faculty does indeed include the foremost musical names of the day in America. Moreover Curtis's celebrities really teach, and are not, as some cynical per-

sons hinted when the plan was announced, merely a species of still life for window dressing. Naturally, however, they do not devote their time to teaching scales.

" The possession of a native musical gift " is not in practice quite " the sole qualification for entrance." The student must also be musically literate in most cases, and if he wishes to make a serious study of an instrument he must usually have gone pretty far before he enters the Curtis Institute. But unusual ability is encouraged, not only by flexible entrance requirements but also by a number of free scholarships. The newcomer enters a preparatory grade, unless he can qualify for the so-called " Artist Grades," which demand exceptional technical accomplishments or professional experience. Educationally the school is experimental. Musically it is not. The young musician must learn music as a craft before he has an opportunity to use it as an art. Composers may be asked to " defer attempting original composition " until they have attained a degree of competence in harmony and counterpoint; afterwards, and only afterwards, " they will be encouraged to experiment freely in whatever direction they are inclined." If they move in the general direction of fire whistles, tin pans and flat wheels it will not be because of an ignorance of other sound-producing devices; and if they scramble their tempos and pile up their notes like skyscrapers they will be well aware that the dead classicists are turning in their graves.

The force which keeps the student animated is, as the observer soon gathers, personal ambition. The

thirteen-year-old prodigy from England, Russia, Iowa or Palestine is a type. Youth is at a premium, for once the 'teens are passed the flexibility of voice and fingers is often gone, too. For those who can meet the conditions there is every conceivable opportunity. Six pupils in instrumental music, ranging in age from thirteen to eighteen years, were selected in a single recent season to play with the Philadelphia Symphony Orchestra in a concert series. Students' concerts are a matter of course. Once admitted to the school the student will go as far as his or her own ability, health and persistence will carry. There are no artificial obstacles to recognition, no more long struggles to obtain a mere hearing.

It might not be surprising if the Curtis Institute were to offer a scanty menu in the field of general cultural studies. But this is not the case. The academic department is crowded for time, but it does attempt to give " the collegiate background and understanding of cultural values essential to the true development of an artist." This means an elementary and an advanced course in English composition; courses in English literature, the novel, the drama and English poetry; a course in comparative literature; courses in elementary and advanced English diction; courses in the language, diction and literature of French, German and Italian; a historical survey course; a course in psychology; lectures in the history of the art of music; and lectures in the field of comparative arts. Some of these sources are especially adapted to the needs of singers, but no one will deny that they form an excellent background for a lit-

erary education. Quite as obviously, mathematics, economics and science are missing.

The typical graduate of the Curtis Institute will doubtless be more highly individual; less scientific, yet plunged more deeply in technique; more often a performer than a teacher and leader, than the typical graduate of the Eastman School. The Institute frankly bids for genius, and takes its genius where it finds it, from Poland and Rumania as well as from North America. So far it has been less concerned with developing native American talent than with seeking and training talent which will find its future in America — obviously quite a different story. But both schools are working to raise the standard of America's musical competence and taste.

So chaotic is the state of music in this country, and so full is it of elements of originality and gusto which certainly derive from no school, that one hesitates to weigh the importance of these two institutions. With radios, phonographs, motion picture orchestras, pianos and organs, jazz bands and travelling performers who often depend more on personality than on musicianship, music — or " music " — has become almost too common. Of all the arts it has been the most difficult to escape. But if American music is beginning to jell, if recognizable form is again to become a virtue, if the new tradition is to be hooked up with the old, such schools as those at Rochester and at Philadelphia cannot help playing a leading part.

PART THREE

Art as Adventure

I

SAUVE QUI PEUT

I

WE have now made the acquaintance of two types of crusaders who are having a hand in bringing art home to America. One is the college or university professor who sets up standards by which we can tell the difference between good art and bad art, honest art and dishonest art. The other is the sound craftsman who teaches his pupils how to do necessary things beautifully. There is some craftsmanship in culture and some culture in craftsmanship, but so far no one has arrived at an ideal mixture.

There is a third, and very disturbing, element in the situation. This is the man who approaches art as a personal adventure and the schools which minister to his needs. It is he we mean when we speak of artists as temperamental. It is he, if anyone, who is responsible for the popular conception of the painter as a freak with long hair, a pointed beard, a flowing tie, baggy trousers, and morals no board of censorship would endorse. We might find real artists who looked and acted like this if we could turn back the clock a generation or two. They dressed and behaved as they did to show their

independence, and also because, as a result of being independent, they were usually poor. This was particularly the case in France, where, as has been noted, art has been under governmental supervision for nearly three centuries, and where every one who proposed to draw or paint in violation of the established rules was long looked upon almost as a traitor to his country. Painters who defied public opinion by daring to be original were likely to defy it in other ways, including clothes and manners, on the principle that they might as well be hung for a sheep as a lamb. " He was a vicious person," says Professor Mather of Agnolo Bronzino, who died in 1572, " a cold aesthete, with few of the generous virtues that nourish the soul. Yet in his flinty way he was quite perfect and as one of the first professionally unmoral artists he cannot be neglected by the psychological critic." The type has continued to this day, though its viciousness has softened and its unmorality is less conspicuous in this gaily unmoral generation. It is not the purpose of this discussion to prove that artists are or are not at the present time less moral than the rest of us; and especially is there no intention of arguing that some art schools and some methods of art education produce a contempt for the conventions, whereas others do not. But it is true that he who turns his back on groceries to follow a fugitive dream is sometimes indifferent to codes chiefly sanctioned by the desire for a continued supply of groceries. And this is the kind of person who regards art not as a way of earning a living but as a way of life. He is more often found in a certain sort of art school

than in certain other sorts; and so, too, are his imitators and admirers, whose name is legion. He resorts when he can to what are called schools of the fine arts — by which is meant, practically, schools in which art is considered for its own sake and not for its sales value. No disparagement to either side is intended in this definition. The unendowed artist can survive in a money-minded world only if his art does have a sales value. On the other hand it is possible to conceive of a civilization which would not be money-minded, and the creator of the fine arts may be its prophets.

The schools of the fine arts fall into two classifications — those in which there is a progressive curriculum, with a beginning, a middle and an end, and those in which there is not. I shall speak of the latter sort first, since though it does not come first chronologically it does come first logically. It arose out of the romantic revolt against classicism. The older art schools in Europe — by which one chiefly means France — taught not only a way of attaining certain results but also set forth what results were worth attaining. They had a body of doctrine almost as rigid as though it had been adopted by a conclave of the church. They had a vested interest in the traditional ways of doing things. They were consequently unable to distinguish between students who were superbly original and students who merely couldn't draw. Presently, during the generation which followed the Napoleonic wars, there arose a breed of would-be artists who refused to be told what to draw or how to see nature. These upstarts could get

no satisfaction out of the schools, or the schools out of them. So they clubbed together and hired studios in which they could paint and experiment, or they persuaded artists whose work they admired to let them putter about their ateliers. Out of this grew schools of a new sort, informal, modernist, free. Because they were informal they varied among themselves. Some of them thought it impossible to improve upon the venerable practice of having the beginner draw first from the block head and cast and proceed to the living model only after he had acquired a degree of proficiency. But the most characteristic of them left it largely to the student to map out his own education — to study when, where and how he liked, and to be his own best judge of the ingredients he needed to make himself an artist.

This was the policy of *sauve qui peut*, or devil take the hindermost. It was individualism carried to the last extreme. It depended, obviously, upon a somewhat mystical conception of the artist, as one mysteriously endowed who best expressed himself when least interfered with. For those who could not possibly help being artists, who were willing to turn their backs on friends, families and fortunes for art's sake, who were charged with a true creative fury that nothing could defeat, the policy of *sauve qui peut* was probably the best in the world. Magnificent new artistic movements came out of it. Painting ceased to be dignified, respectable and dull; it became colorful, gay, fantastic, insolent. The faults of the new manner were obvious; it not only broke with the academic schools, but it frequently out-

ran all possibilities of popular appreciation. Painting almost ceased to be an understandable language to any but its initiates. These burned candles before it in little rooms and spoke in bated breaths.

There was tragedy also for the apprentice painters, if those who served no masters can be called such. Only a few of us, it appears, are able to educate ourselves. Nine out of ten, or ninety-nine out of a hundred, make a miserable botch of the attempt. The free art school is a place where human wrecks and derelicts are common; where, perhaps, more lives are broken than are made whole. Professor Laird of the University of Pennsylvania, whom I have already quoted, points out three prominent disadvantages of such schools. In the first place the instruction is likely to be unorganized. Teachers boast that they never show their students " how to do things." The classes are likely to be large and heterogeneous, with no fixed standards. Finally, " there is the lack of intimate fellowship with strong men in other lines " — a species of intellectual inbreeding. " The present segregation of art students," thinks Professor Laird, " tends to foster the already hyper-individualistic point of view." Certainly the average student in such schools runs grave danger of spending his years for nothing. But romance is dangerous, and life is dangerous, and perhaps the finest art is the flower of danger.

2

LET US NOW PROCEED to our examples, startling or otherwise. The Art Students' League of New York City

will make a good beginning, for the reason that it goes
further than any other school in America in treating
art as a personal adventure. The League is exactly what
its name implies. It was, and is, in Allen Tucker's words,
" a school made by students, supported by students and
managed by students." It was organized in 1875 by a
group of young artists who desired a little more leeway
than the school of the National Academy of Design was
then, or would be now, willing to furnish them. Thus it
belongs in the same decade with the Massachusetts Art
School, the Pennsylvania Museum School, and the be-
ginning of Norton's teaching at Harvard, not to say the
decade of the scroll saw and the bustle. We shall see a
little later why the young radicals of 1875 felt that
their style was being cramped by the Academy of De-
sign. The Academy, naturally, looked upon the move-
ment as a subversive one. " Our action caused great in-
dignation," says James E. Kelley, one of the founders.
" We were outlawed and they announced we should
never get back without an ample apology." The school
began in a small studio over a piano warehouse, under
a skylight which leaked whenever there was heavy rain.
The sketch classes could not afford models, and the stu-
dents took turns posing. The founders, according to
Tucker, " just made a place where people could come
and study. The student paid for a month or for a year,
and then studied pretty much as he pleased. No attend-
ance was required, no examinations were held, and he
was given no certificate of proficiency. He was left to
come and go, he was his own master, he had no nurse.

The road to art was long and desperate. No one cared if he walked it or not. If he wanted to walk the League held out every possible help, but it was entirely in the hands of the individual what use was made of that help. Therefore a body of students has grown up who really go to school for no other reason on earth than to learn, and they work as people nowhere else work, as men and women work for the sake of really knowing, with no certificate and no reward." The League needs no more eloquent apologia. Most American artists of importance since its founding have been connected with it — Bellows, Twachtman, La Farge, Saint Gaudens, Pennell, Henri, Chase, and many another of less or greater fame.

The League represented a turning from " the careful academic work of the old school," as one early member called it, " to the freedom and enthusiasm " of the new. But its revolt was not so much against a conception of art as against a scheme of art education. The National Academy, it is true, considered either as a school or as an organization of distinguished painters, was not and is not bent upon turning the world of art upside down between lunch and dinner. And one can easily see how an apprentice painter who believes the world would look better upside down or wrong side out, or who would like to invent a new world all his own, may prefer — and might in 1875 have preferred — the Art Students' League. But this doesn't mean that instruction in the League's classes is, or ever has been, predominantly radical. It has been, in the long run, what the students

wished it to be, and has fluctuated with artistic tastes and fashions. Perhaps one in four of the teachers at the present time is ultra-modern. To-morrow it may be one in three or one in five, depending on how rapidly the shock troops of the arts are advancing. The student can be as ultra-modern or as conservative as he pleases. If he likes the past he can consort with it; otherwise he can disregard it.

The League gives preference to its members and former members. Beyond that, and up to the limit of the physical capacity of its quarters, it will admit any well-behaved person who is neither so young as to re-quire a nurse nor so old as to need a guardian. It includes girls of high-school age and grandparents who for the first time in their lives have found leisure to do what they really want to. Sometimes they do quite well, too. It includes society women who prefer art to bridge, or who wish to be able to talk fluently about art between deals. It includes youngsters full of creative fire and fury, earning their own way by some outside occupa-tion, struggling because a blind force within drives them on. There is material for a new *Trilby* or *Vie de Bohême*, though when one has said that he has not fin-ished describing the League.

The organization takes a just pride in never having asked subscriptions or endowments. It has always paid its way out of fees and dues collected from its members. Every student who has worked for three months is eligible for membership, the members elect each year a Board of Control, which must include at least four

students in its nine chairs, and the Board of Control administers the League's affairs without compensation. Order is kept by monitors, and the Board is empowered to " request the resignation of any student, if such a course seems necessary or advisable." Regular attendance and close application to class work are encouraged and expected." A student is expected not to make a nuisance of himself. He is also expected not to take up valuable space unless he works. But this is the extent of the rules. The beginner may sink or swim, live or die, survive or perish, according to what in him is.

Such a school can hardly be said to have a policy, except that of not having one. As the students, through their representatives, elect their own teachers they are taught what they think they need, not what some one else thinks they should have. With solitary qualification the instructor is entirely free to follow his own bent. He is accountable to no president, no academic council, no wealthy alumni. If his classes are too small somebody has made a mistake and he will not long remain on the faculty. If they are too large he will raise the entrance bars. Thus the most respected and feared of the life-class teachers has to sort out the regiments who apply by a series of elimination tests. But a student who fails to get into this man's class one year can take another course and perhaps get in next year. The students remain at the school for a few weeks or months, or for many years — it is no one's duty to ask why. Some study persistently under one or two instructors, endeavoring to wrest their secrets from them. Others shop around, picking up

a little here, a little there. Criticisms are made, as a rule, twice a week. The instructor visits the class room, observes what has been done since his last visit, and gives whatever advice he thinks the individual student needs. The value of these criticisms depends, naturally, upon the teacher's methods and personality. Some teachers are said to give the greater part of their time and attention to a few gifted students, whom they hope to make into artists. The poor and mediocre members of the class, who from the strictly pedagogical point of view need attention most, are often neglected. But this is a defect of the system, inseparable from such virtues as it may have. And a dissatisfied student may always express his disapproval by packing up his paints and brushes and moving into another class — or another school.

The mortality is terrific. One may look at any beginning class and predict with absolute certainty that nine out of ten will never become artists. Some are merely killing time and never intend to follow the arts professionally. Some have ambitions which overleap their abilities. They may achieve proficiency in a minor craft, never in an art. Some plod along indefinitely, unable to make progress beyond a certain point, yet unwilling to give up. The mildly eccentric, the harmlessly rattle-brained, drift in occasionally, as into every independent art school. Perhaps a majority of the failures will have at least gained a wholesome education in the aesthetic point of view. Of the survivors some will compete with the graduates of Pratt and other craft schools in the commercial world. A few will square their sails before

a favoring wind of destiny and travel far. Perhaps they would have traveled far, starting from no matter what school, or from no school at all. The trouble with weighing the merits of schools for genius is that genius carries its own pedagogy around with it; and as for mediocrity, that is something that schools can alleviate, not cure.

Yet unquestionably there are thrills to be had at the League. It is the fashion to work hard and be passionately interested in one's work, just as it is the fashion at many colleges and universities to be passionately interested in anything but one's work. Even the lackadaisical and the indifferent have to pretend to be eager. And despite the variety in ages the atmosphere is one of hopeful youth. In short, the League may not be educational — I do not pretend to judge — but it is, after its fashion, magnificent.

II

THREE ACADEMIES

I

FOR some centuries after Plato walked and talked in the groves of the Academe the word Academy had a pleasant sound in the ears of liberal thinkers. It ceased to do so shortly after the French and English established institutions of art under state patronage and gave them that name. Perhaps the founders of the Art Students' League would not have raised the standard of revolt if the leading conservative art school had not called itself an Academy. But there are academies and academies, some young and staid, some old and hilarious, some treating art as a very practical preparation for life, and some dealing with it as a joyous end in itself. Let us consider three, all of which, I think, may be regarded as approaching art from its idealistic rather than its bread-and-butter side, yet which have few other points in common.

The National Academy of Design, founded in 1825, is thus some fifty years older than the Art Students' League. In several of its traditions it is even older than that, which counts in its favor in some quarters and against it in others. Curiously enough, it was itself the

offspring of a revolt against a still older " New York Academy of the Fine Arts," or " American Academy of Arts." De Witt Clinton was one of the presidents of the earlier organization, and so was John Trumbull, the painter of the Revolution. The secessionists organized the " New York Drawing Association " in November, 1825, and the permanent organization and incorporation of the Academy of Design soon followed, with Samuel Finley Breese Morse as the first president. The Academy soon caught on socially, as any attentive reader of the mid-century chronicles of Manhattan will be aware. Its school as well as its annual exhibitions became metropolitan institutions. It drew to itself naturally the stable and recognized artists of America.

Much water has run under the bridge since Sir Joshua Reynolds was able, amid applause, to lay down the law before the British Royal Academy of 1769 in these terms: " I would chiefly recommend that an implicit obedience to the Rules of Art, as established by the great masters, should be exacted from the young students. That those models which have passed through the approbation of ages should be considered by them as perfect and infallible guides, as subjects for their imitation, not their criticism." None the less the National Academy, though it " believes firmly in the development of individuality," does deny " that such development is helped by the ignoring of the universal heritage, the heritage of graphic manifestation of Man's temperament and impressions." In other words it doesn't kick the Old Masters around merely because they are old.

" It stands for enthusiasm, hard work and for the labor which is inseparable from hard thinking and profound observing," Edwin H. Blashfield said, " and it does not forget Michelangelo's dictum that ' Genius is eternal patience.' Last of all it stands for thoroughness, recognizing the beauty of simplicity, the necessity for simplification, and therein the necessity for thoroughness, since no artist intelligently may leave out of his work what he has not already learned intelligently to put in."

There is certainly enough dynamite in this last observation to fit out a whole army of artists with trench bombs. For, as the critics of this point of view are prone to ask, just what should be, intelligently or otherwise, put into a picture? If the artist puts in all that is possibly there he might as well, they insist, be a photographer — and a good deal better, for that matter. If he puts in only what he sees who is to teach him, for who but himself knows what he sees? But questions like these, ruthlessly pushed, would disintegrate the teaching of art altogether. Practically, it has been agreed by many generations of teachers, a student can be given help in seeing accurately and in recording what he sees. This point of view has been well put by Julius Meier-Graefe. " It is idiotic," he says, " to expect a student to draw and paint from Nature, as idiotic as it would be to set a man who was taking his first lesson in mechanics before a modern steam engine in order to make the elements of the science clear to him. The organs that are to do justice to the complex phenomena of Nature must first be educated; that in Paris this training is still based upon classic

tradition explains to some extent the difference between the French average of artistic proficiency and that of other countries. The Frenchman goes to school to masters who, be they never so Philistine, know something of the principles of teaching. Lecoq de Boisbaudran, in whose school so many modern artists were formed, painted indifferently himself, but the brilliant system of grammar he managed to instil into his pupils was none the less beneficial. In Paris certain definite conceptions are imposed upon the ebullient talents that would prefer to cover large surfaces, regardless of what they represent; they are given the skeleton that must be the substructure, no matter how completely it may disappear under the luxuriant growth of individuality." To the extent that painting is a craft and a science there is nothing more to be said. To the extent that it is something else every one is welcome to his opinions.

The National Academy's school differs from that of the Art Students' League and from most other art schools, of whatever species, in that it makes no tuition charges. The student pays a small matriculation fee at the beginning of each term and there his financial obligation to the school terminates. Naturally there is little difficulty in keeping the student body up to the maximum of five hundred which is all the existing buildings will accommodate. Matriculants must be between fifteen and thirty years old, must be planning to make art their profession, and must either pass a strict entrance examination or produce work which proves their ability. They are admitted only on probation, and are

subject to the control of the governing body of the Na-
tional Academy. If they are beginners they must first
enter a probationary class in drawing from the antique.
Here they work from plaster cast forms and heads. If
they make normal progress they are promoted to " An-
tique in Full," and may then draw from casts of the
torso and full-length figure. Some students emerging
from this regime never want to see a Greek or Roman
statue again. It is a bit like being taught Latin as a prep-
aration for learning French. Finally, as soon as they can
qualify, the students are permitted to enter a life class,
and may then draw and paint heads and figures from
the living model. In the life classes they may choose
their instructors, but having done so must remain in the
same class for the remainder of the term. They cannot
shop around. Special emphasis is laid upon composition
as a means of getting the pupil to do original thinking.
Lecture courses in anatomy and perspective are, of
course, required, and a short series of lectures in the
history of the arts is offered in conjunction with New
York University. The student who wishes to combine
an art course with regular undergraduate work may
take three years at New York University and one year
at the school of the National Academy, receiving a bach-
elor's degree at the end of that time.

A large number of the students — perhaps nearly all
of them — are earning part or all of their living ex-
penses. After graduation — or rather after leaving
school, for there is nothing so formal as graduation —
they must continue to do so, and naturally they hope

to do it through their art. But there are no " practical "
courses, unless etching and mural painting can be called
such. The Academy believes that " continued work in
the regular classes and attendance at the lectures given
is a better preparation for illustrators and commercial
work of high order than special classes would be in these
lines." This, again, is a point concerning which there is
endless discussion. The Academy graduate is certainly
not " fitted to the job." If he enters commercial work
he must undergo an apprenticeship outside the school.
I asked a student if he thought " fine " art and " com-
mercial " art compatible. He was sure they were not, but
he and most of his fellows were choosing commercial
art, to start with, because they had no other choice. They
dream of medals, travels and " one-man shows." But
whether they had more chance of fame than a graduate
of Pratt or Massachusetts Art no one could say. They
probably had a slightly greater chance of starving to
death at the start, or of getting into the salons later on.

The pupil in the Academy school picks up very little
in the way of general culture. Perhaps there is no reason
why he should, since the school does not exist for that
purpose, and several neighboring institutions of higher
learning are available. But he does acquire, in the field
of fine arts, something comparable with the classical
education dispensed by the old-fashioned college. He
lays a foundation upon which a professional career can
be built.

In trying to make a distinction between the at-
mosphere, methods and purposes of the Art Students'

League on the one hand and the school of the National Academy on the other, I trust I have not conveyed the impression of too ferocious a rivalry. The two institutions, unlike the houses of Montagu and Capulet, do not shoot on sight. The copy of the Academy's catalogue which I happen to have on hand carries the names of fourteen instructors and lecturers. Of these five have been connected with the League. A term at the League, a year or so at the National Academy's school, and even a few terms somewhere else, in this country or abroad, are common ingredients in many promising artistic educations. Such sampling uses up much time and causes many false starts. It is excellent, one supposes, for certain types of students and very bad for others. It naturally drives to despair those educators who believe that all education, even education in the fine arts, should be systematic. But despite the shoppers and samplers there is a typical League product and a typical Academy product, whose 'prentice work reveals not only the school but even the instructors under whose influence each has studied.

2

THE NATIONAL ACADEMY OF DESIGN describes itself as " The oldest professional art institution in the United States." The Pennsylvania Academy of the Fine Arts advances the same claim in the same words, although it leaves out the " professional." On the face of it the Pennsylvania organization has the better of the argument. George Washington was still President, veterans

of the Revolutionary war were hale and hearty, with their careers ahead of them, and, in short, it was the year 1791 when Charles Willson Peale, one of America's pioneer crop of artists, decided that the young republic should take steps to be independent artistically as well as politically. He organized an art society which in 1795 held in Independence Hall the first art exhibition ever shown in Philadelphia. This society was known as the Columbianum. Ten years later Peale was one of a number of artists and other distinguished citizens who transformed the Columbianum into the Pennsylvania Academy. The purpose, as expressed in the petition for incorporation, was " to promote the cultivation of the Fine Arts in the United States of America by introducing correct and elegant copies from works of the first Masters in Sculpture and Painting, and by thus facilitating the access to such Standards, and also by occasionally conferring moderate but honorable premiums, and otherwise assisting the Studies and exciting the efforts of the Artists gradually to unfold, enlighten and invigorate the talents of our Countrymen."

Joshua Reynolds himself could have found no flaw in this humility, in which there was no overt mention of an artistic Bunker Hill or Yorktown. The Academy had, and has, every right to be conservative. But it is conservative in a way different from that of its sister academy in New York City. It charges a tuition fee, which the National Academy does not, and it is inclined to leave it to the student to get, or not to get, his money's worth of education, as he sees fit. In fact the

students at the Pennsylvania Academy are almost as free
to succeed or fail as are those of the Art Students'
League, which is certainly saying a great deal. There are,
it is true, certain conditions for admission and promo-
tion. An applicant must be at least sixteen years old and
must have graduated from " the highest grade of the
grammar schools." A high-school education is advised
but not required. The student must prove by his work
that he is qualified to enter the school, or to enter an
advanced class. He must reach proficiency in drawing
from the antique before he is allowed to draw from life.
Similarly the young sculptor must begin by copying
from the Greek or Roman model. These two classes —
Life and the Antique — are the heart of this, as they
are of every school of the fine arts which pays any def-
erence whatever to tradition. From them ramify the
other subjects — composition, still life, costume sketch-
ing, mural decoration, illustration, and, of course, the
inevitable anatomy and perspective.

The student will ordinarily take such of these latter
courses as seem necessary to his progress, and as promo-
tion depends upon a vote of the faculty, his teachers
do have a control over his choice of studies. But this
control is loosely held. One reads in the catalogue that
" the individuality of the student is not repressed by
fixed methods." Certainly there need be no " implicit
obedience to the Rules of Art " unless the pupil is tem-
peramentally so inclined. During most of his school
career he can browse almost as he likes, on such pastur-
age as he can find. His fate will depend partly on the

instructors under whom he happens to study, but more on his own efforts. He is urged but not compelled to attend his classes, and is spurred on by the hope of praise, prizes and scholarships, of which there are a great many, or by the inborn yearning to draw, paint or model, instead of by a system of grades and sheepskins. The school is loosely organized, with perhaps as little intercourse between the faculty and the lay board of trustees as takes place in the ordinary university — that is to say, very little, indeed. The list of instructors contains, and always has contained, famous names representing almost all shades of artistic opinion. A few lean toward classicism, for the Academy tries to give a balanced diet. More are for leaving the young brush to find its own way — if it can. If it can't — well, there are always plenty of would-be artists.

Some teachers at the Academy think that even now the gifted student, whom they care most about, is not free enough. " An artist should spend a good deal of time by himself," said one of them. " He must be lonely. He shouldn't hold himself to a schedule. It would do many of our students good if they would drop out for a few weeks now and then, and go off by themselves to paint and think." Some do this very thing. Usually they are the purposeful ones, who are fortunate enough, school or no school, to know exactly what they want out of art and out of life. They develop individuality. One is likely to hear from them, later on. This is one side of the picture. It is such a pleasant one that one almost hates to mention the other. However, it does bring up the

question raised by Professor Laird. I recur to it because it is the most important question we have to consider — it is, indeed, the fundamental question, not only with respect to art education but also with regard to the place of the arts in American life. It is the problem of just what an artist is and just what his relations with the rest of us should be. It is generally conceded that a student at such a school as that of the Pennsylvania Academy can master the technique of drawing, painting and modeling. Not that he always does, but he can. He may also acquire ideals about art and learn the artist's way of looking at life. But is this all he needs? Many would say no with Professor Laird. Modern life, they would remind us, is tremendously varied and complicated. Moreover, it is magically different from life as it was lived ten, twenty or thirty years ago. Like Alice in *Through the Looking-Glass* one has to run very fast to keep up with the scenery. If an artist is to interpret modern America he should know something about it — something more, that is, than can be obtained by a merely casual inspection. But at the Philadelphia Academy, at the Art Students' League and too many other art schools, it is insisted, he doesn't learn about life, he learns about art.

He may remain ignorant of even the rudiments of information regarding the world in which he lives — of history, literature, science, politics. He may associate largely with art students who have his own tastes and limitations, and so miss the wholesome give and take of more diversified circles. He may shut himself up in a

little art universe all by itself, away from the swirl and
flow of life, like a Trappist, and there offer up perfunc-
tory prayers for the artistic salvation of a public which
he despises. He won't understand the public and the
public won't understand him, which is bad for the pub-
lic, bad for the artist, and possibly even bad for art. For
the work of the artist (I am still summing up an argu-
ment not necessarily my own but one which one fre-
quently hears) ought to be just as necessary, just as un-
derstandable and in a way just as commonplace as that
of the farmer, carpenter and tailor. He ought to be
friendly and human first, then artistic. But the older-
fashioned art schools, it is said, haven't made him so.
Is this Philistinism? But Philistinism is partly a product
of the failure of the artist to make himself understood,
just as religious fundamentalism is partly a product of
the failure of the scientist.

It would be a pity if this discussion lessened any read-
er's sense of the glamor and romance of schools of the
fine arts. Here come scores of young people, to whom
the thought of art and the artist's life has proved allur-
ing. Some are drifters. Some are pathetically mistaken.
Some of the girls are merely filling in time until they
are ready to get married. The majority will drop out in a
year or two. Art is not for them. For those who remain
the struggle will be long and desperate, and there will
be casualties all along the line of march. A scattering
will earn their livings as illustrators or designers. A hand-
ful may succeed as portrait or landscape painters. Once
or twice in a generation a genius will appear — and if

the school helps him, even to the extent of teaching him how to mix his paints or clean his brushes, it may have justified the grief, the cost, the waste of what is admittedly a haphazard scheme of education.

3

THE AMERICAN ACADEMY in Rome is at once the youngest and the most venerable of our Academies, the most thoroughly committed to classicism and also the most completely American. For it is attempting, in a methodical, businesslike, well-organized way, to Americanize the aesthetic traditions of Greece and Italy. It seeks to capture, not a casual Blue Boy or Cleopatra's Needle, but the essence of a culture. It is on foreign soil, it is addicted to archeology, it believes in evolution rather than revolution, yet it is as thoroughly native as a Ford car.

The American Academy is obviously modeled upon the Academies in Rome which have been established by various governments, beginning with the French, in 1661, under Louis the magnificent. As the American government — perhaps fortunately — has refused to have anything to do with art, except as it can be attached to, or inserted in, the federal buildings, our own enterprise had to be privately organized and financed. Here, again, we come upon the trail of Charles Eliot Norton, if so Western a word may be used with respect to so Eastern a man. Mr. Norton, in 1879, founded the Archeological Institute of America, and the Institute

in turn founded first the American School of Classical Studies in Athens, and later the American School of Classical Studies in Rome. An American School of Architecture had been founded in Rome in 1894, and in 1905 this was reorganized as the American Academy in Rome. Finally, in 1913, the Academy and the School of Classical Studies joined forces. In this way the literary as well as the artistic and archeological specialists were brought together. The tradition of Norton was linked with that of such men as Abbey, Blashfield, La Farge, Saint Gaudens and McKim. The Academy was to be a graduate school, primarily for competitively selected students who were to spend three years in Rome on scholarship funds intended to meet all their necessary expenses. It was hoped to bring the best of classicism to America by enlisting the most promising young artists, architects, musicians and scholars who could be found and then exposing these elected few to a kind of benevolent artistic malaria, if it is not irreverent to refer in this way to the classical remains of Greece and Rome. The scholarships have been eagerly sought and have been held by a number of young people of both sexes who have later distinguished themselves. Perhaps the Academy would not attract the wilder sort of genius, for it makes conditions and imposes a discipline. But it does attract highly gifted men and women.

The Academy is clearly conscious of what it is trying to do. It believes, in the first place, that " in the arts of classic antiquity and their derivatives, down to and including the major Renaissance period, are contained

189

the fundamental principles upon which all great art so far known and proven is based." It believes " that nobody can afford to depart from tradition and great example who has not first learned them; that freedom can never be born of ignorance nor high performance of slovenly mind or hand; that the field to which the Academy limits its students is so vast, so richly fruitful, as to give all needful scope to the student in the matter of design, and that the three years of residence should be exclusively devoted to the study of that field." " Therefore," it concludes, " we have made rules in accordance with our belief and expressive of our policy. It is the duty of every Fellow to become fully aware of the policy and to accept it as a governing law without further question. . . . Then when they have satisfactorily completed their course and are in a position to choose their ways of expression because that choice is grounded upon essential knowledge, let them elect as they will the manner in which they shall contribute to the civilization of their country."

If this seems to any prospective student too much like spending three years in a gilt and marble jail the Academy is not for him. If he bows the knee and is accepted he finds himself not so much in the position of a pupil in a school as of an apprentice who is permitted to undertake creative work in a prescribed field under a supervision kind but firm. He must become thoroughly familiar with the history and monuments of Rome, and with the Italian language. He must keep notebooks and sketchbooks. He must do some traveling each year,

under the direction of his professor and of the director of the School. He must make a particular study of some special task or object in his field. Finally, he must do a definite amount of original creative work. A sculptor, for example, must execute in his third year " a group of not less than two figures in the round of not less than one-half life size . . . in a rectangular space not to exceed one hundred and twenty cubic feet." A painter, in his second and third years, must design and complete " a decorative painting in an architectural setting, with at least three figures." A musician must produce an oratorio, choral symphony or opera, suitable for public performance. There is no ambiguity about these requirements. They leave the student some time for browsing, however. It is realized that the classical manner cannot be decanted into a young man or woman like so much mathematics. But the browsing is never irresponsible. If the student wishes to go and lie in the sun under an olive tree he must somehow reconcile that impulse with the main purpose of his stay in Rome; he must take his notebook or his sketchbook along.

But the characteristic, and most thoroughly American, trait of the Academy is its stress upon team work. " The architect, the painter, the sculptor," the School believes, " if each is to reach his highest expression, must work all together, mind to mind and hand to hand, not as separate units fortuitously assembled, but as an intimately interwoven and mutually comprehending team — as men worked in every great age of the past to make great works of art." It is a regular practice

191

to assign problems upon which an architect, a sculptor, a painter and a landscape architect can coöperate. This problem is treated " as a work combining, as essential parts, all the elements of architecture, sculpture, painting and landscape architecture, rather than merely as a problem of architecture to be eventually set, carved and painted upon." The teams compete and their work is judged at the end of a six-weeks' period. It seems likely that men and women who have done this sort of thing in their student days will be tempted to try it in their mature professional work. The idea, obviously, is independent of the classical flavor given it by the Academy. The modernist as well as the classicist can use team work to good advantage. Though the modernist who is really an aesthetic anarchist might find the necessity of collaborating with such atavistic realities as architectural strains and stresses a little too much for his temperament.

Though the program of the School may seem frigid and rigid, as programs are likely to do, the reality is human and genial enough. " Not merely Fellowships but fellowship," wrote Grant La Farge, as secretary of the Academy, " constant discussion and criticism of each other's different lines of work; talks about how to tackle the collaborative problems set for them; a painter illustrating his ideas by modeling a figure; architects, painters, sculptors, historians, and archeologists going about together to see works of art. An architect designs and executes a fine decorative relief in color; a sculptor makes such drawings of the minute detail of classic or-

nament as the best architectural draughtsman would be proud of; a painter discovers the wonderful picturesqueness and interest of ancient Cretan costume, and so goes to Crete, works as an archeologist, makes all sorts of notes, collects all sorts of objects, and then embarks upon a huge mural figure-painting, in which he brings back to life this extraordinary newly-discovered past. They go together to Greece and all over Italy — it is human and real and vital, and, what is more, it is pregnant with possibilities for the development of beauty in American art, of capacity to handle in a masterly way the tremendous problems that this growing country has in store, beyond any present conception."

The ideal outruns mere individuality. The eccentric and original genius will take care of itself without an Academy. What the Academy plans and foreshadows is not a few more paintings, to be added ultimately to museum collections, but a disciplined attack upon the needless ugliness of America's material life, a joint effort to express broadly and architecturally, in classic terms but modern idiom, something essentially American. With such a task even a classical Academy may some day become dynamic.

III

COMMUNITY ARTS

I

THE adventure of art need not be either a personal gratification nor the private property of a professional school. It can also be an exploit in which an entire community shares. There are probably not many neighborhoods, even in money-grubbing, holy-rolling America, whose inhabitants will not enjoy and even attempt to create objects of fine art if they are shown how. On first glance this statement may seem to run contrary to the conspicuously available evidence. It is easy to convince people that a Russian, an Italian or a French peasant has somehow a deep appreciation of the aesthetic, but it is almost impossible to make anyone believe that the same thing can possibly be true of an American farmer or mechanic. We have, or at least our principal spokesmen have, a profound humility in this matter. Yet the truth may be, not so much that we are as a nation hopelessly lost to the finer and more delicate perceptions, as that the experiment has not often enough been tried. Wherever it has been tried the results have been sufficiently striking to make the sceptics pause. The hunger for something better than our national life has

yet offered us certainly exists. It is perhaps only the proper diet that has been lacking. Obviously it is impossible to produce in a few pages evidence enough to establish such a thesis. The best that can be done is to suggest a theory and illustrate it with two or three pertinent instances. I shall begin with two successful attempts on a small scale before taking up a third which has become fairly familiar — the Community Arts Association at Santa Barbara, California.

A landscape painter from New Orleans set up his easel one day in a lonesome spot in central Louisiana. Two farmers came along and stopped to chat. They eyed the canvas for some moments. Then one of them cleared his throat.

" We're painters, too," he said.

In their way they were. They had never seen an original painting, but they had decided — on just what stimulus didn't clearly appear — that they wanted to make pictures. So they had ordered materials from a mail order house in Chicago and gone to work. The results, as the New Orleans artist later found out, were not without originality. Not being sufficiently sophisticated these backwoodsmen avoided the faults of insincerity and dishonesty. But the point of the story is that, infantile though their products may have been, they really did, in a remote region which had not had any artistic traditions since the Civil War, and perhaps none prior to the war, have a hankering for self-expression. It might be worth while to give such people a chance to learn what art is for and what it has to offer them. An

entire rural community can hardly be sent to Chicago, much less to Rome, for a three-years' course in classical antiquities, down to and including the High Renaissance. But it can be made aware of certain elementary standards in aesthetics about as easily as in hygiene.

It was in a Louisiana neighborhood, Natchitoches, on the Cane river, that two young Southern women several years ago decided to make just such an experiment. Their names were Gladys Breazeale and Irma Sompayrac. They began by building a log cabin on a beautiful rise of land on an ancient Creole plantation. Old Natchitoches is proud — and rightly so, for its permanent settlement antedates that of New Orleans. It was not, however, what could be called an art center. But its citizens turned to and helped, if not with gifts of money, then with materials and personal services. Carpenters gave their labor, merchants donated from their stock, and Uncle Remus, who could remember the Civil War, took pride in being allowed to cut the weeds. Perhaps he remembered, there was an art in Africa once. The school opened and began to grow, without endowment enough to run a coffee stand. Most of the students came from Louisiana. A few drifted in from Mississippi, Texas, Arkansas, Alabama, and Chicago. Would-be artists come from the most unlikely places. They sometimes sprout side by side with sheeted chapters of the Ku Klux Klan. Like Topsy they have no father and no mother, they just grow. The Natchitoches colony will never rival the Chicago Art Institute, but it soon had

several dozen summer students. Because it shows what might be done elsewhere let us look at it for a moment.

The regular term was for five weeks in the spring, though artists could and did come to paint all the year round — or at least during the season between October and the end of July when the weather is not what a Louisianan would call hot. Students were accepted for as short a time as two weeks. Tuition was thirty dollars for five weeks or fifteen dollars for the shorter period. Some of those who came were professionals, or pupils in metropolitan art schools hunting for a new and stimulating experience. Others were amateurs whose household cares or business preoccupations made it impossible for them to put in more than a few weeks in the year. They were what the French call " Sunday painters." They were of all ages. Most worked under instructors. A few wandered off and painted to their hearts' content, all by themselves. Landscape painting and composition were feature courses, and there were classes also in drawing, painting and design. The amateurs got as much fun out of the adventure as did the professionals, though the amateur works of art that resulted were not what one would expect to find in a Fifth avenue exhibition. They were marked, necessarily, by enthusiasm rather than professional finish. Indeed, Natchitoches has proceeded on the belief that there are a number of things more important in life and art than professional finish. It defends the first clause in the layman's artistic bill of rights — the right to draw. It first encourages its students to make pictures. Then it teaches them to

make as good pictures as they can. Its objects, admittedly, have to be cultural rather than technical. It will not, except by accident, create artists. But it is imparting not only to its handful of pupils but to a whole neighborhood something of the zest and flavor of art. Natchitoches knows by this time that fine art isn't necessarily up in the clouds. It may be a second or third cousin, once removed, of something one's grandmother, sister or uncle does, after a fashion, with paints and crayons.

Besides this the region is waking up to such aesthetic appeal as there is in its own topography. It is beginning to see the possibilities of art in nature and to cultivate a local patriotism based on something more respectable than tourist trade and real estate values. This is important for Natchitoches. If the idea spread it might also be important for larger areas. For art thrives on differences. As no two feet of soil are identical there might some day be an artistic vernacular of Louisiana, and a different one of North Dakota, and a still different one of California. This interesting possibility would be strengthened if it were realized that an " Art Colony " is as easy to start as a golf club and as much fun when started. For one doesn't feel the heavy-footed tread of a Cause or a Movement at Natchitoches. The enterprise has its ideals, but its success, in its modest field, is due to the quite human reason that it shows people a new way to have a good time.

2

CATHERINE STREET is decidedly not Philadelphia's prize
thoroughfare. Residence there does not, and never did,
entitle one to admission to the city's inmost social cir-
cles. There are portions of it that are distinctly sus-
ceptible of improvement in almost every way imagi-
nable. And in a block which is neither Catherine street's
best, nor its worst, one comes upon a churchly-looking
building which is no longer a church at all, but Mr.
Samuel Fleisher's Graphic Sketch Club. Mr. Fleisher's
surroundings are as different from those of rural Louisi-
ana as anything could be. His methods and purposes are
also somewhat different from those of Miss Breazeale
and Miss Sompayrac. He has combined the gospel ac-
cording to Cézanne with that according to Jane Addams
and Lillian Wald. In short, he has created what might
be called an artistic community house; he has fostered
art, not for art's sake but for humanity's sake. This is
probably a mistake. All that makes one doubt that it is
a mistake is that it has, after its fashion, worked very
well.

Mr. Fleisher began about a generation ago, in what
would certainly be called a slum, with a small class
of boys. He seems to have thought that these youngsters
would get more good out of learning to draw than out
of what they might learn in an equivalent length of time
on the streets. The class was held at night, as the Graphic
Sketch classes mostly are, because the members were
at school or at work during the daylight hours. Soon

there was a demand for a class for girls, and since that time the club has been coeducational. It grew rapidly. It grew until what had been a hobby with Mr. Fleisher became a lifework. Some years ago he bought a church which was about to be abandoned and turned it, with the parish house next door into an artistic sanctuary — Sanctuary, in fact, is the word he still applied to what used to be the church. The altar is still there.

The club membership has passed two thousand, with an average nightly attendance of more than five hundred. There is no tuition fee, beyond a small payment for the services of a model in the life classes. Anyone may join and nearly every kind of person does. No discrimination is made for or against any age, race, religion, or social position. The students may come on foot in broken shoes, or they may roll up in limousines. It doesn't matter. Nobody cares. This is literally true. Snobbish people, rich or poor, don't come; or if they do they are either cured or they shrivel up the first night. French, Germans, Poles, Irish, Italians, Russians, Scandinavians, Negroes, Chinese and Japanese, as well as unclassified Americans, have been on the class lists. So, too, have all occupations as well as no occupations at all. They come not only from Catherine street but from all parts of Philadelphia. Each must register and answer a few questions, but there are no other formalities.

" If a man came off the street, drunk, and asked to be allowed to draw," says Mr. Fleisher, " we'd let him, so long as he was able to sit up decently and hold a crayon.

We'd do it on the theory that he would be better off here than in any other place he would be likely to go to."

This heroic attitude is not often put to the test, though Mr. Fleisher is fond of telling how he has exposed his collections of pictures and objects of art, some of the latter valuable, fragile, and easy to carry off, to the toughest waifs who could be found in Philadelphia. Once a small silver crucifix was stolen — nothing else. Something in the atmosphere of the place quiets rowdiness. Nothing is ever broken. There is no unnecessary noise. Whether this is due to a personality or to a principle the visitor cannot be sure. As anyone who wishes can join the club and work in almost any class there is little uniformity in the class groups. The classes include a few students who are intellectually below par, but who are not made to feel discouraged on that account. These are allowed to keep on because Mr. Fleisher believes that even a sub-normal person is better off if he has been subjected to a tranquilizing influence. But the Club has also attracted many students of marked ability, who would hardly have found an opportunity anywhere else. In the first quarter century of its existence it sent fifty-eight on scholarships into the Pennsylvania Academy of Fine Arts. Of these thirty-four went abroad on scholarships won in competition at the Academy and one attained the Prix de Rome. During my own visit to the Club I met a successful artist, now living in New York City, who got his start by working all day as a stock clerk in a Philadelphia department store and attending classes at the Sketch Club at night.

All this should be enough to indicate that the Club is a school as well as a settlement house. Its courses are carefully planned, and include the elements of a beginner's art training — drawing from the antique, sketching, illustration, drawing from life, portraiture, and modeling. There are classes also in etching and in costume design, and there is a class in rhythmic expression, or dancing. Painting has to be left out, except for certain classes on Saturdays and on Sunday afternoons, owing to the difficulty of judging color accurately by artificial light. This is a problem all evening art classes have to deal with. In some schools it has been met by the use of specially-designed electric lights which are said to give true color values.

Mr. Fleisher's achievement obviously falls into two divisions. First he has provided a social life which undoubtedly has changed for the better the lives of hundreds of boys and girls. He might have done this with only an incidental reference to the fine arts. But the use of the arts in his club is not an accidental thing. He sees in it a release of a natural instinct to use one's hand constructively, as bringing the element of successful effort into young existences which consist mainly of frustrations and unfulfilled desires. Perhaps this accounts for the tranquillity of the Graphic Sketch Club's atmosphere — a tranquillity which has led one or two Philadelphia physicians to send nervous cases there to recuperate. In most night schools the students are visibly struggling against the burden of fatigue. In the Graphic Sketch Club they are not, though most of them

have been working in stores, offices or factories all day. There is no sense of strain. For nearly all art seems an exquisite game; for the few it is life itself.

" There is no full and proper realization," Mr. Fleisher has said in summing up his philosophy, " that art is a democratic thing. People use the term ' art ' in a way that makes the average person feel as though it meant valuable paintings or sculpture. And yet we cannot say precisely what art is, where it begins or where it ends, or even whether it has any beginning. Art is something that will cause a girl to put a flower in her hair. It is what prompted a child to invite me to come to the court of her tenement because, at a certain time of day, the sunlight fell so beautifully aslant the pavement there. This impulse and appreciation of beauty must have a name, and by whatever name you call it, it is a part of art and as definite a thing as painting."

Almost everyone, given a chance to know what art is, does want a taste of it, at least. At any rate one begins to believe so after looking at such enterprises as this in Philadelphia, or the Art Colony at Natchitoches. Yet one feels the necessity for a note of caution. Mr. Fleisher believes that the fine arts have a moral value, that if a child is sufficiently exposed to them " the grosser emotions will be crushed out." It may be observed that this is harking back, after a fashion, to the doctrines of Charles Eliot Norton, although what Professor Norton would be disposed to define as a gentleman, somewhat set apart from the mob, Mr. Fleisher would describe as a good citizen and examplar of democracy. But it is

not certain that we can safely put art and morality into the same pigeon-hole in the Twentieth Century in America; for if we did, we might soon have art enforced by federal statute and ugliness bootlegged, smuggled and sought after by all truly independent spirits. It may be sounder to hold that art is self-justifying, just as morality supposedly is. But the Graphic Sketch Club has earned its right to honor on either score. Leaving all morality aside it has rescued at least one or two creative artists from an environment which was stifling them.

3

SANTA BARBARA, CALIFORNIA, has little in common with either Natchitoches or Catherine street. Once it was a Spanish town; friars at the Mission tended their vineyards, their olive trees and their fields of wheat; caballeros rode with jingling spurs into the patio de la Guerras; guitars were heard at night, torches flamed, there was dancing. In the name of progress the American pioneers labored to extinguish this glowing, colorful life, first by fire and sword, then by deadlier but less bloody devices. They brought in their own unspeakable architecture, with high roofs designed to shed snow in a country which rarely knows a heavy frost. They reared mansard roofs, cupolas, bay windows, front porches with little pillars scattered about, like fat women's legs. They imported terrible clothes from Boston and New York. In short, they tried to build up, by the western sea, in a land of thrilling color and heart-breaking romance,

under the shadow of Grecian mountains, where every tree cried out for a legend and every hillside whispered of dryads, an imitation of New England and the Middle West at their grayest and sorriest. Then, after two generations had devoted themselves to wreaking this havoc, a third generation conceived the idea of undoing it. An earthquake, which shook down not only old walls but various old ideas, strengthened this revulsion. Amid such throes the Community Arts Association of Santa Barbara took shape and grew. And within this association there were active not alone certain modern American conceptions of the proper place of the fine arts in a community, but also the more evasive influence of dead and gone Spanish pioneers, lonely exiles from their native land, who had practiced here the finest of all the arts — the art of living. The passing of years and men has lent this dead civilization glamor, and much dirt, ignorance, corruption and misgovernment has been conveniently forgotten. But how much there was behind the casual observation of Richard Henry Dana, in 1835: " A common bullock driver, on horseback, delivering a message, seemed to speak like an ambassador at a royal audience! "

When Santa Barbara began its revival of the arts, therefore, it imported a good deal from Chicago, New York and Paris, but it also strove to rescue a little that was native. The beginnings were modest and spontaneous, though they were doubtless expedited by the fact that Santa Barbara had many citizens who possessed more wealth and leisure than they quite knew what to

do with. First came a small art school. The modern artist tends to be more and more careless of his environment, since he does not conceive it to be his duty to copy what nature has already satisfactorily created. But Santa Barbara appeared to all laymen and to some artists as an excellent spot in which to practice painting. There was color, intrinsically not superior to that of Minnesota or Arkansas, yet different. So people did come to Santa Barbara to paint landscapes, just as many went to Carmel and Monterey. In 1920 a group of amateurs assembled, as amateurs have been doing since the days of the Miracle Plays, to put on a drama. The affair was so successful and the players enjoyed it so much that they continued their organization. Persons from the art school had helped with the play, and it seemed natural for the dramatic club and the art school to join forces. An old adobe house was secured, and here art classes were conducted and preliminary rehearsals for the plays held. Soon the drama section had a professional director and was giving plays every month. A small orchestra had been gotten together, and when this was combined with the art section and the drama section the Community Arts Association came into vigorous being. By 1922 the enterprise had shown such promise that the Carnegie Corporation made it an annual grant with which it might continue to grow and experiment.

" The direct purpose of the gift," said Dr. Henry Pritchett, at that time President of the Corporation, " was to aid in establishing an association whose work would make for a wider appreciation of beauty on the

one hand and for a trained and technical skill on the other. The trustees of the Corporation believe that the accomplishment of these two objects could not fail to contribute to the usefulness and the happiness of the inhabitants not only of this city and of this region but of the country; and that a demonstration of a coöperative community arts association in one community would be both stimulating and helpful to the same cause in other communities."

The public has become accustomed to the conception of health demonstration areas, within which some benevolent foundation coöperates with the local authorities in applying to all within reach all that is known about the laws of physical well-being. The result is invariably a decrease in the death and morbidity rates. The expectation is that a community which has once known what modern health measures are will not thereafter willingly forego them, even at the expense of a few extra pennies a year in taxation; and that other communities will be moved to follow suit. The art demonstration area, if it may be called that, is similarly motivated. The connection is not so remote as it may seem. If better health prolongs life better art makes the additional years more desirable. But a community art enterprise has another justification. It is, as I believe Dr. Pritchett has said, the only thoroughly democratic community activity. Santa Barbara, like every other city, is divided by political, economic, religious and racial cleavages, and by social distinctions resulting therefrom. Topsy-turvy as these things are, not even the California species of reformer

has yet been able to abolish them. But the Community Arts Association cuts across all such lines. It has enlisted, if not the whole community, at least representatives of every group and class in town. When it produces plays, women from the plutocratic suburb of Montecito come down to sew and gossip beside the women who do housework by the day — and all give their services freely. There may be certain embarrassments and condescensions, but they are not the conspicuous features. The cast of one drama a year or two ago included an insurance agent, a student, four salesmen, two teachers, two newspapermen, an author, a carpenter, a housewife, a laborer and a retired merchant. No other organization, except possibly a jury panel, could have brought them together on such easy and democratic terms.

Just what effect the earthquake of June 29, 1925, had on the Community Arts Association is doubtful. The Association was prospering without this terrific object lesson, and in a material way it was badly set back by the damage done. But the disaster, by removing a number of buildings which had been eye-sores, brought about a swift improvement in the physical appearance of the city. For several months an architectural board of review, sponsored by the Association, actually had legal power to pass on plans for new buildings in the business district. Even after this benevolent dictatorship ended the Association was able to do much to impose a harmonious and attractive style of architecture on the city. The new Santa Barbara is dominantly in the Spanish tradition; but what is more to the point is that

it is consciously and intelligently in any tradition at all.
A distinction should be made between Santa Barbara's
Spanish and the whited sepulchres that often masquer-
ade as Spanish in the modernized portions of California.
And for this distinction the Community Arts Associa-
tion should have much of the credit.

Of late the Association has been vending its product
to the people of Santa Barbara in ways which may or
may not be dignified but which are certainly effective.
It addresses open letters " to the thinking citizens of the
community " and takes a full page in the local news-
papers to publish them.

" Some people," so ran one of these advertisements,
" shy at the word ' arts ' as though it meant ' arson ' or
' child murder.' Others act as though it ran ozone a close
second as a necessity to bare existence. There's a grain
of truth in both attitudes, but the whole truth lies be-
tween the two. If ' art ' means a painting that the artist
and his friends rave about but that no one else can make
head or tail of, then ' art ' is nobody's business. But if
there's art in a Saturday Evening Post cover or a Ches-
terfield ad that gives the man in the street a thrill he
can't explain then ' art ' can be in a man's language
without his being ashamed of it." From certain points
of view this sort of appeal is barbarous, it is Billy-
Sundayism in the field of art. But it makes converts.

The advertisement went on to point out a number
of miscellaneous and significant facts about the Arts
Association's work — to wit, that the Association was
then spending as much as $150,000 in Santa Barbara in

a single year; that seven thousand people came to the first three dramatic productions in a recent season; that the Plans and Planting Committee's book of small house designs has carried the name of Santa Barbara in a peculiarly pleasant way all over America; and that if New York city had as many art students in proportion to her population as Santa Barbara has they would amount to a grand total of forty-two thousand. It is obvious that there is an appeal here to the citizen who is thinking in terms of real estate, tourist travel and retail trade as well as to him who lives upon a more ethereal fare. The sensitive soul shrinks. Must the arts summon the aid of drum and calliope? Well, in America perhaps they must. When breakfast foods are sold by ballyhoo the food of the gods may have to be distributed by the same means, or not at all.

The Santa Barbara School of the Arts, being a subsidiary of the Community Arts Association, must necessarily be all things to all men and all women. Its avowed purposes are " to provide instruction for students intending to follow a professional career, students who desire to develop their own interest and talent in a particular branch of art, and others who wish to advance the organization in the community of music, drama and the fine arts." If it is to be of immediate service to the townspeople it must have classes which are open to amateurs. If it is to attain the rank among art schools to which its directors naturally aspire, it must have high professional standards. To meet both these demands on a limited expenditure and with a total registration of

between two hundred and fifty and three hundred students has not been easy. Yet, partly because Santa Barbara has natural advantages which make it possible to attract creative men as teachers, a successful beginning has been made.

The terms of admission to classes or courses are elastic, but are generally conditioned upon the pupil's ability to profit by the work. There is a fairly high tuition fee for those taking a full course, though this by no means pays the cost of instruction. High-school students may secure credit for work done at the art school, and older students may be credited at the Santa Barbara State Teachers' College or at various collegiate institutions. It is thus made practicable for a boy or girl living in Santa Barbara to fit much more than the usual amount of art into his or her secondary training. For those who cannot afford the fees, and who show marked ability, there are scholarships. No really gifted boy or girl in Santa Barbara will be denied the chance to attend the art school. Some, with sufficient energy and ambition, earn their way by outside employment. The serious student has a chance to do serious work. There are, of course, life classes — the heart of all professional art schools. There is a landscape painting and sketching class, as there should be in so paintable a region as that around Santa Barbara. There is a class in etching and another in woodblock printing. Sculptors who wish to cast small pieces in bronze are able to follow the process through. They may also model from life and from the antique. There is a class in design, illustrated by its application to

posters, window cards and advertisements. There are elementary classes in drawing and painting for children, and more advanced ones for older students who are not yet ready for the life classes. An outdoor class draws and paints flowers and plants " for the study of proportion, poise, form of growth, and contour." There are lectures in architecture and students who are qualified to do so work out the Beaux-Arts problems. Thus one may find on the school's registration lists at almost any time children in the elementary grades, high-school and normal-school students, professional students of the arts, women who are following out a hobby or filling out leisure moments in a decorative way, and home owners who wish practical instruction in landscape gardening to help them in solving their own problems.

Side by side with the courses in the graphic arts there are being developed classes in music, in drama and in dancing. Music students may enter the Community Arts Chorus, which gives two varied recitals a year, in addition to an annual performance of Handel's " Messiah." The director of the Community Arts Players supervises classes in stage technique, and the members of these classes have an opportunity to take part in plays put on by the Association. Classes in the ballet have also been offered. There seems no reason why a well-rounded school of the arts may not grow out of what already exists under the Association's roof. Despite some flourishing art departments and art schools the Pacific Coast has yet to find itself in the field of art education. There is no institution which does for the Coast what the

Chicago Art Institute does for the Middle West. Geographically San Francisco might be the ideal location for such a school; and that gorgeous city already possesses, in the California School of Fine Arts, a vigorously-managed, modernistically-tinged institution which may yet fill the need. Los Angeles, with its wealth, its large leisured class and its vaulting cultural ambitions, might contest the title. But it is also possible that Santa Barbara might essay the rôle of Florence in a California renaissance.

The success of the Santa Barbara enterprise will mainly come, however, in sticking to the original idea of a community undertaking, a social adventure. Its professional artists are likely to be a by-product of raising the level of artistic appreciation in Santa Barbara's own dooryard; of better houses, better gardens, better-looking streets, a richer, more gracious life. Given these attributes a community will probably not suffer from a dearth of creative talent; for it is in this kind of soil that creative talent seems to grow best. There, at least, is free play for an experiment which will determine whether wealth, leisure, an extraordinarily picturesque environment, and an honest desire for cultural adventure will, in fact, produce fine art.

4

NATCHITOCHES, Catherine street and Santa Barbara have this in common, that each testifies to a demand for a species of aesthetic provender not commonly supplied

in the United States. Differ though the three communities may in almost every other conceivable fashion, they share an instinct, rudimentary though it may be, toward self-expression. This is by no means the same urge which gave birth to Lyceums and Chautauquas, to women's study clubs and specially conducted tours, to five-foot shelves and cultural correspondence courses. In all these the learner was essentially passive. He or she might learn something about art but not attempt to create any. But in our effervescent generation this is no longer enough. Rank amateurs, long after they have put away other childish things, have clung to the unspeakable delights of picture-making; some of them, too old to play with mud pies any longer, have taken up modeling; and they have been encouraged in these subversive tastes by a new species of art teacher who asked if it were not as sensible to learn to draw correctly as it is to learn to write correctly. This, be it noted, is an echo of the question which Walter Smith was asking in Massachusetts in the early eighteen-seventies.

In discussing the several types of professional art schools I have said relatively little concerning the evening classes which nearly all of them maintain. The reason was that evening classes do not take the place of day classes in professional art training. A course which might be completed in three or four years by students registered for a full day curriculum may very well require ten or twelve years for a night student. The consequence is that no one ever does acquire a complete professional training solely by attending evening

classes. It is true that men have managed to be successful artists with no other formal training, but this feat has also been accomplished by men with no formal training at all. Night art school students fall into two general groups. In one are those who come to the evening classes to supplement an art education they have already acquired, or who are trying their hands before venturing on the day course. There are a number of crafts which may be studied as well in the evening as at any other hour, though no evening class has quite the energy or the enthusiasm which the same class would have shown from seven to twelve hours earlier in the day. In the second group are the tasters, the experimenters, those who make art a hobby or an avocation. And the connection between the main subject of this chapter — the community adventure in the arts — and the work of the night schools is just this, that this group in the night schools is the same as that to which community art enterprises appeal.

An elderly dentist and his wife have raised several children, who are now safely off their hands. In their access of leisure they plan a trip abroad. They wish to go to the galleries and it occurs to them that they will understand pictures better if they study picture-making. One finds them in an evening life class, drawing from the nude in charcoal. " I'm a natural-born artist," says a business man, past middle age. " I've never had time to paint. Now I've got time and I'm going to do it." A young butcher by day is an art student at night. Three brothers are sign painters. One of them is

interested in the higher possibilities of paint; at five in the afternoon he takes off his overalls and at eight in the evening puts on a smock. A group of busy physicians meet, almost furtively, and employ an artist to teach them the rudiments of sketching in water color, from which, perhaps, they go on to oils. Why not? There is no law to forbid. The Academy of Medicine in New York city holds a creditable exhibition of painting done by medical men. A banker or lawyer makes a recreation of the study of art, preferring it to golf. For ten or fifteen years he attends evening school regularly, working in a life class. The proprietor of a well-known restaurant in a certain city contrives to make his establishment a favorite resort for artists. This gradually awakens in him the desire to be an artist himself, he takes lessons, and finally, in his early fifties, is painting portraits which are not half bad. An elderly lady watches her granddaughter painting in oils. " I think," she remarks, " I could do that myself." She tries, and the results, after a few months, are actually good enough to exhibit. A mother in the middle thirties sends her children off to school, and for some reason tries her hand at modeling. Her first work shows rare native ability.

Naturally it is the acquisition of an unexpected proficiency that gives the thrill to amateur art work. One finds that the gap between himself and the professional artist, while wide enough, is not the chasm between two worlds. It is a little like discovering, late in life, that one can sing — not as well as Caruso, not even so well as the leader of the church choir, but still in recognizable

tune. In most cases one's tastes outrun one's perform-
ances — at any rate it is to be hoped they will. But in
the meantime a new delight has been revealed, that of
seeing things as the artist sees them — which means,
perhaps, seeing them for the first time in one's life as
they actually are. This new adventure of seeing is the
amateur's greatest exploit. The adventure of the fine
arts may not lie primarily in any canvas, mural, statue
or building. It may consist of a greater awareness of life,
a more vigorous response to an environment. And an
increasing interest in the creative processes may testify
to the nation's virility as did the settlement of the old
West — these may be the covered wagons of a new
national culture whose caravans are already on the
march.

In the concluding two sections of this book I shall dis-
cuss two other institutions by means of which the aes-
thetic impulses of present-day America are being
mobilized. These are the museum of art and the non-
commercial theatre. No treatment of the American
approach to the arts, or of American education in the
arts, would be complete without at least a brief con-
sideration of them. Occasionally, as we have seen is
the case at the Chicago Art Institute, a museum, an
art school and a theatre may be found under the same
roof. This may foreshadow a new institution, quite
American in its genius for synthesis, which will co-
ordinate the community's aesthetic activities. The time
may come when we shall have an artistic Community
Chest. Does the individualist recoil in horror? Personally,

I do. But it is the American spirit, the American destiny that is to blame, if blame there be — the America of Whitman, America thronging more and more into cities, building subways, setting up skyscrapers, listening by millions to the same jazz orchestras, in short, America en masse. But if the essential spirit of creative art survives, then Natchitoches, Santa Barbara, Chicago, New York, will still smack of their private and peculiar square miles of soil.

I

THE METROPOLITAN

I

WHAT may be called the attic or garret instinct
seems to be deeply embedded in human nature.
In its earliest forms it arises from a tendency to preserve
even the unlikeliest objects against a time of need. No
sooner does a tribe establish a semi-permanent camp
than it begins to accumulate relics of one sort and an-
other. At first these may have a religious efficacy. After
a while the historical or time sense may develop. As
Oswald Spengler believes, the Egyptians had this sense,
whereas the Greeks did not. The pyramids and the tombs
in the Valley of the Kings were after their fashion mu-
seums of historical antiquities, and there were libraries
in Nineveh in what are for us almost pre-historic times.
As religion is instinctively past-loving temples and cathe-
drals invariably had something of the museum about
them. In the more glorious periods they particularly
tended to become museums of art, with this advantage
over most modern museums that sooner or later the
compulsion of custom brought almost everyone in the
community within their doors. The vanity of kings and
nobles led early to the preservation of effigies and

counterfeits of the illustrious dead, and so there was a beginning of private or semi-public galleries. Palaces themselves readily become a species of museum. When the State takes a hand in the arts there are state museums of the arts; and when the industrial era produces its new regiments of rich men, many of whom build lavishly and collect fabulously, the privately-endowed museum is inevitable. In a humbler way the attic instinct manifests itself in the preservation of old furniture, old clothes and old knick-knacks generally, as is the custom in New England. This, too, contributes directly to the modern museum, as the collections in the American Wing of the Metropolitan Museum of Art in New York City abundantly testify. Time lends value to what was once thought rubbish, just as it makes rubbish of what was once thought valuable.

The Metropolitan Museum runs back to the dim antiquity of the eighteen-seventies — that pregnant but awful decade which saw the beginning of so many cultural movements in America. It was, in fact, incorporated on April 13, 1870, " to encourage and develop the study of the fine arts and the application of the arts to manufacture and practical life, to advance the general knowledge of kindred subjects, and to furnish popular instruction and recreation." William Cullen Bryant, George William Curtis, Joseph Choate, Frederick Law Olmsted and other eminent citizens whose names meant much to their own generation, however little they may mean to ours, were among the founders. Henry Marquand, father of Allen Marquand, of whom something

was said in our chapter on Princeton's art department, was an official of the museum from 1871 to 1902. The list of trustees from 1870 on is like a roster of the conspicuously public-spirited citizens of New York City.

But whatever its announced objects the museum was at first a pretty formidable institution. It offered privileges to the public, but these were, after all, privileges; it was not realized that the public would make next to no use of museum facilities unless they were as effectually advertised as drygoods or theatrical performances. The accumulation of material went on efficiently but the material once accumulated tended to gather dust. In this respect the Metropolitan was very much like every other museum then existing in the world. The ideal was primarily to preserve, secondarily to exhibit. Museums were for posterity — which meant, practically speaking, that they were for people who never had been born and never would be. A curator was exactly what the word implies. He was not by any chance a teacher.

The use of the Metropolitan as an institution for the teaching of art developed slowly. The first museum lectures were given in 1872. Coöperation with the public schools began in 1905. A lending collection of lantern slides was assembled in 1907, and in the following year the first museum instructor was appointed. Henry W. Kent, the first Supervisor of Museum Instruction, began his work in 1907. As a practical policy the modern conception of the museum's function is therefore hardly more than two decades old. Meanwhile other museums

were swinging into line with dynamic modern theories. Boston, Cleveland, Minneapolis, Detroit, Philadelphia, St. Louis, Buffalo — the list is too long to give, and a volume would not do it justice. The museums took to themselves a definite share in public education. Through them and from them began to run threads which connected them with the colleges, the professional art schools, the high schools and the elementary schools, finally, even with the merchants and manufacturers. The word museum, with all its former implications, is now hopelessly out of date. The museum has become a people's university.

2

THE METROPOLITAN's contact with its public begins with the children of the elementary schools. The children come first, perhaps, for a story hour, on a Saturday or Sunday afternoon. Next they come in classes and during school hours for " Picture Study." The museum is, of course, more than aesthetic — an Egyptian mummy, for example, does not come strictly under the head of fine art — and classes in history and geography find material illustrating their studies. But much stress is put upon the pictures and other objects of art, and sooner or later the pupil is encouraged to make drawings of his own. At least one New York high school held an exhibition of drawings and designs, all of which had been suggested or inspired by things seen at the Museum. Classes in oral English at the same school were regaled with lectures on Museum material, with Museum lan-

tern slides, delivered by pupils. Occasionally small exhibitions of students' work are held at the Museum itself.

It might be possible to teach fine arts in such a way that after leaving school the student would never willingly enter a museum again, just as some schoolmasters succeed in eliminating certain literary classics from their pupils' reading, definitely and forever. But museum teaching is still fresh and unburdened with traditions. The range of material is so wide that the study of it cannot easily become stereotyped. It is first-hand stuff, such as our bookish schools cannot provide outside their scientific laboratories. The story of human culture is visible in statues, paintings, pottery, prints, armor, coins, furniture, textiles. The student learns to make his own judgments. " It is surprising," says Huger Elliott, who has directed the Museum's educational work, " how often the child's selection will correspond closely to that of our most eminent critics. The adult, with his ' complexes ' and his ' inhibitions,' is rarely so simple and so sure." The work with children is cumulative, and shows itself in an increased and increasingly intelligent museum attendance. Children who have come as part of their school work are likely to return voluntarily, and often they bring their parents. An artistically literate population may be produced in the course of time. This is not to underestimate the hugeness of the task. There are more than nine hundred thousand school children in New York city and the total annual attendance for a typical recent year was not more than a third greater.

However, the Museum's educational services cannot be measured by the turnstiles. Some of the most important of its functions operate outside the building and even outside the city. The institution sends out for wide circulation lantern slides, photographs, color prints and traveling exhibitions of paintings. These, as Mr. Elliot says, " are in constant use by teachers, clubs, and other organizations all over the Eastern section of the United States. The photographs, color prints and facsimile etchings — of a size suitable for exhibition — are used by schools, clubs, libraries and hospitals. Schools borrow the duplicate textiles, the Japanese prints, the maps and charts, while through the coöperation of the American Federation of Arts sets of the facsimile etchings and of paintings from the Museum collections are circulated throughout the country."

But this is not the most striking of the Museum's extramural services. Since 1922 the institution has been not only distributing but also making its own motion picture films. One film shows the ruined temples, statues and carvings of ancient Egypt. Another has characters shown wearing medieval armor. Still another, enacted by a company of players headed by Edith Wynne Mathison and Charles Rann Kennedy, illustrated the mythology of ancient Greece. A fourth had to do with an incident in colonial life, with the American Wing as a background. Miss Maude Adams, assisted by Robert J. Flaherty, directed the production of a film showing a potter's shop. The possibilities are endless. Mr. Elliott makes the comment that " Quiet contemplation of a

thing of beauty would seem to be the keynote of aesthetic enjoyment, and with this the motion picture has little in common." The observation is a tempting one, for it opens up the whole question of the manner in which a generation which is certainly neither quiet nor contemplative is to take hold of the arts. But the Museum has chosen the practical course. It has appealed to its audience in a language which that audience can understand. The result is to increase the number of those who are interested in what may be seen inside the museums, and in this case the end doubtless justifies the means. And it might also be argued that a noteworthy motion picture, whether produced by the Metropolitan or by a corporation in Culver City, is an actual contribution to the art of the age. We may be pretty sure that da Vinci would have dabbled in the technique of the film if it had been known to him, just as he dabbled in almost everything; and very likely there were other artists of the robust decades of the Renaissance who would have seen an opportunity in the new medium.

3

THE SAME practicality marks the Museum's approach to the industrial and mercantile applications of the arts. This began with lectures for salespeople in 1914, an exhibit of industrial art was held in 1917 to show what the museum had to offer in the way of suggestions for design, and an " Associate in Industrial Arts " was appointed in 1918. The industrial exhibit became a yearly affair. Until 1923 the articles shown had to be

derived from museum research. Since then the only condition has been that they be good designs, made under plant conditions. " Yet," as Richard Bach, the Associate in Industrial Arts, has said, " though no single piece may show Museum influence or betray a trace of originals here, the list of exhibitors consists of none but regular students of the collections. And in the group of seven hundred and sixty-four objects, the work of more than twenty firms, shown in the last exhibition, no small portion owed their success directly to Museum sources and all registered in some degree the favorable effect wrought by the Museum contacts of their designers. For to them the study of the collections, not for the specific purpose of an order in hand but for its tonic value, has become second nature."

It is difficult for a layman to understand exactly what the difference is between copying an attractive design, perhaps from a suit of medieval armor, and reproducing the spirit rather than the design itself. It may not help matters to say that the first process requires about as much acumen and good taste as may be found in an adding machine, whereas the second is creative. But there seems to be, behind each design which has been good enough to survive the ages — and a surprising number of the common elements of modern patterns have survived hundreds and even thousands of years — a characteristic way of thinking and seeing. And this way of thinking and seeing contains two elements, one that is peculiar to a given time and environment, and

one that is merely peculiar to human nature. The modern designer's problem is to get at the eternal human that is concealed behind the medieval or Grecian or Egyptian exterior, and to add to it the proper seasoning of his own day and his own personality. Another element enters — that of material. A good designer will not clap directly upon silk a design that was created to be expressed in Toledo steel. The material, wood, fabric or metal, has an accent of its own, which must be made audible. All this should help to explain why it is that patterns for which the Museum collections should have credit are not always recognizably derived; it is a wise design that knows its own parent. But this is but another way of saying that good design will bear the mark of its century, whether that is the sixteenth or the twentieth. One could complicate the discussion further by pointing out that from the artist's point of view — or perhaps one should qualify by saying from some artists' points of view — there is an " idea " behind the pigmentation and patterning of a butterfly's wing, a fish's scales, a flower, or a longitudinal section of a sea shell; and the idea can never be measured by ruler and calipers. It may be enough, however, to say that the Metropolitan Museum sees creative possibilities in machine design.

The exhibitions of industrial art accept the machine frankly on its own terms as a means of indefinite duplication. The more perfect the machine the more nearly will all its products be alike. There is none of the " individuality " to be found in objects made by hand. But what was this individuality in the days of handicraft?

Mr. Bach, whom I have quoted above, will tell you that it was proof of human failure, not of human expertness. The craftsman's pots were all different because, try as he might, he could not make them all alike. An element in our enjoyment of them is the thoroughly human, thoroughly un-aesthetic pleasure of possessing something that other persons haven't got and can't get.

It will be clear that this phase of the Museum's policy is closely allied with the theories actuating such institutions as the Massachusetts Art School and the school of the Pennsylvania Museum. It might be summed up as an effort to perpetuate an ancient artistic tradition through a new medium, to incorporate the machine in the fabric of aesthetic culture, to demonstrate and utilize the continuity of the arts. Good industrial design does more than that. It makes available to the many what in the best days of handicraft could be had only by the few. Millions of Americans are groping toward higher standards of living. If they are given the opportunity they will accept higher standards of taste. To some extent they have already done so. And taste formed on sound industrial design is by no means hostile to an appreciation of " fine " arts. An eye accustomed to simplicity and harmony in houses, furniture, and clothing is already half-trained for the finest galleries.

But good design is wasted unless the public will demand it in preference to bad design. Here, perhaps, one needs to have faith that good design is good because it meets some need in human nature, and that in the long run it will always drive out bad design. However, the

public is being so continually educated in what is bad and tasteless that a counter-offensive has been found necessary. I have told of Mr. Farnum's course in retail merchandising at the Massachusetts Art School. The Metropolitan has undertaken, less formally, a similar course, though this is mainly intended to train not retail salespeople but the buyers who select the goods carried by retail stores. A number of New York stores send members of their staffs to school at the Museum on the employers' time. The work consists of a series of lectures and demonstrations. The theory is taught, then its application to the immediate object — the clothing, furniture, china, or whatever illustrative material may be picked up in the stores. Next, if the design is a good one, it is traced to the Museum collections, or compared or contrasted with them. Thus the student gets an idea of the continuity of the fundamental principles involved. There are classes in design, too, for teachers of all grades, from kindergarten to college, for women in the home, and for children. In all of these full use is made of the museum collections as a basis for the formation of taste. Taste emerges from such courses, not as a set of phrases or memorized color combinations, but as a perception of what humanity, by a long process of trial and error, has found acceptable. If a woman learns to shudder at the stuffiness of a Victorian parlor it is for stated reasons and not because Victorianism happens for the moment to be under a cloud.

It is, of course, impossible to convey in a few pages an adequate notion of what the Metropolitan Museum

has meant and is coming to mean in the life of New York city. Its development has been symbolical of that of the city itself. It began with a certain austerity and exclusiveness. Its backers formed the four hundred of metropolitan benevolence. Its architectural and its cultural aspects were equally dignified and for the humbler sort of citizen probably equally alarming. A frigid conservatism might easily have overtaken it. It is but fair to say that in its attitude toward the newer American art it is, in fact, accused of being frigidly conservative — a charge which happily is not pertinent to this discussion. But in its attitude toward the industrial arts it is not merely progressive, it is literally futuristic.

Yet one is inclined to believe that the career of the Metropolitan as an educational institution, or as an educational nexus or ganglion for many institutions, is merely beginning. In serving individuals, public schools, colleges, universities, study clubs, stores, factories and other organizations it tends to become a kind of cultural clearing-house. It follows the national inclination to centralize and combine several functions under one management. It is partly public, since it receives aid from the city of New York, and partly private, since it depends upon endowments, loans and gifts. It is a storehouse of great individual works of art, and has paid fabulous sums for pictures of corresponding worth and notoriety. But it may be that its most important achievement will be to play a large part in developing an American type of design, and of course in helping to provide a public capable of appreciating such design.

II

CHICAGO AGAIN

I

I HAVE already spoken of the art school of the Chicago Institute. But the school is only a part of the Institute; or rather the Institute is a school in a larger sense. It has been made so deliberately, even at the expense of what other museums have often considered more important uses of funds. " The policy of most museums," as Director Robert B. Harshe has said, " is to spend money on acquisitions. The income of the Art Institute is spent largely in service to the community. As a result of this policy the Art Institute ranks about eighth among American museums, considered from the point of view of its ability to purchase works of art in the open market." The question of a nice balance between acquisitions and service is obviously a difficult one. But educational service is the growing point of a modern museum. It is the test of the museum's viability, and one which the Art Institute, quite as much as the Metropolitan, has met superbly. The Institute has, of course, the advantage of being able to delegate to its art school all its strictly professional teaching, and thus confining its museum instruction to the layman — or, as more frequently happens, to the laywoman.

The simplest form of art teaching is the lecture course. Those at the Art Institute usually consist of twelve lessons, which cost, let us say, from one-third to one-half the price of a seat at a matinee. These are illustrated by lantern slides and reproductions and of course by tours through the museum. Any one may enter, no outside reading is required, and a ticket which admits to any class will admit to any other. No one is under an obligation to learn any more than he or she wishes. The success of a particular course depends to a great extent upon the personality and enthusiasm of the teacher, and it is for personality and enthusiasm that the teachers of museum courses at the Institute seem to be chosen. In addition they are among the busiest persons in an extraordinarily busy city. Four kinds of classes for adults are listed. These include the courses in art history and art appreciation; evening courses for those who cannot come during the day; " special short courses given by the curators of the different departments on their special subjects "; and " classes in sketching and painting for non-professionals, for those who have the desire to ' try to paint,' though their talent may be slight, and who for various reasons are unable to attend regularly the professional school." The courses in history and appreciation need scarcely be described. They cover as much ground as can be covered in a short space of time. Their educational value may be questioned, just as may the educational value of all lecture courses, Chautauquas, lyceums and similar devices for instilling knowledge painlessly. But they probably do

predispose their hearers to a greater tolerance for the arts. Similar in their objects, though less systematic, are the promenade lectures for which clubs or other groups may arrange; classes from colleges or schools may study the collections under the guidance of members of the museum staff; and individuals may arrange for private lessons in art appreciation. Persons who have taken this instruction are apt to talk more intelligently about art and to look at pictures with greater understanding. By these means the Institute builds up its public and adds to the number of its subscribers. The leaven of aesthetic appreciation works undramatically but there are signs that it works.

There are also general lectures, which are free to members and may be taken individually or in series. A typical program began with a series of talks on home building and decoration, under the direction of the Architects' Small House Service Bureau. There were discussions of " Color Symbolism and Influence," " Color Harmonies," " Color Schemes for the Living-room," " Color Schemes for the Bedrooms," and finally, " Personality and the Home." Under the heading of " The Art of To-day " were talks on American architecture, sculpture and painting; on the art of Spain, France, Italy, Hungary, Sweden, Norway and England; and on " What Goes into a Picture," " What to Look for in a Picture," " How Artists Have Worked through the Ages," and " Nationality in Art." For children from six to sixteen there were Saturday afternoon lectures in which story-telling and seasonal interests were skillfully

exploited. A child might find the adventures of Renaissance artists quite as thrilling as those of Richard the Lion-Hearted, even though in deference to tender years certain episodes might have to be left out. Ninety per cent of what passes for history is dull compared with such a subject as " The French Artists Who Painted in the Forest of Fontainbleu." Then there was talks on cartoons, on " Snow Pictures and How to Make Them," on Easter cards, on the art of batik, on flower painting. It would be an unimaginative child who would not be fascinated by such themes. Any one who has ever watched the usual uninstructed holiday crowd tiptoeing and whispering through the galleries of an art museum will be aware of the value of teaching like this, if continued long enough and extended broadly enough. The merest inkling of what an artist is trying to do and why he tries to do it will double and treble and quadruple the pleasure the ordinary man gets out of easel paintings. It may even make a visit to an art gallery as enlivening as a visit to a motion picture theatre. But the earlier the age at which the art of appreciation is taught the better, because the less self-consciously will it be practiced.

2

THE LECTURES just mentioned do not exhaust the Museum's program for children. There are regular gallery tours for boys and girls, usually from the eighth grade of the public schools, under the supervision of an instructor appointed by the Board of Education. They

come only once as a class but they are encouraged to come as often as they will individually. There are similar gallery tours for children from suburban schools, but in this case the Museum furnishes an instructor and makes a nominal charge. Then there are special classes from private schools and from the high schools, who come to round out their text-book studies by some contact with originals.

Finally, there is the Children's Museum, established in 1924. In this room are given Saturday morning talks to which any child is welcomed, and there are exhibits of varying kinds in which it is thought children will be especially interested. Much is made of the so-called " process cases," in which the steps in the making of objects of art or utility are graphically shown. One such exhibit illustrated the technique of wood carving, of ivory carving, of two methods of using enamel, and of water-color painting. Even an adult finds this almost as fascinating as a circus. Each step in the process, as well as each tool employed, is shown. To illustrate the making of a cloisonné vase twelve small vases were shown, together with the necessary wire ribbons, tubes of enamel, instruments and polishing stones. In the instance of the water-color the artist made six drawings to show how the idea was elaborated. A color chart, with the proper technical names, was added. If the child's curiosity is thus excited pamphlets, pictures, diagrams and bibliographies are at his disposal. It is difficult to overestimate the possibilities in demonstrations of this kind, though one is quite aware of the difficulty of giving

anything but a pedestrian description of them. If a child has artistic tastes he is certain to respond to a pictorial presentation more quickly than to an oral or printed one. A Saturday morning tour of the Children's Gallery may suddenly reveal to him a life work — such instances are not too rare to be taken into account. The average child, who is not the child of the gods, will at least learn — if I may use the phrase — to think with his hands. He will be the better prepared, too, for the rôle of appreciator in which it is the Museum's policy to train him. For the artist, if he has the necessary vigor to make his work significant, can be trusted to find a way for himself sooner or later. The appreciator, on the other hand, must be carefully reared if, in a large percentage of cases, he is not to lapse into Philistinism. To put it in another way, if the schools and museums do not civilize him there are an abundance of influences, from tabloid newspapers to censored motion pictures, which can and will barbarize him.

The Art Institute, whose average daily attendance, the year round, may not pass three thousand, will not, of course, reach all the children of Chicago. Much of the influence it exerts will be indirect, through teachers and, as has been shown, through selected individuals. But the educational work done by the Institute has encouraged the schools to install collections of their own, by means of which the students can become familiar with good copies of at least the standard classics. Probably no large public school would be erected in Chicago to-day — even under the rather barbarous political influences

which afflict the Chicago school system at this writing — without some provision for a school museum. The result is, or will be, that a bowing acquaintance with the A-B-C of the arts will cease to be a mark of caste or class. Any child in Chicago who really wishes to do so may take in art along with his grammar, arithmetic and geography. The fact that his father works in the stockyards or that he himself has been brought up in the streets and encouraged to take not more than one bath a week is no real obstacle. There is at least a potential democracy. And democracy in the arts has a very practical value. It means a larger group of individuals to select from, and consequently, by the laws of chance, a larger residue of talent. And a larger residue of talent means higher standards of taste and accomplishment. Twenty years from now, perhaps, we shall be able to measure the tangible results attained by what is being done at this moment among the public school children of Chicago under the patronage and encouragement of the Art Institute.

3

I SPOKE, a page or two back, of the adult classes for " those who have the desire to ' try to paint,' but who are not able or prepared to take professional work in an art school." As we have seen in another connection this desire is not rare among adults, conceal it though most of us do. It is as natural as a desire to write or to play golf. One such class, as announced in a current leaflet of the Institute, meets one morning a week from nine until

twelve, at a cost of a little more than a dollar a lesson. " This class is organized," says a footnote, " for those who never have drawn, who doubt whether they ever could draw, but who would like to try." Anyone, of either sex, of any occupation, and of any age may enter these classes, coming in at any time and withdrawing at any time. In a typical sketch class a sequential program is laid out, with talks and criticisms by a regular lecturer, assisted occasionally by members of the Art Institute faculty and visiting artists. Each lesson is " a distinct and complete unit," and " no problem in the course is dependent upon other problems." If there is a royal road to art this it is. Possibly the tendency is to make some amateurs think they know more about sketching than they do. However, a trip through the galleries should cure that. Perhaps nothing so lends pleasure to such a pilgrimage as an impression that one knows even a little about painting. Until he took his course in drawing the novice may have believed that pictures came into being instantaneously, by a special act of creation. Now he knows better. He sees how even the great artists must have planned, puzzled, rejected, suffered, triumphed in their cosmic way just as he himself, in his insect fashion, has done. He is a brother, though many times removed, to the great. He loses some of his superstitious awe for painting, but he gains in intimacy. He begins to see what it is that is difficult in a work of art and what it is that is comparatively easy. In short he acquires a smattering of painter language; he may even become a better critic than were Professor

Norton's students, who learned infinitely more about art and artists but never made any pictures. As is so often the case, however, we should probably say " she " instead of " he " for persons who are able to attend amateur art classes on weekday mornings. Male or female, none the less, the principle is the same.

The Institute's indefatigable popular lecturer does not win the whole-souled approval of those austere souls who take the priestly view of the arts. He seems to them to be letting the public in on secrets which should be reserved for the initiates. He is evangelistic rather than clerical. He teaches that everybody can be saved. But this is democracy; and as political democracy produces its spellbinders so must aesthetic democracy. Moreover, it may be found in the end that the aesthetic variety stands on much firmer legs than the political. Not that artistic ability is distributed with any pretence at equality; quite the opposite is manifestly the case. But the aesthetic gift does seem to be independent of the factors which determine wealth or social position. It is not a " unit characteristic." We cannot breed it at will. It often has earth clinging to its roots. It flourishes among the hewers of wood and drawers of water. As the Art Institute broadens its work — and this is true of any museum in any city — it naturally loses a good deal of the social particularity which once belonged to it. When everyone is encouraged to love, study and even practice the arts to the top of his bent, then art ceases to be a measure of invidious distinctions. But when this

fortunate event has actually taken place much of the pose, smugness, pretence and mere prettiness of the aesthetic cult is swept aside, and with them so many obstacles to a true aesthetic revival. The popular lecturer on the arts can never be the universal figure that Professor Norton was, but he represents the Norton formula logically prolonged. When he has done his work all of us will be gentlemen — or none of us.

Like the Metropolitan Museum of New York the Art Institute receives public support, though in its case it is the state, not the city, that pays. The sum is relatively small, amounting to about one-seventh of the annual disbursements. It is, however, a recognition that a museum, like a railway, is affected with a public interest. The endowment funds have grown greatly during the past quarter of a century, and even during the past ten years. They did not pass the million-dollar point until 1917, yet by the beginning of 1927 they were in the neighborhood of five million dollars, with some subsequent increases. It is a curious fact that while the endowment, the physical facilities and the educational offerings of the museum were increasing rapidly during a portion of this period there was an actual decline in the total number of annual admissions. But this is largely due to the deliberate decision of the Institute not to devote its energies to herding large portions of the population of Chicago, stockyard fashion, through its corridors. A mass of people moving through a museum doubtless do experience a vague sense of uplift. But the Institute looks to the individual, on the theory that

even a democracy is composed of individuals rather than masses.

As with the Metropolitan one feels that the Art Institute is far from being a finished product. Its incompleteness, however, is not mainly a matter of physical equipment, it is a matter of function. The Institute has grown up to meet a number of purposes. It even possesses, as we shall see a little later, a theatre. But when it is compared with the public-school system, with the University of Chicago, or with the ordinary professional art school it is evident that it still has to be digested into the educational system. That ultimately it will be so incorporated and that the arts, fine and applied, will consequently play a larger part in the scheme of instruction than they do now the careful observer will not for a moment doubt.

III

PITTSBURGH AND CLEVELAND

I

PITTSBURGH, it is not necessary to repeat, is far from being an arty city. Its inhabitants do not go about carrying lilies in their hands. Yet the same combination of private generosity and public responsiveness which has made the Carnegie Institute's College of Fine Arts distinctive has also created a great museum of art. The public responsiveness had been a long time preparing. Pittsburgh had had an art society as early as 1872, it had had an art exhibition as part of the Sanitary Fair in 1864, and it had had a private art gallery in 1832. John W. Alexander, Mary Cassatt and several other noteworthy American artists were Pittsburghers. The private generosity was of course that of Andrew Carnegie, who found in Pittsburgh the impulse both to win a fortune and to give a fortune away. The story of his gifts to the city has been told by himself and others. He began, in 1881, with an offer to give two hundred and fifty thousand dollars for a free public library. Before his death he had given more than thirty-six million dollars to endow the library and its branches, the Hall of Music, the Library School, the Institute of Technology,

the general museum and, which concerns us in this chapter, the museum or department of fine arts.

The purpose of the museum, as its director, Homer St. Gaudens, put it, " is to make mankind, from wage earner to millionaire, realize the natural pleasure to be gained from attractiveness in its man-made surroundings; to disseminate the appreciation of art in its broadest sense among all classes of people; to keep in this, their own city, those who have means or taste beyond the ordinary; to draw from afar others who will come to live and work among what should be known as pleasing and fortunate surroundings." Rather an ambitious program for smoky, yet somehow glamorous Pittsburgh! One senses here the beginning of a new civic patriotism, of a sort long unknown in Pittsburgh or in any other American industrial city. Old Pittsburgh lies between the rivers, on the lowland of the Golden Triangle. New Pittsburgh is developing, body and possibly soul, too, on the hills around the Institute, on what used to be the Schenley Farms. To get to the Institute Pittsburgh must climb out of the heaviest of its mist and soot, which is perhaps symbolical. Symbolical, too, if not great art, are the well-known Alexander murals, in the great entrance hall, depicting " The Crowning of Labor." Here, out of smoke and steam, labor climbs to some Utopian Schenley Farm, where there is a flutter of wings and gleam of mail. Mr. Alexander may have taken too simplified a view of the problems of labor and its employers, and the great machines which dwarf them both. But one does not forget, even in these tranquil art galleries,

the material bases of civilization — and of culture. Art in Pittsburgh can never be an evasion. It must come to grips with the material facts of its century. And this, indeed, it does. For, just as boys and girls from the mill towns come up to the Institute to study art, so their parents, men and women plainly marked with hard work, do come into the galleries to look at the pictures. This is not inserted to turn a sentence: one sees them, and they are hungry for something they hope to find here.

Like every great museum of the present day the Institute has its educational activities, though these are not so intensively organized as is the case at the Art Institute of Chicago, and as we shall see is the case at the Cleveland Museum. The entire eighth grade of the public and parochial schools of the city is brought into the galleries, three times a year, with its teachers, to make the rounds of the permanent collections. This is a beginning, and an ambitious one at that. The Museum, it should be observed, has one distinguishing feature. Its statuary and its architectural exhibits lean, as is natural, toward the classical. In architectural detail the whole development of the building arts from the Egyptian to the late Renaissance is shown. In painting, on the other hand, the effect is practically contemporary, since the oldest work in the permanent collection has not been dry more than a hundred years. This note of modernity is carried over and reinforced in the special exhibitions. These exhibitions may be one-man shows or they may be diversified. They may be tame, for some modern work

is, and they may be wild. At any rate the people of Pittsburgh have an opportunity to see and judge them. The most important of the Institute's shows, and one of the most important of its kind in the world, is the International Exhibition. This has been an annual event since 1895, with the exception of the war years during which everything international was under suspicion. Paintings are sent from every country which boasts painters and are hung by nationalities. The individual selections are made by an international jury on a basis of merit, and the artists represented are sometimes veterans and sometimes brilliant newcomers of whom no one has previously heard. There have usually been about three hundred canvases. Prizes are awarded, the Institute itself makes purchases, art dealers are present in force, and the leading critics come to pass judgment. The exhibition lasts six weeks and experiments have been made in sending some of the best of the paintings on tour. There is hardly a better opportunity anywhere for students who wish to keep up with modern ideas in the fine arts, and especially to compare the American with the foreign product.

The result has been to enhance very considerably the self-confidence of the American artist, and to increase his prestige in the eyes of those who saw his work placed side by side with the best modern work of Europeans. It is true that the exhibitions may have erred on the side of conservatism and left out of consideration some decidedly interesting modern trends. But so, perhaps, has every exhibition ever held in which the hanging

committee consisted chiefly of artists of accomplishment and reputation — that is, of men whose vested interests are in the present and immediate past, not in the future. But modernistic art has met with a warmer welcome in Pittsburgh than it has, for instance, at the Metropolitan in New York.

Aside from the professionals, critics and serious students the people of Pittsburgh themselves come up the hill to the International Exhibitions, out of mills, stores and offices, in surprisingly large numbers, and every year find excitement in voting for their favorites. The fact that the music auditorium and the library are under the same roof with the art galleries swells the crowds. But no one can mingle with them on a Sunday afternoon without being aware that here are hundreds of the common run of humanity not learned in the arts — certainly not graduates of Harvard, Princeton or any other institution for the manufacture of gentlemen and scholars — who are intensely interested in the merits of painted canvas. Under the respectable uniform of Sunday clothes are a dozen different nationalities. Here is growing a vigorous audience for such voices as the arts may find. Here is an American note, questing, questioning, thoroughly healthy, unaware of a compulsion toward any aesthetic theory, all the more native because it is so thoroughly foreign.

Night school, part-time courses, and Saturday morning courses for high-school students, all held at the College of Fine Arts, do some of the work of instruction that the Institute might otherwise have attempted. The

influence of the Carnegie galleries is not the result of an elaborate organization for serving the public of Pittsburgh. In the first place Pittsburgh, outside of its industries, has no fondness for elaborate organizations of any kind. In the second place, the arts seem to have a greater pulling power here than in some communities whose environment is a shade less lurid. The cultural life of Pittsburgh is leavened by the mere existence of the Carnegie galleries.

2

CLEVELAND IS, in many ways, what Pittsburgh is not. It is a city of the plains, whereas the determining feature of Pittsburgh is hills; it is a city of diversified industries, whereas Pittsburgh is almost exclusively metallic; it is a democratic city, whereas Pittsburgh has always been under the influence of great families and their great accumulations; it is a coöperative city, whereas Pittsburgh is proudly, fiercely, and colorfully individualistic. The Cleveland Museum of Art is Cleveland to the core, especially in matters of organization and coöperation. It dovetails with nearly everything else in the city, including the art schools, the public schools and the library. It does not play a lone hand — no one can do that in Cleveland — but is part of what may be designated as the Cleveland Movement. The Museum itself is the product of a difficult piece of coöperation between the trustees of two overlapping bequests. In some cities the result would have been two independent and possibly competing museums, but not so in Cleveland.

The work of building the museum was delayed for nearly a generation, until, in 1913, a legally and architecturally feasible plan of joint action had been evolved. Provision was even made for the participation of a third fund, which in the meantime had been bequeathed for a similar purpose. The completed Museum, opened in 1916, is legally a patchwork, but functionally and to the eye it displays admirable unity.

It is, in fact, one of the loveliest in the country, and in its setting in Wade Park one of the best situated. There are features no visitor is likely ever to forget — for instance, the exquisite Garden Court, with its Roman pillars and the organ loft at one end, as one sees it quietly peopled during a concert. One detail of the exhibition policy is noteworthy; this is that the galleries are never allowed to be crowded with pictures, statues or objects. Display itself is treated as a fine art and the storehouse, in a negative way, does its share in making the museum attractive. In true Cleveland style " the gallery lighting was planned by a committee of experts who conducted extended experiments at Nela Park." They did a good job, too. Artist and public alike could ask little more.

As far as is possible in a marble building filled with valuable works of art the Museum has avoided austerity. " The ideal from the first," as Director Frederick Allen Whiting once put it, " has been to create a place of beauty, the abode of the Muses, where all forms of loveliness would be at home, and where beauty of surroundings and of arrangement would enhance the

charm of individual objects. It has been our belief that the blending with this beauty of objects and surroundings of a warm-hearted and intelligent desire to serve would inevitably develop a human, tangible spirit, which speaking through the sensibilities would come to be recognized as the spirit of the Museum." Royal Cortissoz has spoken of the Museum's " extraordinarily close contact with the public " and of its collections as being installed " so skillfully, so charmingly, that they cease to be mere ' specimens ' but are vital parts of a living organism." The building is inviting and hospitable. It is never more characteristically itself than on a fine Saturday afternoon, with the sun pouring into the courts, and children everywhere. It is youthful, as indeed it has every right to be, and it is a place of good cheer. It has, what churches, banks, governments, fraternal organizations, politicians and even debutantes find essential in any age of advertising, a publicity department. Mr. I. T. Frary, secretary of this department, has written an account of the first " Museum Week," which gives an engaging idea of what a Cleveland enterprise can do when it really tries.

" The newspapers," says Mr. Frary, " ran special articles, news items, rotogravure pages, feature articles and stories regarding the Museum. Special articles on the Museum and its work were published in foreign language newspapers, house organs and club publications. The Federated Churches issued a special bulletin asking that notice be given from the pulpits or published in the church bulletins, which request was complied with

quite generally. Two thousand posters were distributed throughout the city and large framed photographs of the Museum were placed in store windows. Two hundred display cards were placed in street cars. Cases containing Museum material were installed in theatre lobbies and store windows, and special movie films showing the Museum and the activities carried on within it were shown for two weeks in theatres. Talks were given at luncheons and other meetings of important clubs, and all possible means were employed to give the Museum desired publicity. . . . The result of the undertaking was most satisfactory, not only because of the tangible increase in membership and added income, but because of the increased importance which the Museum assumed in the mind of the public."

Thus it will be seen that the Museum does not hide its light under a bushel or behind its own marble walls. The methods described certainly would not have appealed to the founders of the Metropolitan of New York, and possibly not to the present trustees of the Boston Museum of Fine Arts. They have, however, the inestimable advantage of being successful. They are modern. They are American. And they temporarily took away the attention of the people of Cleveland from automobiles and breakfast foods by causing more clamor than the manufacturers of those valuable commodities. The Museum was definitely placed on the map of Cleveland, and with the aid of its own merits and continued publicity it has succeeded in remaining there. One Cleveland newspaper has given space each week on its

editorial page to an article by a member of the Museum's educational staff. There are ten issues yearly of the Museum Bulletin. Special exhibitions which may appeal to particular racial groups are announced in the foreign language newspapers. Publicity of this kind is worth an editor's while, for it is just as much news as is the latest murder or the most fascinating divorce — though naturally it will not occupy such a prominent position.

Like the Metropolitan, the Art Institute, and the Carnegie Institute the Cleveland Museum offers its attractions to all ages and to all sorts and conditions of men. Perhaps it is its work with children that most strikes the casual observer. Of classes for children there is a great variety, some under the direction of public-school teachers, some under the Museum instructors, and some independent or under other auspices. Some youngsters for whom there is no room in the regular classes come to the Museum to draw independently from whatever objects attract their attention. A special instructor is assigned to aid them, and they stand in a long line before her desk in the rotunda, waiting for her swift but sympathetic criticism. Several years ago the discovery was made that children visiting the public libraries were using newspaper comic strips as drawing models. As an experiment the head of the Children's Museum, which is a department of the larger institution, procured facsimile reproductions of prints and drawings which had stood the test of time — Durer's and da Vinci's, for instance — and distributed them among the libraries. The children liked these better than the comic strips.

Not only did they like them better, but they began to produce better and more original drawings of their own. No doubt this goes to support the theory often advanced — I have quoted Huger Elliott's reference to it in the preceding chapter — that the preferences of childhood and the verdicts of mature sophistication in the matter of pictures frequently coincide. It is the untutored adult, who has forgotten the sweet ignorance of his earlier years, without formulating any dependable principles to take its place, who goes wrong. Children who have been sent to the Museum by the librarians often become intensely interested in what might be thought esoteric objects — Chinese paintings, Byzantine ivories, prints. A number have joined the Museum's art classes, and some have gone on to the School of Art. " The experience tends to confirm the Museum in its attitude toward popular taste," says Rossiter Howard, assistant director. " People tend to like good qualities when they are acquainted with them. Nothing is too good; it may be too strange, or too complicated, or too sophisticated, but not too good."

More than 56,000 children, most of them in class groups, have visited the Museum for study in a single year. One is free to indulge his imagination as to what this may mean in the development of community culture in the course of two or three decades. But it will at least be true that works of art will not be an alien vernacular to these children. They will furnish an instructed public upon which the Museum can rely; and so, year by year, the circle will widen. But among the

thousands of youngsters who come to the Museum every year there will be a few who have creative ability of a high order. Just how many will depend upon what one means by creative ability. Recently the Museum, in co-operation with the Board of Education, has selected from all the schools of Cleveland a small class — it consisted of forty pupils at the time of my visit — of children with exceptional artistic gifts, and has given this class intensive work under a special teacher. Every one of the forty, after a few weeks, could draw in a manner to put the usual untutored adult to shame. They could draw just as some children play the piano or the violin or compose music or write poetry at surprisingly early ages. The ideal method of teaching them has perhaps not been discovered yet, though the Museum instruction is obviously fruitful. The danger is that the gifted child will not only become insufferable but also that it will become lazy and superficial. On the whole these perils have been minimized, much good work has been done, a number of children have received scholarships in the Saturday classes of the Cleveland School of Art, and some have gone on to take the school's complete course. In time it will probably be possible in this way to send a group of super-normal students to the art school. These will not only be worth while in themselves, but they will set the pace for the others. It is worth noting that in this instance the public schools, the museum and the art school work together in perfect harmony.

For older students Dr. Bailey of the School of Art has offered, under Museum auspices, lectures in the

appreciation of art. These have been attended by freshmen from the School of Education, the Kindergarten Training School, the College for Women, Adelbert College and the School of Art. For adults there have been courses in the history of painting, gallery talks on the collections, and regular lectures. Extension exhibits have been sent out to schools and libraries. Much is made of special exhibits. In one year there were five such exhibits of oil paintings, one of water colors, one of drawings, six of prints, two of textiles, one of sculpture, and one of the work of Cleveland artists. Among these were paintings from the International Exhibition of the Carnegie Institute, an exhibition of contemporary American painting, and a " Comparative Exhibition of Art through the Ages " — a sort of Outline of Art.

Thus the Museum is educating its public not only in the history of art but in its modern manifestations. Walter Pach, in a magazine article published not long ago, speaks of " the intelligent guidance of public taste through which the institution has made an enviable name for itself." The task of guiding public taste is necessarily a ticklish one. The Museum officials might prefer to say that they present as much as they can of the material upon which taste can safely be shaped, and leave it to the public to form its own preferences. A frequent criticism of the more conservative museums is that they are weak in contemporary art and so do not keep their publics in touch with the manner in which present-day life is being interpreted. Is it strange that their attendance, in proportion to population, often falls below

that of the Cleveland Museum? A public accustomed to newspapers, news reels, and radios is not satisfied to have its art arbitrarily lopped off with 1900 or 1910 or even 1920. Whether the modernists are of the hour or have in them the stuff of immortality the museum public has a right to see and judge them. They are news. Such is the point of view in Cleveland.

But in thinking of Cleveland one is likely to return to the point at which one started — the policy of co-operation. The precise activities in which the Museum engages are second in importance to the fact that it engages in them as a smoothly-working part of a community-wide educational system. Too smoothly working, perhaps, for some artistic temperaments, but perhaps not too smoothly working when the job in hand is raising the cultural level of a city of a million persons.

IV

DETROIT, TOLEDO AND HOUSTON

I

DETROIT was an incorporated city more than a century ago and a flourishing settlement long before that. It has a history and traditions. Essentially, however, it is a product of the present day — that is to say, of the automobile. The things that distinguish it are brand-new and shiny. It is natural, therefore, that its museum of art, and even its general interest in the fine arts, should still scarcely have the varnish dry upon them. It may also be fortunate, for in leaving behind the dingy old down-town building the Art Institute also left behind some outworn ways of doing things. The new structure, designed by Paul Cret, and set in a generously-parked space opposite Cass Gilbert's public library, is refreshingly and ingeniously modern. It is architecturally most pleasing in its simplified Renaissance style. The salient point about it, however, is not that it is intended as a decoration for Woodward Avenue, which is one of Detroit's show streets, nor even that it protects pictures and other objects of art against the ravages of mice and men. It stands out, rather, as a building in which examples of the fine arts are

actually to be exhibited. It has been built from the inside out.

" A good deal of thought," says Mr. Clyde Burroughs, who as secretary of the Institute had much to do with planning the new building, " has been given to keeping it as free as possible from the faults which produce museum fatigue. The first consideration to this end is the natural lighting of the rooms by means of windows. Next, the mingling of exhibits such as painting, furniture, textiles and small objects of a given period in a home-like arrangement. Third, an attempt to create an harmonious architectural setting for the objects displayed. Fourth, an effort to offer natural relief through the expedient of glimpses of the out-of-doors through the windows and of the indoor garden with plashing fountain or of the architecturally intriguing outdoor court."

" Natural lighting " raises questions which can be settled only by experience. Many museum officials disagree decidedly as to its advantages. For the public it has the effect of making the museum a little less like a church and a little more like every-day life — a result which is good or bad according to one's way of looking at it. The second of Mr. Burrough's considerations is less debatable. The secret of the great popular success of the American Wing of the Metropolitan Museum was that it created and preserved the atmosphere of a period. The visitors found themselves not staring at exhibits but walking into the seventeenth and eighteenth centuries. Furniture, woodwork, silverware, paintings, were all in

key. It is logical to believe that the same effect can be secured with exhibits from other countries and periods. The plan of the Detroit Museum shows a succession of relatively small rooms devoted to the arts of Flanders, France, Spain, and so on through Rome, Greece, Egypt, Persia, Asia Minor, Turkey, Japan, China and Korea, Thibet, the countries of the Aztecs and the Peruvians, and of course contemporary Europe and America. Each of these rooms has, or is to have, not only framed pictures, where they are appropriate, but also sculpture, murals, pottery, and furnishings which will create the atmosphere of a civilization. This is not an easy thing to do where the civilization in question has existed, grown and changed over many generations, but it is thought worth while to attempt it instead of placing Chinese or Egyptian pictures or statuary against a palpably American wall. Wherever possible the rooms are copies of originals. One is a chapel from the fifteenth-century Chateau de Lannoy. Another is an original wood-paneled room of the French eighteenth century. A suite from Whitby Hall serves as a fitting background for the American Colonial exhibits. There are, in addition, rooms for temporary exhibitions.

The arrangement is such as to give the visitor a sequential view, beginning with the most familiar and working toward the least. He may commence with the modern European group; then, as he proceeds, pass through the English, French and Dutch rooms of earlier periods, and so on, through the Italian Renaissance into the Gothic, the Romanic, the Greek and the Ro-

man, thence into the Egyptian and thence into the rooms devoted to the arts of the Near and Far East. The plan is meant to show the historical and logical relations of the arts, as well as " their vital relationship to everyday life." The museum is an actively functioning educational plant — or, as its secretary calls it, " a community house where all activities with an aesthetic impulse will find encouragement." As at Cleveland much is being made of classes for children. Illustrated lectures on the museum collections are given in the public school auditoriums; classes and their teachers are given expert guidance when they visit the museum; there is a special Children's Museum, from which selections are sent to the schools; and there is a Saturday morning class whose membership, as in Cleveland, is made up of children selected for unusual ability. But these are beginnings. Efforts are now being made to outline courses in art which can be fitted into the curriculum of the schools, and carried on with the coöperation of the Museum officials. The place of fine arts in the public schools is a problem of large dimensions. It is evident, however, even to the most casual observer, that the field has hardly been scratched, even in Cleveland and Detroit.

For students of an older growth there are study rooms, one for American art, one for European and one for Asiatic. A large auditorium is available for museum lectures, for pipe organ concerts, for symphony concerts, or at a nominal rental for meetings of non-commercial organizations whose aims are harmonious with those of the museum. A smaller lecture room, with a

projecting apparatus, seats a more intimate audience of about four hundred people. There are a number of studios which may be used for limited periods by local or visiting artists engaged upon definite commissions.

Most museums of importance have received some public aid in addition to their private endowments, but the Detroit Museum — or, to give it the official title, the Detroit Institute of Arts — is a civic institution, under the guidance of an Arts Commission which reports to the Common Council. This does not prevent it from accepting gifts, but it does lay upon it the obligation to be popular at all costs. And in this it has been successful without a fatal loss of dignity or prestige. It has been quick to seize the opportunity offered by a diversified foreign population. When Ivan Mestrovic visited America several years ago he was invited to bring his sculptures to Detroit and the event was widely advertised, especially among his fellow-countrymen. Members of the Jugo-Slavic colony put up placards in the streetcars on their own initiative, a banquet and reception were held, and finally the Jugo-Slavs started a subscription to buy one of Mestrovic's statues — the " Contemplation " which is now in the museum's collections. The reception to the sculptor aroused great enthusiasm; hundreds turned out; and Jugo-Slavic women, on the spur of the moment, danced the native dances of their country in one of the galleries of the old museum. A few judicious inquiries were enough to show that the Czechs, the Greeks, the Poles and representatives of half a dozen other na-

tionalities were equally interested in their racial arts and ready to aid in acquiring examples of them. In addition there is the Detroit Museum of Art Founders' Society, which has more than five thousand members who contribute both in money and in objects of art.

The museum's democracy is a fact, not a pose. Workers from the factories, including many of foreign birth, are a large ingredient in the Sunday afternoon crowd. They listen to a program of music, then mill through the galleries, stopping to listen to a " gallery talk " about some new acquisition. They peer at a Matisse or at Odilon Redon's butterflies, and some one says, " Can't make much of these new painters." But they keep on seeing them, Sunday after Sunday, and the chances are they will be able to make something of them in the end. Mere familiarity will attend to that.

Detroit's financial upper-crust is much given to buying paintings — five million dollars' worth, it is said, in a single recent year. Some of these will doubtless come to the Museum in time, filling up spaces now bare. Edsel Ford has been a member of the Arts Commission. But it may be more important that an understanding of the place of art in ordinary life is making progress with considerable numbers of Detroiters who are less lavishly blessed with the world's goods. Wealthy men will almost always buy paintings if it becomes the fashion to do so, just as they will buy horses, yachts and jewelry. In so doing they may acquire taste. Their poorer brethren have to go without the horses, yachts and jewelry, but taste — by which one means discrimination, judgment, an

appreciation of the furors and the niceties of artistic expression — is theirs as much as anybody's.

2

THERE IS no art museum in the United States, I am sure, which holds a larger place in its community than does that at Toledo. None could have had a more humble beginning. The Toledo Museum was incorporated in 1901, the product of the united enthusiasm of George W. Stevens, who became its first director, and of Edward Drummond Libbey, a manufacturer and collector, who gave much of his time, money and strength. Mr. Libbey was a collector of glass, he aided the work of archeological excavation in Egypt, and he had sound preferences in both the contemporary and the modern arts. One of the Museum's prize pieces is George Bellows' " Blackwell's Bridge," which Mr. Libbey bought in 1909 when Bellows was still practically unrecognized. He sent this painting to Director Stevens with the note, " You need not hang this canvas unless you care to. I feel that some day it will be important." The Toledo Museum was in this way the first American institution of its kind to own a Bellows. In 1916 Mr. Libbey bought Ralph Blakelock's " The Brook by Moonlight," paying $20,000, the highest price ever given up to that time for an American painting. These instances show the kind of zest that went into the forming of the Toledo collection. Mr. Stevens brought the same vitality to his work as director.

The Museum's first quarters were bare rooms in a down-town building, where exhibitions were successfully assembled. Like most similar enterprises it was in dire financial straits for a long time. Yet as soon as possible it laid down the policy, first of admitting students and teachers without charge on certain days, and ultimately of admitting " the public free every day in the year." The first unit of the present Museum building was completed in 1912, the second and final unit in 1926. Unhappily Mr. Libbey died before the dedication of the completed building and Mr. Stevens shortly after, in October, 1926.

" In the entire American museum field," said a writer in the Bulletin of the Chicago Art Institute, in speaking of Mr. Stevens's death, " there was no more vivid personality, none more unselfish, none better loved. He made the beginnings of the institution which he served; almost literally he built it brick on brick. For a long period he directed its affairs from his bedside. He was an heroic figure who had no conception of his own greatness." The visitor still senses this man's vibrant influence in the Toledo Museum. It is the character of George Stevens which explains why the institution never had to rid itself of any dead lumber of tradition; it never had any. Stevens had been a newspaper man, and this and other experiences had convinced him that a museum should begin by giving the rudiments of appreciation of the arts to as many persons as possible. Like the directors of the Detroit Museum he put great stress upon work with children; the Toledo Museum is said to have

been the first institution of its kind in the world to admit children unaccompanied by adults. Through the children Stevens believed he could reach the parents; in any event he could reach the parents of the next generation. The museum instruction was systematized until it finally produced a School of Design, with a staff of its own. Tuition in this school is free, though it is intended for residents of Toledo and outsiders have to be discouraged. The courses include color and design, composition, lettering, poster work, home planning, fashion drawing and methods for art teachers. The term runs from September to June, and classes are held on weekday afternoons and evenings and on Saturday mornings.

The enrollment has been sufficiently heterogeneous. There have been classes of high-school students, who attend during regular high-school hours. There have been one or two classes in which both adults and high-school students were enrolled. The first year eighty business men and women took the course in lettering. Thirty-five adults took home planning. There were two classes of thirty adults each in color and design, a class of fifty business people in poster making, and forty adult teachers in the teacher training course. Nearly all the work was practical. The students, old and young, learned to appreciate art by learning something about the actual processes of drawing and painting. The Saturday morning classes, like those at Cleveland and Detroit, were composed of children selected from the public schools — usually about one per cent of the enrollment of each school — for artistic talent and eagerness. The instruction was

carried on systematically and the work done was surprisingly good. In fact, it seems worth noting that the work done by any class of children, of normal or better ability, who are encouraged to draw and paint and given a little intelligent direction, always is surprising to the layman who inspects it for the first time. Then one hears of incidents like this: A group of twenty business women and girls asked for lectures in the history of art. Their interest was real enough to keep them studying and saving money over a period of six years. At the end of that period they went abroad with their teacher for an educational tour of the European galleries. Spread such an interest as this over about six hundred high-school students and adults and probably as many children from the grades and it becomes significant. The School of Design is not to be thought of as a professional art school, but it teaches appreciation, as the list of its courses shows, in the broadest sense. Or, to be more precise, it gives a basis upon which a student may build up his or her own private course in the art of appreciation.

The general attendance is comparatively far above that for the larger cities. In an average year it will more than equal half the population of Toledo — or from two and a half to three times as much, in proportion to population, as the attendance at the Metropolitan in New York City. On Sundays the Museum is so crowded that, as one is told, it is often difficult to see the pictures. A well-rounded program of concerts, story hours and lectures has brought thousands who were not enrolled in any regular classes. The Museum was a pioneer

in the use of educational motion pictures. But the ideal is more significant even than the methods. George Stevens saw in the arts a positive and regenerative social force, and in the Museum a means of bringing this force into operation. It was not enough, for him, " to bring together works of art, install them properly and thereafter keep them free from dust and on view to members and a very limited public." " It is the function of a modern Museum of Art," he held, " not only to call the attention of the human race to those elemental truths which have smoldered in our treasure galleries or in the ruins of earlier civilizations, but also to take the lead in the educational revolution which is to restore and redevelop this important and vital heritage of man."

Mr. Stevens did not live to see his " educational revolution " in full swing. His influence inevitably survives, none the less, in the museum he did so much to create, and is an active factor in the general policies of American museums. He stands out as a director who saw the educational work of such institutions, not as a variety of more or less closely connected activities, carried out for the sake of convenience under one roof, but as a unified campaign. He saw that museums of art might reach almost as large a fraction of the public as the motion picture theatres themselves; and that they might even correct some of the distortions of taste brought about by the commercial film.

3

HOUSTON LIES in that part of the coastal plain of Texas which has been fabulously enriched in recent years by the production and refining of petroleum. Much Northern capital has been brought in and Southern capital has increased. The city has grown a nucleus of skyscrapers and a fringe of attractive garden suburbs. It has one of the best of the newer Southern hotels. It is the seat of the Rice Institute, which the late William Marsh Rice endowed with ten million dollars for " the advancement of literature, science and art," and which is housed in buildings designed by Ralph Adams Cram. It has the energy, the aspirations and the relative absence of traditions of any sort which characterize the newest South. One could not ask a better laboratory for an experiment with the modern variety of Art Museum. Houston has such a museum, from which the scent of newness has hardly departed. It was established in 1924. So far the permanent collections have not been as important as the building in which they are housed; yet in its transient exhibitions, in its encouragement of picture buying, and in its educational activities the institution is already notable. During the first twelve months of its existence it held thirty-five different exhibitions, including two of prints and etchings, one of sculpture, one of architecture and one of children's work. During the second year there were twenty-seven exhibitions, in which were included not only paintings, sculptures, etchings, textiles and decorative arts, but also advertising,

theatrical settings, work done by children, flowers and " an assembling of articles of distinct merit artistically which pertained to the early history of Texas." This last might have to be seen to be believed. A Remington memorial exhibit naturally had an especial interest for a community on the edge of the Southwest. The sixth annual exhibition of the Southern Art League attracted attention, and so did the first exhibit of work done by Houston artists. " We hope," said the director's report of this exhibit, " that it will open the eyes of Houstonians to the talent, both developed and latent, which is right at hand. If we are to be an art-loving city we must be an art-producing city." This attitude of courage and expectation is typical of the community as well as of the museum. There may be struggles ahead but all things are thought possible.

The most striking showing of pictures, however, was that of the Grand Central Galleries of New York city. The admissions to this exhibit, which lasted a month, were equal to about one-third of the population of Houston, and $90,000 worth of pictures was bought. Showings like this help to make up for the relative meagerness of the permanent collections, and these are likely to grow if Houstonians fall into the habit of buying paintings. Incidentally, it was not Houston alone which profited, for the museum succeeded in obtaining reduced rates from the railroads and advertised its offerings in newspapers in the near-by towns and cities. The attendance came not only from all parts of Houston but from all sections of Texas, which means much in

that region of vast distances, and even from other states. The racial tradition of the South did not permit Negroes and whites to be admitted simultaneously, but a special evening each month for colored people showed that the latter had a genuine interest in the fine arts, and particularly in work done by members of their own race.

An ambitious scheme of instruction for adults as well as for children is in process of realization. One course was in "Puppetry, Costume and Scenic Design," in which the pupils created their own puppet shows. "Talks on Art" is a ten-week course, given once a week. In addition encouragement is given teachers in both the public and the private schools to bring their classes to the museum. For adults there are lectures on American art, on art appreciation, with some attention to the technique of painting, and on the history of the arts and crafts. As in other museums there are gallery talks for those who ask for them and extension lectures before groups and organizations. Several clubs make regular trips to the Museum in connection with plans of study. Students from the Rice Institute, which is within a few minutes' walk, are also making frequent use of the collections. At this writing the Institute has developed no art courses except those which are given as part of its regular work in architecture. There will probably be closer coöperation between the two institutions in years to come.

A new art museum faces almost as many financial as aesthetic difficulties. The Houston Museum charges no

admission fee, and consequently has to depend upon dues and endowments. One plan, similar to that followed in other cities, was the organization of the " Houston Friends of Art," each of whom agreed to pay one hundred dollars a year for five years, half of the money going into an accessions fund to increase the permanent collections. The problem of permanent collections for the smaller and poorer museum is of course a serious one. They need originals in the representative fields of art. Yet the more museums there are the harder these are to procure, and the more likely they are to go to the wealthier institutions. But as this may compel them to speculate in the current artistic output the poorer institutions may do more to encourage living artists. And living artists are the most important features of a contemporary renaissance.

But whether it is a large or a small museum that is being considered, a poor or a rich, a radical or a conservative, one comes back in the end to the impression I have already described that the museum is an institution of vast importance which is still in flux. All that one is sure of is that it can be made to play a significant role not merely in teaching the arts of appreciation but in encouraging the creative artist, both by providing him with a sympathetic audience and by buying his pictures. Emphasis upon modern work and a greater use of travelling exhibits may be looked for among the smaller museums. Perhaps we shall see the evolution of what might be called a repertory museum, in which the

permanent collections will never become of leading significance. At any rate the dry-as-dust systems and ideals of half a century ago are obsolescent. The modern museum is as dynamic as any other educational force in the country — or can be made so.

PART FIVE

The Arts Dramatic

I

WORKSHOPS AND UNDERSTUDIES

I

IN a sense, of course, there is no art that is not dramatic. A painting, like a play, selects, rearranges and reëmphasizes the raw material of life in order to produce in it a significance not formerly visible. The frame of a picture and the wings and back drop of a stage are precisely the same sort of make-believe. Any statue with a lasting emotional appeal could be resolved into the stage business of a three-act tragedy. Every pose of the consummate actor is a brush stroke or a shaping of wet clay. This likeness of function is not altered by the undeniable fact that few of our actors rise above the level of cartoonists or illustrators. There are social, economic and technical reasons for that. For one thing it is much cheaper to deviate from the normal in a painting than it is in a play; hence there are more experiments in studios than on the stage, and consequently a greater appeal to creative and original minds. What is called experimentalism on the stage is a pretty tame affair compared with the vagaries of modernistic painting. But the opportunity is the more inviting because its possibilities are so far from being exhausted.

There are signs that the American stage will catch up before many years with the development of the sister arts.

It should do this if for no other reason than that it summarizes so many of them. Modern theatrical design is a novel and stimulating form of architecture, though its possibilities as yet have scarcely been realized. A stage setting itself is architecture. It is also painting and sculpture. In fact the theatre, to be significant, must pull together all forms of human expression — the uses of color, of lines and masses, of light, the grace of words, the eloquence of the dance. The state of the arts, major and minor, will be reflected in the theatre. It is there that one can best measure the community's attitude toward them and the heights and depths of community taste. It seems defensible, therefore, to conclude this examination of the American approach to the arts with a glance at the American attitude toward the art form represented most characteristically at the present moment by the non-commercial theatre. I shall not attempt to discover heretofore hidden facts, but to link up certain well-known phenomena with those tendencies we have already discussed. The stage is a test and a synthesis. It is a craft, an art, an educational device, a propitiatory ritual, a form of penance, a business enterprise, a vicarious release of the impulse toward crime or virtue. It will not reveal the best that the arts can offer. But it should reveal, as nothing else can, the general trend of the arts. I have already mentioned the schools of the theatre at Yale, at the Carnegie Institute, at the Chi-

cago Art Institute, and at the University of Washington. I should like to consider these a little more carefully as representatives of their type.

One of the best sources for an elementary study of this field is the report of the proceedings of the Conference on the Drama in American Universities and Little Theatres, held at the Carnegie Institute in November, 1925. At that meeting Professor Baker of Yale called attention to the fact that the teaching of the dramatic arts had grown up in the universities in response to a manifest desire for such services.

" We have seen our work develop from simple beginnings," said Professor Baker, " not so much because we have planned for this development as because we have had to meet the steadily increasing demands from our students for instruction in more subjects; and secondly we have all come to the production of plays as the necessary test of our work. It is only to-day that schools of the drama are starting with announced courses intended to cover the whole field of the arts of the theatre. In the older organizations one or two courses in playwriting or in acting have brought all the other courses in their train. Originally, probably, too, few of us expected to give as much attention to the producing of plays as has become necessary. Gradually, however, we have come to know that only when the products of the courses in playwriting, acting, scenic design, costuming, and lighting are assembled in the production of a play can we surely assess the value of these results. The astonishing increase recently of educational and commercial

organizations offering instruction in the arts of the theatre rests, then, on a genuine demand."

This is the same kind of demand we have seen operating in the art schools, though in the case of the drama it has had practically to create a new kind of school. The evolution of Professor Baker's work, which budded out of courses in English literature at Harvard, is the best possible illustration. At first the object was cultural, as with other undergraduate courses. By degrees the practical element intruded. Professor Baker no doubt realized quite early that it was nearly as easy to make a competent professional as an elegant amateur. He discovered also, as his words show, that a play is not a play until it has been not only written but staged, costumed, lighted and acted. But this meant that to give professional training in playwriting necessitated giving an equivalent training in producing, scenic design, stage costuming and stage lighting. Professor Baker's students at Yale are now expected to " have in view work later in the professional theatre, in the experimental theatres of the country or in community settlements, colleges and high schools." Two or three courses in the department may be taken by the Yale College undergraduates who wish " to make their theatre-going more intelligent and enjoyable," but these seem to be exceptions reluctantly made in deference to the spirit of a university. The professional camel now occupies almost the whole of Mr. Baker's cultural tent. And with the best of excuses, for there is a greater demand for professional services in the dramatic arts than can easily be met. This

is true of at least the non-commercial drama, and the non-commercial drama is coming to be of nearly equal importance with that which is manufactured on Broadway.

But a school of drama, like a traditional school of fine arts, runs the risk of training without educating. It has the further problem that its different specialties do not demand the same degree either of maturity or of imaginativeness. The actor may profitably begin his professional studies at less than college age, Professor Baker believes. On the other hand the technical discipline of a playwright may well be postponed until well past the usual age of college graduation. A producer will need even more time, and certainly more technical experience, before he will know his way about in the theatrical world. Stage designers may fall into an intermediate class. A school of the drama not only has to make conditions for admission which will give the best results, but it has to weld together into a working organization those students of varying ages and tastes. It has to deal with individuals who expect to live by means of their personalities — a word often taken as synonymous with eccentricities — and yet it must impress upon them the ideal of team work. It would be too much to say that even Professor Baker has evolved the perfect formula. He has no cure for the egotism which is interested " not in acting as an art but in acting as self-exploitation." He would be hard put to it, one guesses, to tell where one leaves off and the other begins. The desire of the students to specialize is another difficulty. " They want

to study only what interests them from the first. They want to study only what at the moment seems attractive. They have small sense of the interrelation of the arts of the theatre, or of the theatre in all arts with the other fine arts — architecture, painting, sculpture, music. They are content to travel their narrow road till, too late, they discover that they have built walls of ignorance about them so high that they cannot clearly see where they should go."

But the very nature of the dramatic arts demands a breadth of view and a coöperativeness that are not essential in most other fields of aesthetic expression. The successful director must be able to instill group consciousness into a miscellaneous assemblage of individuals, often mutually jealous and suspicious. The successful playwright must remember that his words are to be strained through other personalities. He must write, in a sense, coöperatively. The community theatre is in especial need of these abilities, because it usually must depend in part on voluntary service which will not work smoothly without leadership. The school of the drama is fairly driven, therefore, to practice those virtues of harmony and farsightedness which ordinary art schools are tempted to neglect. It has to contemplate a joint and marketable product, which perishes with each performance and is of no value if the public cannot be induced to come and see it. A play production cannot be stuck away in a studio to await the coming of a better day. It is doubtful if even the bare script would survive if it were not first given a successful presentation.

Shakespeare and Bernard Shaw began by being played, not by being read. The ideal dramatic school, bearing these necessities in mind, would be as thoroughly American as a big league training camp — American because, as I have tried to point out, Americans have displayed a native inclination toward team work. And for the same reason the drama may become, as Professor Baker thinks it will, the characteristic form of America's artistic expression.

At Yale Professor Baker has the advantage and prestige of what is possibly the best-equipped small theatre in the country, a building completed in 1926. The large auditorium in the new theater will seat seven hundred and fifty persons and the stage is of full professional dimensions. There are two rehearsal rooms, one of which has a smaller stage, and there are rooms and equipment for a carpenter shop, scene-painting studio, costume studio and other necessities for a complete production. There are also class rooms, a library, a Green Room and abundant storage space. In fact, this is almost a factory plant for the production of plays.

Great emphasis is laid upon the practical. Students in advanced stage lighting direct the lighting of regular performances in the theatre; students in advanced productions direct plays at the school and often amateur performances elsewhere. The professional spirit is carefully built up. Students in certain specialties are encouraged or required to take courses in drawing, architecture or other departments of the School of Fine Arts. But the connection of the Department of Drama with the other

departments of the School is not an intimate one — certainly not yet so intimate as one would expect it to be.

2

THE COURSE in drama at Yale may require as short a time as two years or as long a time as four years, depending upon the student's preparation and objective. At the Carnegie Institute of Technology he is expected to spend four years, to earn the Bachelor's degree, and to round out his work in drama with certain other studies. The purpose is " to provide a practical training for young men and women who wish to become actors, playwrights, stage directors, technical directors or producers," and many students come with their minds already made up as to the specialty they wish to adopt. At the outset, however, they encounter a provision which at once differentiates Carnegie from Yale. The first two years are the same for everyone, with the single exception that the men make and handle scenery and properties, while the women learn to design and make costumes. Diction, English, folk-dancing, lectures in the history of the theatre, the history of costume and the general history of the arts, make-up and fencing, all are on the list and all must pursue them.

We thus find at the start that Carnegie has by main force avoided some of the intense specialization of which Professor Baker complains. It has done this, of course, by requiring students to take a number of subjects in which, perhaps, they are not immediately interested.

The awkward youngster who has a passion for stage lighting or design does not always enjoy the study of diction or sword play, or the necessity of learning and enacting parts. If he goes through with it, however, he comes out better fitted for his own particular job. In practice the student who cannot be taught to act and who does not want to be taught to act will not find himself in important parts. He will be made, however, to comprehend what an actor's problems are like. But there are occasionally students who enter with no more than a general interest in the theatre, and who find their especial talent during the two years' probationary period. They may be able to pass the department's entrance tests in " imagination, application, voice and general equipment for the dramatic profession," become fairly competent actors, and yet find their true rôle in some technical phase of the theatre. With the junior year specialization begins. The student may major in production, in acting or in playwriting. But even here he has no chance to become narrow in his interests, for he is likely to do work and take parts outside the field of his specialty. He will also continue with one or two courses outside his department. If he elects production he will study not only model making and electricity and lighting but also a modern language, introductory psychology and aesthetics. If he is to become an actor or a playwright he will still take the three studies last named in addition to his technical work.

As Professor Baker demonstrated at Harvard, and later at Yale, the way to teach the arts of the theatre

is to produce plays. Carnegie has not turned out as many student playwrights as have appeared in Baker's classes. This seems to be largely because Carnegie is an undergraduate school, and does not offer its wares to the mature and experienced student. Its boys and girls write plays in abundance, but these plays are not ordinarily produced publicly. Some original plays have been given their world premier in the well developed theatre of which the Institute is justly proud, but the repertory has been divided as a rule into two parts — classic plays, and modern plays which would not otherwise have been produced in Pittsburgh. The play-producing machinery is very busy indeed, for new plays are put on at intervals of from four to six weeks, and four plays are generally in process of preparation at the same time — one ready to present, one being read for the first time, and two in intermediate stages. The classes are distributed through the four casts, with the most experienced or most gifted students naturally in the most exacting rôles. The productions are expected to run a week and sometimes they actually do run longer. *Hamlet* held the stage for twenty nights. Shakespeare has, in fact, met with pronounced success. Mr. Ben Iden Payne of the department of drama has said that his experience with student productions has convinced him that " Shakespeare, in the case of the earlier plays at any rate, requires to be presented by young actors, for it is only by this means that the buoyant, youthful spirit of the plays, which is of the essence of their charm, can be retained." Certainly those who remember productions of *Romeo and Juliet* in which

the leading feminine rôle was taken by buxom actresses of forty and more can see Mr. Payne's point.

The audiences at Carnegie are selected, as are those at Yale. Practically this means that the plays can be seen by any one who is sufficiently interested to make application for a ticket. It means, too, that the theatre is assured of a capacity audience for a six-night run, and sometimes, as has been said, for a longer one. The commercial element can be omitted from the calculations. None the less these are by no means amateur productions. The effort is made to create in every respect the atmosphere of the professional stage. The discipline is that which any competent professional manager would impose. The curtain goes up and comes down on time. Rehearsals run far into the night, with small regard for that mathematical balance between time spent and credits given which holds in most colleges. Incidentally it should be mentioned that the department of drama also gives part-time night courses in acting. Like all night classes these have much of the pathetic and heroic about them. But, though they cannot of themselves produce professional actors, they help lift the average of amateur acting and do something toward building up intelligent local audiences.

Men and women are fairly well balanced in the drama courses, with an excess of women largely in the freshman year. Half or more of those who enter as freshmen fail to complete the course. But those who drop out are by no means all failures. Nearly every actor and actress who comes to Pittsburgh visits the Institute and

sees a play at one of the Friday matinees, and the prom-
ising student performers sometimes receive offers before
they win their degrees. The classes are, of course, care-
fully pruned during the first year, for it is a notorious
fact that in the case of the stage many are called and
few chosen.

Some of Carnegie's graduates have found the road
that leads to Broadway. More have gone into com-
munity theatres and into the schools. Their influence
in the dramatic revival has not been small.

3

THE DEPARTMENT of drama at Carnegie was built up
during the first ten years of its existence by Thomas
Wood Stevens, who went from Pittsburgh to take
charge of the Kenneth Sawyer Goodman Memorial
Theatre at the Chicago Art Institute. This theatre, dedi-
cated in October, 1925, is unusual in being both a reper-
tory theatre, with a group of paid professional actors,
and a school of the drama, on a footing with other pro-
fessional courses in the Art Institute. Physically it is
one of the most attractive, though by no means the
most elaborate, of the smaller theatres. The playgoer
has reason to be especially grateful for the wide spacing
between the seats, which incidentally made it possible
to do away with center aisles. The auditorium will
accommodate seven hundred and fifty persons. There
is an admission charge, though it is well below the level
of the commercial theatre of Chicago, and there is a

special rate for members of the Art Institute. The professional group plays four times a week. Its casts include not only the repertory group but also, in minor parts, a number of qualified students. Besides this, distinguished guest players are sometimes invited. The plays are chosen for their artistic merit, which may or may not mean their popularity. Thus the first season opened with an American premier of Galsworthy's *The Forest,* and this was followed by a program of Shaw, Shakespeare, Molière, and some of the moderns and ultramoderns. " The Theatre has no special style or type of drama to promulgate," said Director Stevens, shortly after the building was opened, " any more than the exhibition galleries of the Institute exist for any special group of artists. In each case the question is whether a particular old play is worth revival or a particular new play is suited to performance. In the end the audience must aid in making these decisions, and the greatest thing the Goodman Theatre can hope for its future is an alert and creative audience."

So much for the Repertory Company. Despite its intention to promulgate " no special style or type of drama " the very fact that it is non-commercial influences its selection of plays. Ordinarily it must present those in which the commercial managers and theatrical landlords do not see a chance of profit. The types it chooses will be circumscribed to that extent. They will perforce be experimental, whether the selection is from the classics or from the latest importations from Vienna. But an intelligent, non-commercial producer, who can

afford to take a loss now and then, can sometimes out-guess the producer who estimates dramatic values solely by the cash register. The Goodman Repertory company is finding its public and its place in Chicago. In the membership of the Art Institute it already possesses the nucleus of an understanding audience, and this audience is growing. Even more important, perhaps, the company is finding itself. A first-rank repertory group is not created in a day. That at the Goodman Theatre is the result of enthusiasm combined with long hours and hard work.

The repertory and the studio departments of the Theatre have been organized to work smoothly together, the one serving the other. As has been said, qualified students appear in the repertory productions. Members of the Repertory Company, in turn, act as instructors. Students are admitted to the school, as at the Carnegie Institute, only after competitive tests. They must be at least eighteen years old and must have completed a four-year high-school course, or its equivalent. The period of study is four years, and is intended to give " a thorough professional training in the entire work of the theatre." Stage craft and lighting are required courses, on the theory that even an actor should know what makes the wheels of the stage machinery go round. Make-up, scene design and scene painting, costume de-sign, and the history of the drama are also on the school's bill of fare. General culture is represented by a survey of art history, given as part of the regular course in the Art Institute. For those who show the necessary ability

there is a course in dramatic composition, and students' plays of sufficient merit are to be produced. But such plays, among young people who may not have been two years out of high school, are not easy to find.

The principal part of the work is the actual staging of plays. These are given publicly, on a scale of prices lower than that of the Repertory company. An interesting feature has been children's matinees, usually of plays adapted especially to juvenile audiences. *Robin Hood* was a successful example. These are, it is announced, " in part educational, but the Goodman Theatre would prefer to stress its more important purpose of entertainment." This may be taken as a wholesome augury, even for plays not intended for children. There have been, and obviously still are, too many non-commercial theatres whose managers have forgotten that the primary purpose of drama, whatever its secondary, tertiary and quaternary purposes, is to entertain. One does not visit many such theatres without reaching the conclusion that of all the arts of the stage that of keeping the audience's attention is the greatest, and that it should be cultivated as assiduously by the experimentalists as by the Broadway managers. Perhaps the only way to raise standards above the commercial level is to be more amusing than commercialism has yet dared to be.

The students of the drama appear to flock by themselves at the Art Institute as they do at Carnegie and Yale. In each case they are a part of a larger institution more in form than in fact. The unity of the arts is obviously not a living thing with most of them; they are

occupied with acquiring the peculiar stamp and flavor of the stage. One is inclined to think that this is a real defect in their teaching. The tradition of the actor is accepted with too little inquiry as to how defensible, how well adapted to modern conditions, and particularly to conditions in the non-commercial theatre, it is. And sometimes there seems to be danger that the student will mistake the Green Room for the world. But this is a danger inherent in any " workshop " scheme of education. The problem of the school of the drama is that of the art school in miniature.

<div align="center">4</div>

A SCHOOL of the drama connected with a state university is obviously on a different footing from one which is a part of a privately endowed institution. In the first place, as Professor E. C. Mabie, who has done distinguished work in the teaching of dramatics at the University of Iowa, has pointed out, " university courses in the fine arts come into existence only when the economic condition of the people of the state is such as to give them leisure in which they may turn their attention to art." The art of the theatre comes home to more people than the art of paint and canvas, yet it must wait its turn in any institution supported out of taxation until more " practical " subjects have had their innings. When it is introduced it must encounter, very often, hostility within the university faculty and indifference without. To overcome this hostility and make headway

among students and general public requires time and patience. That Professor Mabie and others have succeeded in this task speaks well for their abilities and perhaps also for the receptivity of the public mind.

The very difficulties are, in a sense, correctives. The theatre is at present the most democratic of the arts, though there is not the slightest reason why it should not be equaled in this respect in the course of time by the arts of design. A democratic art must fight for its existence and its prosperity exactly as though it were a motor car or a shaving cream. No training that does not emphasize the competitive necessity is likely to produce a really robust type of graduate. It is notorious that the aesthete does not always have an easy time in institutions supported out of taxation; and it is perfectly natural that this should be the case so long as the aesthetic is not looked upon as one of the essentials of life. Art, dramatic or otherwise, will doubtless be compelled for some time to come to justify itself in the state universities, not only by its courses but by what amounts to state-wide crusades. But such crusades are in the larger sense the business of democratic education. And, as has been repeatedly shown, the art of the theatre lends itself most admirably to it.

Departments of the drama rarely begin under that name. Thus Professor Mabie's courses at Iowa were listed under the Department of Speech, and those at several other colleges and universities are grouped as departments of public speaking, of oratory, of expression, and

so on, or are impounded, as were Professor Baker's classes at Harvard, under the English department. I have already spoken of the work in drama at the University of Washington. This began with classes in elocution, intended mainly for the benefit of high-school teachers. By degrees an interest in the theatre developed and elocution was metamorphosed into dramatic arts. But the university reflected rather than created this new interest. The high school had begun to demand teachers who could coach dramatics, just as they also demanded teachers who could put a semi-professional finish on their athletic teams. Back of this was a perfectly healthy enthusiasm for a form of expression usually denied to pioneer communities. There was also a loosening of the old religious prejudice against any form of the theater. But dramatic art at the University of Washington has remained largely a subject for teachers.

The work at Washington is still in that pioneer period in which enthusiasm and *esprit de corps* are heightened to make up for deficiencies of equipment. The practice stage is small, and though a large university auditorium is available upon occasion there is no theatre dedicated to the department of dramatic art. But this produces an informality and an adaptability that are not without their advantages. The student learns to get his results economically, as he will probably have to do in most instances after graduation. To hold this up as a desirable situation, in contrast with that which exists at Yale, at Carnegie, or at the Chicago Art Institute, would be absurd. Nevertheless a lean and hungry period may often

be one of sound foundations. Such, at least, seems to have been the case at the University of Washington.

In the next chapter I wish to consider briefly three community theatres — the Boston Repertory, the Cleveland Play House, and the Pasadena Playhouse. It may also be worth while to return for a moment to the work of the Santa Barbara community theater.

II

THEATRE AND COMMUNITY

I

THE term Community Theater covers a multitude of dramatic enterprises, including some dramatic sins. We may apply it for our present purposes to any theatre regularly conducted for some motive other than private profit. The principal sources of difference among these playhouses are, first, the extent to which they make use of a professional staff, and, second, the degree to which they rely upon paid admissions to meet their expenses. A community theatre which has a nucleus of competent professional actors naturally finds it easier to compete with the commercial stage and with the glamor of the motion pictures. A theatre which lives upon its admissions, without recourse to endowment, guarantee or subvention, has obviously come nearer to meeting a community demand than one which does not. But the question cannot be dismissed as easily as this. A function of the community theatre is to educate; otherwise it would be hard put to it to explain its own existence. A theater can educate by giving as many persons as possible some experience in the art of acting. This is one way of training intelligent audiences, though a slow one. Another way,

296

which is sometimes inconsistent with box-office prosperity, is to raise the level of taste by producing something a little finer than the public has been accustomed to. But here, again, good judgment as well as good intentions is required. Mr. Henry Arthur Jones has pointed out very entertainingly in a letter published in one of the bulletins of the Repertory Theatre of Boston some of the pitfalls of community drama.

" Of course," he states, " it is always possible to obtain what is called an ' artistic ' success by discovering some new and laudable way of boring the public in the theatre. Unquestionably many of our repertory theatres " — he is speaking as an Englishman — " have gained this kind of success, and deserve great credit for losing their promoters' money in so praiseworthy an enterprise. Much credit may also be given to our repertory managers, in that while they have disdained to pander to the base and universal desire of playgoers to be amused, they have at the same time overwhelmingly demonstrated that social problems and ' ideas ' can be debated in the theatre without arriving at any conclusion about them. At times I have suspected some of our repertory managers of being social reformers. For these reasons there has been a general deficit both in the banking accounts and in the nightly audiences. It is, however, only fair to say that the failure of our repertory theatre to educate the public has been solely due to the large number of absentees from the performances. It is impossible to educate playgoers unless they are present to receive the instruction, and are also prepared to pay for the process."

The symptoms are familiar, even in America. We have not a few little theatres and community theatres whose audiences attend as a matter of duty or for social reasons or for any reason at all except that they enjoy the plays presented. We have also had such top-heavy enterprises as Mr. Winthrop Ames' New Theatre in New York City. If the Guild Theatre of New York city, which may possibly be considered a community theatre, has succeeded, it has been because it found the golden mean between plays which the public will not come to see and those which it ought not to come to see. Yet the Guild is frequently criticized, by the sterner members of the movement, for the, let us say, catholicity of its standards. I know of one community theatre of high standing and heroic attainments and ambitions, which turned down the first rights in its city to the Guild's great success, *They Knew What They Wanted*, on the ground that the play was both commercial and immoral. The theatre in question then proceeded to play Sudermann's *John the Baptist* to thin houses. I mention this incident, not by way of criticism, but to illustrate the problems with which the manager of a community theatre must deal. If he is to succeed he needs all the qualities of the commercial manager and a few peculiar to himself besides.

It is not, unhappily, enough to desire the public's good. One must desire it intelligently, and one must work for it with the proper equipment of technique. I suspect there should be at least one hard-boiled and thoroughly cynical member on the directorate of every

community theatre. I have mentioned these considerations by way of hinting that this chapter has to do, not with perfection, but with struggle and experiment.

2

THE REPERTORY THEATRE of Boston owes its beginnings to Henry Jewett, an actor of Australian birth, who came to Boston in 1915 to give a twelve-week season of Shakespeare. The support received was sufficient to encourage Mr. Jewett to take over the Toy Theatre, later known as the Copley, the following year, and set up in repertory. In this adventure he had the active assistance of his wife, Frances Jewett, and the names of the two are inseparably connected with the theatre they eventually founded. In 1919 the Repertory Theatre Club was organized to help sustain the enterprise. High rents and other disabilities led to a disagreement which disrupted the original company. But in the meantime ground had been broken for a new theatre on Huntington Avenue, opposite Symphony Hall — a most auspicious site in Boston — and the curtain in the new building rose for the first time on the eve of Armistice Day, 1925.

The Repertory Theatre is one of the handsomest of the smaller American theaters of its type, though one has to measure his words in making comparisons with such structures as the Community Playhouse in Pasadena, the Lobero Theatre in Santa Barbara, and the new Cleveland Play House. It has seating room for about one thousand persons in its main auditorium, in addition to

a smaller hall in which about four hundred and fifty can find space. There are offices, lounge rooms and reception rooms, quarters for the Repertory Club, and, which may be, after all, important even to a community theatre, a superbly-equipped stage. Members of the Club not only get their tickets at a reduced rate but have the opportunity to exchange views with members of the cast in the Green Room after an evening performance. No doubt this adds a little to the intimacy which exists nearly always between the players in a stock company and their regular audiences. There are other ways of creating a sense of participation. Club members, if they wish, may sign up as associates with the director of the theatre, and may then be called upon to fill such supernumerary parts as they are suited for. Of course no large number of amateurs can be brought upon the stage by this means. But every such device helps. In the long run, however, it is clear that the success of any community theatre will depend, not upon the relations it established with its constituency back stage or in the Green Room, but upon those it can manage to establish across the footlights. A theatre is, after all, a theatre.

Since its beginnings at the Copley the Jewett company has played Shakespeare, Shaw, Galsworthy, Pinero, Henry Arthur Jones, Somerset Maugham, Barrie, Zangwill, Arnold Bennett, Dunsany, Milne, Ibsen, and a number of classic revivals. It was not afraid to open its doors for the first time with a play as ancient and well-worn as *The Rivals;* and in fact, though sufficiently

modern, it cannot be said to carry experimentalism to the verge of eccentricity. One would not resort to it for the Czecho-Slovakian, the Viennese, or the post-revolutionary Russian. It seeks the balanced ration, with proven material as the basis. None the less it professes itself ready to produce original plays from time to time, and its members are invited to submit such plays to the reading committee.

In close connection with the Theatre is the Repertory Theatre Workshop, " a practical school " for training young people in the dramatic art. This is under the direction of the officers of the Theatre and instruction is given by members of the acting company. If the students qualify they are allowed to go on in regular productions as supernumeraries or in small acting parts. But there the line is drawn. The Theatre does not jeopardize the professional finish of its productions by allowing awkward students to clutter up the stage. The play comes first, the school next. However, this does not prevent a thorough training. Indeed it exposes the student more than do most schools of the drama to the atmosphere of the working theatre. There are no examinations on systems of grading. The school is conducted like an acting company. Students report each morning to the rehearsal room and are given parts or called for rehearsal, exactly as though a professional production were being prepared. The course is a continuous one of thirty weeks. An effort is made to place students, through a theatrical agency, as soon as they have acquired sufficient proficiency.

Besides the course in acting there is a course in playwriting, modeled on the methods followed by Professor Baker at Harvard and later at Yale. There are classes also in modern drama, and in dancing, fencing, costuming, scenic design, and stagecraft. The workshop plays are presented on the smaller stage in Rehearsal Hall.

The legal status of the Theatre is unusual enough to be worth mentioning. It is organized under a trust fund incorporated for " educational, literary and artistic purposes," to which must be returned all receipts after operating expenses are paid. The Theatre lays claim to be the first in the United States to be declared exempt from taxation. This privilege was granted on the ground that it is an educational institution, and in accordance with this fact representatives of the state and municipal departments of education are asked to sit on the board of trustees. In this way the Theatre is given a quasi-public status, much as is a museum or a public library. The financing has been done by the sale of bonds, through bequests and through fees and dues. The Club has eight different types of membership, beginning with the Founders, who subscribe one thousand dollars, and ranging down to the annual members, who pay five dollars a year, and the junior members, under sixteen years of age, who pay two dollars a year. This, too, is very much like the plan followed by most museums. In short the scheme of organization has been intelligently devised to make the Theatre a community institution, around which a tradition will grow and

which will not be dependent on a single group for permanence.

One enthusiastic writer predicted that the Theatre would become " the artistic dramatic capitol of New England." It may become so if its directors will not rely too much upon the cultural and respectable upper layers of Boston society, but will occasionally look across the Bay and consider the movement which started so humbly on a wharf beyond the sand dunes of Provincetown, not many years ago.

3

ALL COMMUNITY achievements seem easy in Cleveland, and none can be mentioned without mentioning Cleveland. The visitor fancies that some one waves a hand and museums, libraries, orchestras and art schools come into being forthwith. But this is an illusion of perspective. Coöperation in Cleveland has cost sweat. There have been humble beginnings. For instance, the Cleveland Play House originated in a church.

" At first," wrote Charles S. Brooks in the *Theatre Arts Monthly,* " there were seats for two hundred, then a gallery was thrown across for twenty-five extra chairs — two hundred and twenty-five in all, with scanty space for knees. Four rows of pews remain and are the favored seats " — this was before the new theatre had been occupied — " but other hints of holy living were covered with gaudy paint, and time has now tarnished that. At first the office was an alcove from the

auditorium, with telephone silenced by a rubber band. The cellar beneath the stage served all purposes for dressing rooms, paint and carpenter shops and storage. . . . On a crowded night there is no corner without its litter or workers. A chair between the furnace and the coal hole is the only spot of quiet retirement, its septic gas the only air unbreathed."

This, it will be admitted, was heroic. But heroism is not the worst of necessities. The Play House took its rise, about a dozen years ago, as a purely amateur enterprise. " At the start," it is hard to resist quoting Mr. Brooks, " there were four productions to the year, each of three or four performances, and these at times drew out but a meager audience. On a rainy night, perhaps, the heroic speeches rattled back from empty chairs. This was the period of Maeterlinck and purple lights through which most private theatres ran, filmy plays of moving shadow and things unrealized." Besides the inevitable *Pelleas and Melisande* there were such things as *Everyman, Sakuntala,* Synge's *Deirdre of the Sorrows,* and dramas by Strindberg, Tchekov, Andreyev and the like — some of them rather heavy-going for the untutored audience. Ideals have not been lowered as the years have gone by, but there has been a tendency toward the less depressing type of drama. O'Neill, with his strong grasp on theatrical realities, made his appearance; Shaw became a staple; Milne, Chesterton, Wilde and Galsworthy had their days and nights; and Cleveland saw such box-office successes from Broadway as *John Ferguson, Rollo's Wild Oat,* and *Icebound.* Be-

tween 1921 and 1926 the Play House gave thirty-three important plays their first performance in Cleveland and gave ten plays their American premier.

The only professional member of the staff at first was the director. The rôles were filled by volunteers, of whom there were almost too many, and whose acting, like that of all amateurs, had its drawbacks. In 1921 it was decided, not to drop the amateurs but to supplement and coördinate them with a nucleus of professional actors. Within the next few years the professional personnel rose from three to fifteen members, and with it grew the artistic and popular success of the productions. By the end of 1926, when the new playhouse was nearing completion, the yearly audience had risen from four thousand to forty thousand, and the theatre was filled to an average of between ninety and ninety-five per cent capacity the year round. The new building permitted an immediate expansion. It has a main auditorium which will seat more than five hundred persons, or double the number who could be squeezed into the former quarters. The large stage is so arranged that steps leading down to the orchestra floor may be uncovered and part of the action take place, if desired, on a level with the audience. Whether devices of this sort have their place in the theatre of the future — whether, in other words, there is any enhanced sensation of reality when the actors come out of the picture frame made by the front plane of the stage — is a question for the technicians to worry about. The Play House, at any rate, is ready to experiment. In addition to the main

auditorium there is a smaller one, also with its well-equipped stage, and seating one hundred and eighty persons. Then there is a charming open court, where in good weather refreshments are served at tables to the music of a fountain. A Green Room enables the audience to meet members of the cast upon occasions when this is mutually agreeable. The community theatre becomes to some extent a community social center — a development of no little significance.

The plays, generally speaking, are those which, in Director Frederick McConnell's words, cannot " meet the commercial quotient of the regular commercial theatre." If they could, the commercial theatre, with its larger financial resources, would outbid the Play House. Mr. McConnell also makes the fine distinction between amusement, which is a proper function of the commercial theatre, and enjoyment, which is the object of the Play House. An audience which is willing to take some pains to enjoy itself does not spontaneously walk in off the street on any fine evening. It must come as a result of previous experience, and with a pretty definite expectation of what it will find. Such an audience has to be built up slowly, just as does the patronage of the art galleries, the libraries and the orchestras. But once built up it can be relied upon.

The mingling of a cast of paid professionals with a group of amateurs who work for love and glory might be thought to offer problems. In fact it does not seem to do so. The Play House, as I have said, has its repertory company. Many of these players have come from the

school of the theatre at the Carnegie Institute of Technology. It also offers opportunities to students of the theatre, some of them college graduates who have acquired the customary outlines of a cultural education, and now wish professional training. But not all the students come under this category. A year or so ago the Play House had on its rolls a young man who worked half of each day in a grocery store thirty miles from, Cleveland, commuting regularly to the theatre after his grocer's tasks were finished. Finally, there is the amateur group, who have numbered thirty or more, each one appearing in two or three productions a season. In several instances these amateurs have discovered a vocation for the theatre and have adopted it as a career. Those who remain non-professional acquire a technical finish which prevents too ragged a performance.

The smaller theatre is devoted to work of a more intimate, informal and experimental nature. Its first function is to provide practice " in the arts of stage production and in the technique of playwriting." One or two notably good plays have come out of the Play House — Mr. Brooks' *Wappin' Wharf*, for instance — and it is hoped there will be more. The second function of the smaller theatre is " to make possible, in connection with and supplementary to the program of the main theatre, the presentation of classics, in dramatic literature and other plays of especial literary quality and distinctive novelty or newness which in the first instance need not depend upon immediate or general popularity." As the smaller stage is carried by the budget of the larger it

need not pay its own expenses. On the other hand it may serve the larger stage by producing plays suitable for the general audience. In this way there may be a steady building-up process. Finally, the workshop theatre is also a laboratory in which definite instruction in the dramatic arts may be given without prejudice to the work of the larger stage. The Play House thus takes on the dimensions of a plant, of a community clearing house for dramatic ambitions, experiments and ideas. It conspires with the museum, the art schools and other aesthetic agencies to raise the cultural level of its city — a development, indeed, since the old days of Maeterlinck and purple lights!

4

IN ONE respect the Pasadena Community Playhouse had an evolution exactly opposite to that of the Cleveland Play House. It grew out of a professional stock company and into an organization in which the acting rôles are all taken by unpaid amateurs. Mr. Gilmer Brown, to whom the major part of the credit for the enterprise is due, came to Pasadena in 1916, and established a stock company in a small theatre which had formerly been devoted to burlesque. He had ideas above the usual humdrum stock-company level, and soon began to coöperate with the Pasadena Center of the Drama League of America. This coöperation took several forms. One of them was the sale of subscriptions through the League. Another was the production by Mr. Brown's players of prize plays for which the League

held contests. A third was the formation of an Amateur Players' Section of the League, from which Mr. Brown was able to recruit capable non-professional actors. This latter step became urgently necessary at the end of the first season, when the professional players had to be released for lack of money to pay their salaries. In 1918 the company was reorganized on a purely amateur basis under the title of The Pasadena Community Playhouse Association. Its financial struggles were severe, though the Association hired a publicity expert and did its best to sell its ideas to the wealthy community in which it had set up shop. For many months during the influenza epidemic the theatre was dark. When this period had been weathered a commercial stock company offered such effective competition as almost to put the Association out of existence. But meanwhile Mr. Brown had built up a corps of amateur actors whose work drew audiences of steadily increasing size. By 1924 it was possible to make definite plans to carry out the long-deferred project of building a playhouse and in May, 1925, the new building was opened.

As it stands the Playhouse is the symbol of a very considerable success. Externally it is perhaps as effective a piece of architecture, with its tiled roofs, its arcades and its skillfully-projected tower, as Pasadena possesses. Internally it is superbly equipped and styled. The perfection of its details is evidence of a generous community backing, to which architects, artists, engineers, technicians and contractors gave their services. Amateur players have rarely had so luxurious a setting for

their performances. The main theatre has a seating capacity of about six hundred persons on the orchestra floor and an additional two hundred in the balcony. The Recital Hall, which has a separate entrance and special uses of its own, possesses a smaller stage and will seat three hundred persons. Green Room, dressing room and other facilities for the comfort of actors and staff are enough to arouse envy in any professional's heart. At this writing the Play House produces two plays a month the year round, giving eleven performances of each play. The play committee has a card index of one thousand or more volunteer players, together with a brief notation of the experience and qualifications of each one. The capabilities to be found in so large a list naturally vary considerably. Some can be used only for supernumerary parts. A small group come near being professional actors in every respect except being paid for their acting. Thirty or more have actually graduated to the commercial stage. Occasionally a professional from the legitimate or even the motion picture stage will take an unpaid rôle in the Playhouse in order to fill in part of an idle period. As the actors in one play need not appear in the next rehearsals can be started well in advance of production, and while one is running two will be under preparation. Each play is given, on the average, eighteen rehearsals.

It is plain that we have here not only a different scheme of organization but also a different objective from that sought by the Boston Repertory Theatre, or even by the Cleveland Play House. The emphasis at the

Repertory Theatre is upon proficient performance. All else is subsidiary. The Cleveland Play House, as we have seen, combines amateurs, students and professionals very successfully, yet there, too, it is what the audience sees across the footlights that chiefly counts. But it is no insult to Gilmer Brown's directorship to say that he is aiming at a far broader target than a smooth production. His Savoy Players, when they were still a paid stock company, probably came nearer that mark than is possible for the Playhouse to-day. Mr. Brown and his associates achieve an amateur performance of high rank, with all the spontaneity and enthusiasm that go with the amateur spirit, and with some of the unavoidable faults. If acting is an art certainly no one who spends the greater part of his life doing something else will become a journeyman actor. But, as Mr. Clinton Clarke says in describing the work of the Playhouse, " the plays are incidental to the deeper purpose of the organization, which is not to make actors but to provide opportunity for self-expression as well as to bring people together in joyful co-operation for their own entertainment." There is no doubt as to the joy of the coöperation. Every community theatre which allows amateurs inside its stage doors bears witness to an almost pathetic eagerness of the layman to have some part, however small, in the stage world of make-believe. Nearly three hundred volunteer workers helped make costumes for the Playhouse in a single year. Memberships are divided into classes, according to the amount the candidate is willing to pay. With its first year in the new building the

Association more than paid expenses, and it gives every indication of remaining solvent — which is, all things considered, a fair test of its service to its community.

The plays produced have been for the most part modern, though Shakespeare, Molière, Beaumont and Fletcher, Goldsmith and Sheridan have not been neglected. Mr. Brown's amateurs have courageously essayed Chekov, Andreyev, Ibsen, Shaw and Molnar as well as the less exacting plays and playwrights. The Playhouse has nursed its audiences along with such productions as *The Great Divide,* Pinero's *Enchanted Cottage, Good Gracious, Annabelle, Mrs. Wiggs of the Cabbage Patch, The Potters, The Passing of the Third Floor Back,* and *The Servant in the House.* It has sufficient common sense to present a holiday play when its audiences are in a holiday mood; and sufficient audacity to intersperse the other kind. But it lacks the perfume of the uplift. Mr. Brown has done a workmanlike and therefore an inspiring job, but he has not wrapped himself in the mantle of Elijah. Few community theatres are so simple, so free from the attitude of patronage.

By way of discovering and building up new material the Playhouse has its Workshop, which gives productions on Saturday evenings on the smaller stage in the Recital Room. Here candidates for the regular casts may show their abilities and original plays may be tried out. A nominal admission fee is charged and the atmosphere is informal. Of a different order are the Playbox productions, which are labors of love, given frankly for small and intimate audiences. The stage is dispensed

with and the barrier between players and spectators made as slight as possible. A typical Playbox production was *The Chester Pageant of the Water-leaders and Drawers of the Dee Concerning Noah's Deluge,* put on during the Christmas holidays. The actors in these Playbox dramas are often chosen from the most experienced of those who have had parts in the larger plays.

5

I have already spoken of the work of the Community Arts Players at Santa Barbara. The Lobero Theatre here operates upon substantially the same principle as the Pasadena Playhouse. Its plays are acted and much of the activity of production carried on by amateurs under professional direction. But the Lobero has the advantage, which the Pasadena Playhouse lacks, of being part of a community organization larger than itself. It appeals to an audience and to groups of volunteer workers already trained to coöperate in other things. The response has been generous. Of more importance than the actual work accomplished is the sense of participation gained by the volunteers. The Lobero does not stand outside or above its community.

Its program has been varied but never " arty." *Twelfth Night,* Pirandello's *Right You Are, Caesar and Cleopatra, Rain,* Noel Coward's *Hay Fever, The Show-Off,* and *To the Ladies* are perhaps representative. The Broadway success of the better type is by no means frowned upon. Efforts are also being made to secure

good original dramas. Indeed, here as in Pasadena, Cleveland and one or two other cities, one of the most encouraging signs of the community theatre movement is the attempt to mix the Broadway product with some more homespun ingredients. A new school of playwrights may come into being to meet the need, for Broadway is not all there is to America.

I have thus hastily sketched in outline the policies of a few out of the multitude of American community theatres which are doing significant things. I should like, in conclusion, to consider very briefly the manner in which the theatres, art museums, art schools and community art movements are interrelated.

In Conclusion

IN CONCLUSION

THE aesthetic movements to which the preceding chapters have been devoted would not mean much if they did not possess a kind of unity. But one cannot study them consecutively without coming to regard them as manifestations of a cultural and creative impulse which is a new thing in America. I did not set out to discover any such phenomenon and I have resisted as well as I could the temptation to take it too solemnly. In such cases it is easy to fall into an error of perspective, and this may have happened in the present instance; it may be that the enthusiasm of the few with whom my pilgrimage necessarily brought me in contact obscured the apathy or hostility of the mob. But, after making such allowances, I still am convinced that something is going on. It is young, it is unformed, it is divided between the desire to imitate a gentlemanly civilization that is past and the urge to wrest a more democratic civilization out of the future. As yet it has hardly got beyond the first stage of wonderment through which all explorers pass when they blunder into a new world. Nevertheless, I think that there can be no doubt that America, having expressed herself politically, mechanically and administratively, is on the point of attempting to ex-

press herself aesthetically. This has been thought before. It has been thought as far back as the false dawn of the 'forties of the past century. But now one begins to believe it true. Wherever one touches the arts in America there is at least a sense of life. Our very crudities, our very vulgarities, are lusty. In manner, indeed, the foreign influence is still heavy upon us. But we are beginning to dream of walking alone.

We see a drawing together of elements heretofore set apart. The colleges begin with purely cultural, conscientiously impractical courses about the fine arts. Little by little, under one pretext or another, the actual practice of the fine arts creeps in. Spokesmen for the universities openly lay claim to the professional art school, as they have successfully done to the professional schools of medicine, law and engineering. Schools of the crafts approach the fine arts; schools of the fine arts find new value in the workmanlike integrity of the craft schools. Teachers of the arts realize more and more that their work is not half done if they do not enable their students to fit into an actual, industrial, commercial world. Industry feels the need of better design and goes to the art schools to find it. Museums remove the dust from their exhibits, let in sunlight, send out to invite patrons of all ages, plan their work with the public schools and the libraries as well as the art schools, become, in short, active educational institutions. Little theatres are metamorphosed into true community theatres; the more successful of them are as ready to learn from their communities as they are to teach. Nearly all these institutions

are growing rapidly in wealth and in patronage. The American public is not artistically sophisticated; indeed, it is inclined to resent sophistication in that field. But properly appealed to — and that means, to start with, not too arrogantly — it reveals itself, in such samples as we have dipped up out of the mass, hungry for beauty, eager to have a hand in a creative enterprise, wistful for a significance so far lacking in the national life.

To those who are not unmindful of anti-evolution laws in Tennessee, burnings alive in Mississippi, book censorships in Massachusetts, the Monday morning litter in Central Park, the millions hypnotized by motion pictures aimed skillfully at the nine-year intelligence, our murders, our childish careering about in automobiles and resulting fatalities, our gasoline filling stations, our hot-dog stands, our derby hats, our plus fours, the tabloid newspapers, the Ku Klux Klan, our extensive use of chewing gum, the standards of eighty per cent. of our radio programs, our sheeplike susceptibility to suggestion in any form, whether made in advertisements, newspaper headlines or presidential ukases — to those who bear these things in mind the statements made above will seem a sorry sort of irony. But these symptoms come from two sources — first, from a species of infantilism to which the human race has always appeared disposed, and second from pure boredom. As to the childishness of a certain percentage of minds out of every human group nothing can be done. Feeblemindedness can doubtless be bred out of the race but, as some of

the modern eugenists show in their own persons, narrow-mindedness and mediocrity cannot. Some of us, to the end of time, will be less bright than the rest of us. There will always appear to be, no matter how far humanity progresses, a moronic mass; if the majority of mankind were to develop into Platos they would still annoy the super-Platos and the super-super-Platos with their relative stupidity and insipidity. But this sort of relativity has not prevented heroically creative ages in the past and should not prevent them in the future.

Boredom, on the other hand, is probably one of the causes of mankind's most splendid actions, as well as of some not so admirable. It led nearly everyone in the countries concerned to welcome the World War; it has provoked dangerous explorations, inventions, wild romance, reforms, revolutions, crimes and martyrdoms. But these episodes are merely the result of attempts to live more intensely. And what is intense living? Is it not primarily an effect of an increased consciousness, of heightened sensitiveness? Ragged battalions from the front-line trenches, convalescents drifting back from the gates of death, lovers — to such actors in the human drama there is no taste, there is no color, there is no touch or texture, there is no sound or smell that is not new and lovely because it partakes of life. But it is this sensitiveness that inspires art, that is expressed by art. Art itself can be the greatest adventure. It will be seen that what is meant by art in this sense is not mere recreation, not decoration, nor a refinement of life, not an escape from life, but a whole-hearted, wide-armed,

exultant acceptance of life. And that is possible in America, invigorated by an unprecedented mixture of bloods and illuminated by a fabulous success.

Politics has lost its elemental importance for us. There are no more discoveries to be made, no more new lands to conquer. Our economic life is hardening into patterns. The channels into which our violent energies can be turned are fewer. Yet this has all come about so swiftly that we are still in the morning of our communal existence. Is it incredible that we should turn to the arts, and there write in our scrawling masculine characters the name of America beside the names of Italy and Greece? Is it a vain dream that in this enterprise we shall find the democracy, at least the equality of opportunity, which in other phases of our life has failed us?